Aristotle in Hollywood

The Anatomy of Successful Storytelling

Ari Hiltunen

intellect™
Bristol, UK
Portland, OR, USA

First Published in Great Britain in Paperback in 2002 by
Intellect Books, PO Box 862, Bristol BS99 1DE, UK

Consulting Editor:	Julian Friedmann
Editor:	Jonquil Florentin
Copy Editor:	Peter Young
Typesetting:	*Macstyle Ltd*, Scarborough, N. Yorkshire

A catalogue record for this book is available from the British Library

ISBN 978-1-84150-060-7

Printed and bound in Great Britain by 4edge Ltd, Hockley. www.4edge.co.uk

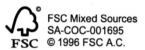

FSC Mixed Sources
SA-COC-001695
FSC © 1996 FSC A.C.

Contents

Aristotle in Hollywood

Throughout the centuries Aristotle's *Poetics* remained something of a mystery. What was the great philosopher really trying to communicate about the nature of drama and storytelling? What did he mean by pity, fear and *catharsis*?

In this book, Ari Hiltunen explains the mystery of *oikeia hedone*, the 'proper pleasure', which, according to Aristotle, is the goal of drama and can be brought about by using certain storytelling strategies.

By examining the key concepts and logic of the *Poetics* and analysing Sophocles' tragedy *Oedipus Rex*, the author explains Aristotle's insight and relates it to drama, film, television and multimedia today.

In the 1920s the Russian folklorist Vladimir Propp was surprised to find a common pattern in folktales from all over the world. Later the American anthropologist Joseph Campbell found a common pattern in stories and myths in ancient cultures and wrote about this in *The Hero with a Thousand Faces*. Ari Hiltunen demonstrates how Propp's and Campbell's discoveries, the world's best-loved fairy tales, Shakespeare's plays, empirical studies on the enjoyment of drama and brain physiology all give support to the idea of a universal 'proper pleasure' through storytelling. This pleasure can be achieved by skilful use of certain storytelling techniques. Aristotle's argument is that the more pleasure a drama can bring about, the better the drama.

By analysing such novels as *The Firm* and movies such as *The Fugitive* and *Ghost*, and the TV-series *ER*, the author demonstrates how Hollywood blockbusters and bestsellers are examples of the power and magic of the 'proper pleasure'. He also shows how Aristotle's ideas can be applied to create compelling experiences in computer games. Ari Hiltunen arrives at the fascinating conclusion that Aristotle's ideas and insights are as valid today as they were over 2000 years ago. Today when a story brings about the Aristotelian 'proper pleasure' it appeals to mass audiences all over the world and makes huge profits for its creators.

This book offers a unique insight to anyone who wants to know the secret of successful storytelling, both in the past and in today's multi-billion-dollar entertainment industry.

Intellect's *Studies in Scriptwriting*

Julian Friedmann – Series Editor

It is very appropriate to announce a new series of books on scriptwriting with the publication of Ari Hiltunen's *Aristotle in Hollywood*, as Aristotle is the earliest script analyst whose theories remain so convincing today.

Aristotle's *Poetics*, incomplete and open to interpretation, is not an easy read. Ari Hiltunen has therefore done us a considerable favour in the clear way he has applied Aristotelian drama analysis to contemporary entertainment such as blockbuster movies, top-rating television drama, best-selling novels and even computer games.

Aristotle's theory of drama at its simplest could be described in three little words: *pity, fear* and *catharsis*. What is so remarkable is that over 2000 years ago Aristotle realised that writers needed to address themselves to the audience and their emotions rather than primarily to the characters and theirs.

However, today many of the scripts that circle around above the desks of script editors, producers, broadcasters and agents show little attention to the needs of the audience.

The reasons why people watch movies, television drama and the theatre, and why they read, are not a mystery. We are seeking more from life, we want to understand life's meaning – and that of death.

Firing the imagination of the audience or a reader remains one of the greatest creative challenges, which is perhaps why so many people wish to write. Whether scriptwriting can be taught is a broad question over which even the experts disagree. Does writing for soaps and series television inhibit the talent required to write feature films? How much is talent a matter of applying common sense (something Aristotle had in plenty)? Does it lie more in a writer's ability to be truly original?

There are those who believe that learning to write is done best by studying human behaviour. Others believe that mastering the three-act structure to manipulate the audience's emotions is the key. Some now vociferously argue that the three-act structure is *passé* and we need to be more sophisticated in our approach to the combination of the art and the craft of screenwriting.

While undergraduate and postgraduate degrees in scriptwriting become more common, writing remains a fairly lonely and solitary occupation. The blank page cannot be avoided. *Aristotle in Hollywood* joins Phil Parker's book, *The Art and Science of Screenwriting*, and my own, *How to Make Money Scriptwriting*, as the beginnings of a series of practical books that will help scriptwriters.

Intellect's Studies in Scriptwriting

It is our intention to publish books in this vein that combine the academic with the vocational, the practical with the inspirational. If you would like further information about future books in the series, please let us know at Intellect Books.

Julian Friedmann
Series Editor, Intellect's *Studies in Scriptwriting*
Industry Consultant, MA in Television Scriptwriting, De Montfort University
Editor, ScriptWriting Magazine (www.scriptwriting magazine.com)
Joint Managing Director, Blake Friedmann Literary Agency, London

Preface

Chris Vogler

'Aristotle in Hollywood?' At first it sounds like the pitch line for a bad time-travel movie. 'So this Greek guy Aristotle gets conked on the head with an amphora and wakes up in Hollywood where his philosophies are turned into blockbusters, saving a major studio.' But in fact Aristotle in Hollywood is a great idea, and not just for one movie. It's an idea that can benefit anyone who is trying to be a more effective artist. Mr Ari Hiltunen's 'high concept' is to re-examine Aristotle's writings on Greek drama and mine them for narrative principles that can be of great value to modern-day storytellers, be they playwrights, screenwriters, or novelists. He shows how Aristotle's profound observations on human nature and the effect of drama on an audience can still inform the work of modern writers.

My awareness of Ari's work began in the mid-1990s when I first had the good fortune to participate in the PILOTS program in Spain, a yearly workshop where creative teams from all over Europe develop TV and movie stories with the guidance of industry professionals from the U.S., U.K, and Europe. It has been my doorway to the world, and has brought me into contact with many bright, interesting people from diverse cultures.

One of these people is the author of this book. Ari Hiltunen appeared on my radar screen in my first year at PILOTS, when I was still soaking up the beauties of Barcelona and the seaside resort of Sitges where the PILOTS workshops are held. I had just given a presentation in which I described the pattern of the 'hero's journey', a map of the psychological or spiritual process that seems to underlie the structure of most movies and stories. I had discovered this pattern in the work of the American mythologist Joseph Campbell, and my book *The Writer's Journey* was an attempt to 'translate' Campbell's academic theories into a practical guidebook for TV and movie writers.

Ari came up to me after the presentation and introduced himself as a television executive for a Finnish broadcaster. Apparently he had found something resonant in my interpretation of Joseph Campbell's 'hero's journey'. Finns are reputed to be rather reserved, but he seemed to defy the national stereotype with his enthusiasm for the subject.

Ari wanted to talk about the 'hero's journey' concept and had many questions about how I had discovered it and how I saw it applied in Hollywood movies, so we went out to one of the many pleasant sidewalk cafés of Sitges to have a drink and talk it over. I soon found he had a keen appreciation for mythology and its potential for

guiding modern storytellers, and was excited to see what I had been doing to develop a theory of mythic structure. He seemed to be experiencing some of the same enjoyment that I felt when I first encountered the mythic way of thinking.

Ari had ideas of his own, and related that he had been working out a theory for screenwriters based on The *Poetics*, Aristotle's essay on dramatic construction. I had mentioned some of Aristotle's concepts, particularly catharsis, in my PILOTS presentation, and I told Ari that the ideas and terminology of Aristotle were certainly an important element in Hollywood's general store of knowledge.

One of the great screenwriting teachers at the University of Southern California was the late Irwin Blacker, a formidable person who left his strong imprint on generations of film students, including John Milius and George Lucas. He treated lateness sternly and forbade, among other things, the wearing of hats in class. Professor Blacker really made us work, and one of the first shocks upon entering one of his classes was learning that he expected us to read The *Poetics* in its entirety, make some sense of it, and put it to work in our stories. This was no easy task, as Aristotle's text has suffered over the centuries. It is incomplete and garbled in places, but Professor Blacker made sure that we understood and applied the essence of Aristotle before we left his class. Together with his other major textbook, *The Art of Dramatic Writing* by Lajos Egri, Professor Blacker gave his students a solid basis in dramatic theory. His emphasis on The *Poetics* had a far-reaching effect, and is carried on by his students, now making films and teaching at all the major film schools.

Aristotle was still fresh in my mind when I discovered Joseph Campbell's model of 'the hero's journey' a little later in my quest for understanding. I found that the two systems neatly complemented each other. They share the same orientation, that drama and mythic narrative are devices for bringing about psychological adjustment and spiritual satisfaction. They both deal with the necessary elements to create a dramatic, cathartic experience in an audience. I could see in films like 'The Godfather' and 'Bonnie and Clyde' that Campbell's description of the sometimes tragic hero's path coincided with Aristotle's ideas of proper sequence, of dramatic unity, and of bringing hero and audience through a cathartic experience. The mythic sensibility naturally pervades Aristotle's idea of drama, since the Greek plays he was writing about were often crafted directly from the myths of his culture. In fact, play-writing and the whole arsenal of drama – actors, masks, stages, prosceniums, choruses, dialogue, etc – were invented to give expression to the tide of myth in Aristotle's culture.

As I entered the film business reading scripts for Hollywood studios, I encountered many professional writers and directors who were aware of Aristotle's theories of drama and applied them in their work. Aristotle's essay echoes down through the centuries and his powerful thoughts still guide dramatists in new formats. Now artists creating Web content are the latest to take advantage of the universal human principles laid down in The *Poetics*.

While studying Aristotle in college, I found many things puzzling and obscure. I felt there was much more treasure there, buried under centuries of changing language and culture, waiting for someone to dig it out. Lurking in the confused, ambiguous language were principles, rules of composition and dramatic unity that could still be

extremely useful today, if only someone would excavate and restore them. Apparently Ari Hiltunen was the fellow for the job. He had the enthusiasm and the deep belief in the material to see him through the challenge before him: figure out what Aristotle might have meant and turn that into usable dramatic principles.

Having recently gone through a similar process of unraveling and re-interpreting Campbell's densely woven concepts, I had appreciation for what Ari was about to undertake. Some terms Aristotle uses have no equivalent in modern languages: others – even simple ones like 'comedy' – have changed their meanings over two thousand years and must be used carefully. Aristotle was not writing for screenwriters but for playwrights crafting religious ritual dramas: these dramas were not considered to be mere entertainment but to be necessary social interactions that eased tension in society and smoothed the relationships between humans and the gods. Some of Aristotle's concepts, such as dramatic unity, have been inflated by Renaissance scholars into elaborate theories and rules that have little to do with Aristotle's actual statements. Ari had quite a job cut out for him to make Aristotle comprehensible and useful to modern artists.

So, several drinks and a sunset later, I encouraged Ari on his quest for understanding. I was pleased that he was doing the work of 'translating' Aristotle's dramatic theory into something immediately useful for modern film and TV writers, much as I had tried to re-interpret Campbell's academic theory of mythic narrative structure into a practical theory of screenwriting. I hoped someday to see a book out of Ari's search, something I could use in my own writing efforts, and something that would advance the understanding of all of us engaged in storytelling.

Now, many sunsets later, I have the pleasure of seeing that book in print. I hope you will find it as illuminating and useful as I have. If you are a writer or creative artist you will find guidelines here that are as fresh and immediate as the day Aristotle dictated them. If you are simply a cinema-lover who wants to know more about why these flickering images can have such a profound effect on us, you may find here a source of deeper understanding and enhanced enjoyment of the movie-going experience.

Chris Vogler

Acknowledgements

The idea for this book was born one night in June 1990 in Los Angeles. I had spent the day at Twentieth Century Fox and Disney studios watching the screenings of their new films and TV series being offered to international programme buyers. In the evening I decided to go to bookshops in Westwood Village and Century City. There I found several books about screenwriting written by famous Hollywood consultants such as Syd Field, Linda Seger, Michael Hauge and screenwriting professors such as Irwin Blacker and Richard Walter. These writers claimed, based on their analysis of a great number of films, that there really are common storytelling elements in successful Hollywood movies.

Many of these writers mentioned Aristotle's *Poetics* as an important book to any screenwriter. I was fascinated by the idea that a book written 2300 years before the existence of Hollywood could be the guide to success in the modern entertainment industry.

These screenwriting books gave some kind of analysis of Aristotle's ideas (three-act structure, conflict, action, and so on), but somehow I felt there was more. What are the mysterious 'timeless principles' that Richard Walter mentions in his book? I went to the UCLA library and through their database but to my surprise I found nothing written on the connection between Aristotle's *Poetics* and Hollywood's global success.

This was the beginning of a journey that took me first to Aristotle's *Poetics*, and then to the fascinating world of folktales, Shakespeare, Hollywood blockbusters, TV series and bestselling novels. This journey offered me many insights into the universal rules of successful storytelling. In this book I hope to offer that same experience to the reader.

I owe thanks to several people: first and foremost to Julian Friedmann without whom this book would never have been written and published; to Jonquil Florentin for wonderful editing; I feel very fortunate to have met them and to have been given so much advice and guidance; to Christopher Vogler for the inspirational meetings in Spain and Los Angeles; to John Wells for encouraging comments on an earlier analysis of *ER*; to Robin Beecroft and Peter Young of Intellect; to Béatrice Ottersbach for the opportunity to have this book published in German; to John Sherlock for his valuable comments; and to Professors Maarit Kaimio and H K Riikonen from the University of Helsinki for reading and commenting on my interpretation of the *Poetics*.

I would also like to thank The Promotion Centre for Audiovisual Culture of Finland (AVEK) and the Finnish Broadcasting Company for their financial support to me while writing this book.

And I want to thank my father Antti and my mother Pirkko from Oulu, Northern Finland, for their love and support.

Most of all, I want to thank my wife Tuire for her love, inspiration and understanding and my daughters Iira and Petra for bringing peace to my soul.

I dedicate this book to them.

Aristotle in Hollywood: The Anatomy of Successful Storytelling

Once upon a time it was a small gathering of people around a fire listening to the storyteller with his tales of magic and fantasy. And now it's the whole world. In Japan and in Finland, in the heartland of America, in Italy and Spain, in Singapore and France... still they gather to hear the stories. But now they gather in multiplexes in Britain, America, Germany, Spain, Australia ... or giant movie palaces in Mexico. That's what has thrilled me most about the Jurassic Park phenomenon. It's not 'domination' by American cinema. It's just the magic of storytelling, and it unites the world. And that is truly gratifying.

<div align="right">Steven Spielberg, Variety 1994</div>

Screenwriters are not expected ever fully to understand the *Poetics*. Rather, they have to study it again and again. They have to make it part of their lives. It need not be read straight through from beginning to end; one can skip around at random. The trick to using the *Poetics* is not to try to extract timeless principles, though they are surely there, but rather to follow it closely in a practical, hands-on way, not to interpret but obey.

<div align="right">Richard Walter, Professor and Screenwriting Faculty Chairman, UCLA</div>

Introduction

Tears of Joy

When my daughter was three years old, we bought her Walt Disney's *Snow White* on video. She watched the movie over and over again without any loss of enchantment and always at the end of the movie, when the prince awakens Snow White from death with his kiss, tears ran down my daughter's cheeks. When I seemed concerned, she said: 'Daddy, I'm not sad, these are tears of joy.'

What is the riddle of the little girl's tears? Why does this folktale of a beautiful girl called Snow White, who had been condemned to death by her stepmother, bring about such an intense emotional experience?

Disney's studios have adapted many popular fairytales into internationally successful movies. Although these stories were all well known to audiences before the movies were released, both children and adults still enjoy them as movies. In 1994 Disney released a new movie called *The Lion King* that was not based on any familiar fairytale but had been created at the studio. *The Lion King* became Disney's most successful movie. The trailer of the movie that was shown in cinemas before the premiere was so effective that it brought tears to the eyes of many adults, and in this way it acted as an impressive promise for the movie's emotional experience.

The Lion King is a story of Simba, a loveable cub who is to be the future king of the savannah kingdom. He has a jealous and ambitious uncle, who murders Simba's father, declares himself king and cleverly tricks Simba into believing that he is guilty of his own father's death. With help from the hyenas, the new king also tries to get Simba killed but Simba succeeds in escaping. He spends several years with his new friends far away in the jungle although guilt over his father's death continues to make him depressed. As an adult, Simba returns to the savannah kingdom where he finds out that his uncle was guilty of his own brother's death. Finally Simba defeats his uncle and becomes the upright and gentle king.

Like *Snow White*, *The Lion King* is also a story of a sympathetic and loveable protagonist who becomes the victim of undeserved misfortune. After numerous difficulties and at the moment of greatest desperation, good conquers evil and justice is realised. The story pattern of *The Lion King* to a great extent follows the same path as *Snow White*, which as a folktale is a product of the tradition of collective storytelling. These stories end with a moving feeling of happiness but before the happy ending we have been held in suspense and witnessed undeserved suffering.

However, it would seem that Disney's storytellers might not be completely sure of the secret of success because their next movies, *Pocahontas* and *The Hunchback of Notre Dame* did not succeed as well as expected. Success in Hollywood appears to be based to a high degree on chance because the majority of Hollywood movies are commercial disappointments.

Aristotle in Hollywood: The Anatomy of Successful Storytelling

In an interview in *The Writer's Digest* magazine (July 1993), American bestselling novelist John Grisham (*The Firm*, *The Pelican Brief*) was asked about the secret of bestselling fiction. He said:

> You take a sympathetic hero or heroine, an ordinary person, and tie them into a horrible situation or conspiracy where their lives are at stake. You must keep a lot of sympathy for the heroine or hero. You've got to put them in a situation where they could be killed. That is basic suspense, whether it's a book by Robert Ludlum or me … You have to start with an opening so gripping that the reader becomes involved. In the middle of the book, you must sustain the narrative tension, keep things stirred up. The end should be so compelling that people will stay up all night to finish the book.

What is clear here is a novelist's storytelling insight that has been productive over and over again. For example, in April 1993 Grisham's novels took the first three places on the *New York Times'* bestseller list. When a writer recognises the pattern of success, he can always dress it in a new story. Readers, on the other hand, expect the recurrence of the anticipated pleasure provided by the author's previous book. That is their reason for buying the new book.

If successful stories have certain storytelling features in common, we can perhaps assume that the experience and pleasure they bring about is also similar.

As far as we know, the first person to analyse the connection between storytelling technique and emotional experience was the Greek philosopher Aristotle, 2300 years ago. This insight into the essence of drama is the basis of his book the *Poetics*. In it Aristotle agreed that with a certain kind of storytelling technique the ancient form of tragedy was able to bring about a certain kind of emotional experience in the spectator. Aristotle called this emotional experience *oikeia hedone* or the 'proper pleasure'. The 'proper pleasure' consists of pity, fear and *catharsis.* However, the *Poetics* is a very difficult book and Aristotle's analysis of the pleasure has remained something of a mystery throughout the centuries with scholars presenting many different interpretations of it.

In this book I shall present my personal interpretation of this mysterious 'proper pleasure'. I shall also show how my interpretation can be used to analyse successful contemporary stories. Although I shall deal extensively with Aristotle's theory of drama, this book is also aimed at the reader who is interested in the strategies of success of all kinds of dramatic story, whether it's a Greek tragedy, a folktale, a play by Shakespeare, a novel by Grisham, a Hollywood blockbuster or a popular TV series. Understanding Aristotle's insight is relevant to anyone hoping to create new and successful films, shows or books in the entertainment industry.

I have taken Aristotle's idea of the correspondence of storytelling technique and emotional experience at face value simply because it seems totally rational: a good story brings about pleasure. It's obvious. Otherwise why would we pay to go to movies or read fiction? We can even say that the pleasure is the object in itself and a story is the means to bring about that pleasure. The more pleasure a story can bring about, the better and more popular the story.

Introduction

To unravel the essence of the pleasure by asking questions of the audience would be very difficult because the components of pleasure are to a great extent unconscious. The audience experience the pleasure of a good story communally but, when asked individually, they name different things as the cause of the pleasure. One person thinks it's the good acting, another thinks it's the attractive women, a third says it must be the beautiful scenery, and a fourth person says it's the genre. These elements are relevant, but they do not explain why certain stories become immensely popular as novels as well as movies, or why a certain Arnold Schwarzenegger or Harrison Ford movie becomes successful and another with the same actor does not. It does not explain why, when a film of one genre is a hit and Hollywood thinks this is what people want and they make several more movies of that same genre, they often fail.

The starting point of Aristotle's drama theory is that the plot structure has the decisive influence in bringing about the 'proper pleasure'. If we accept this starting point, analysing the plot structure will enable us to understand the essence of the audience's pleasure. We could say that the pleasure is the *object* and the plot structure the *means*. By understanding how emotional experience is created by successful storytelling strategies, we might be able to predict, to some extent, the probable success of different stories of any genre before they are presented to audiences.

Predicting success is, in fact, the film industry's (and the publishing industry's) greatest challenge. As Hollywood film production is usually a multimillion-dollar investment, risk management is a priority. Whilst some films may become huge successes, many other films prove to be commercial failures despite the stars, the enormous budgets and the professional marketing efforts.

The effective marketing of the movie and its stars may persuade people into cinemas, but one characteristic of a hit movie is the fact that movie-goers recommend the film to their friends and also go to see the movie a second time. For example, when the movie *Star Wars* was released people were returning to see it repeatedly, as if seeking some kind of religious experience. It was as if people needed this film.

A good film will first be enjoyed in a cinema. It is then rented as a video. Finally it is watched on television. People gain pleasure from the repeated viewing of good films. A good story maintains its ability to create pleasure even though audiences know the events and turning points in advance. Therefore the power of a good story is based on something other than surprise and unpredictability.

Hollywood storytelling – which is often undervalued by European filmmakers – actually reuses the successful strategies used in age-old stories. After all, Hollywood storytelling is not just an invention of greedy studio moguls. People want to experience certain kinds of emotion, which Hollywood movies, at their best, can bring about. These experiences could be called the 'proper pleasure' of modern entertainment.

In the mid-1990s cinema attendance for European films reached its lowest point in popularity. Annual box-office returns for European-made films plummeted after the early 1980s, from $US600 million to just $US100 million, whilst the average box-office returns for American films had remained steady at roughly $US450 million (*Time*, February 27,1995). One of the main reasons for not appealing to mass audiences is that European cinema has become a visual art form estranged from the rules of traditional

storytelling. The European cultural elite tries to protect European films by restricting the import of American films. In the United States, on the other hand, the fact that film still involves traditional storytelling could be why it is so popular. Not everything Hollywood produces represents skilful storytelling; many poor-quality Hollywood movies demonstrate lack of professionalism, lack of talent and insight, as well as lack of business acumen. Because Hollywood is primarily a profit-oriented industry, its decision makers try to make films that they think people will want to see, and at its best, Hollywood-storytelling is able to create satisfying emotional experiences for large numbers of people all over the world.

Any dramatic story can be told orally, in written form (a novel or short story), as a play on the stage or audio-visually (film and television). The main difference between a novel and a film is that in a novel 'visuality' is created with words. Most books on writing fiction advise the writer to 'show, don't tell'. An example of telling would be: 'She walked in the forest and everything around her seemed so wonderful.' An example of showing would be: 'She could hear the twigs breaking under her feet as she walked. She could feel the warm summer breeze on her face and see the oak leaves dancing in the sunshine.' These sensuous details draw the reader into the fictional world, and they can actually see in their mind's eye the world depicted by those words. Telling tends to distance people and encourages them to think and analyse. Showing involves the reader because it makes them use all of their senses.

The novel uses words to build up a visual reality in the reader's imagination which makes them believe in the fictional world described by the writer. Film and television do not need words in order to create this reality. We actually *see* it. Because a good story is a means of bringing about pleasure, many bestselling novels are popular as films, too. Margaret Mitchell's *Gone With the Wind* was a success as a novel as well as a film as was John Grisham's *The Firm*, Tom Clancy's *The Hunt for Red October*, Michael Crichton's *Jurassic Park*, Thomas Harris' *The Silence of The Lambs* and Jane Austen's *Sense and Sensibility*.

Overview

Parts of the *Poetics* are missing and Aristotle's failure to give many precise definitions makes the book difficult to interpret, hence the existence of several different interpretations. My intention in this book is not to give an extensive explanation of Aristotle's aesthetics, but to point out how Aristotle's extraordinary insight and approach can be applied to all types of drama today. My aim is to provide the reader with insight into the nature of the pleasure of drama derived from the *Poetics*. What I call the 'proper pleasure' of popular fiction is my interpretation of the pleasure that Aristotle referred to in his book. I do not think anyone can know the absolute truth about the *Poetics*. So this book is my interpretation of Aristotle's ideas and method of approach.

This book is also an analysis of today's billion-dollar entertainment industry and explains its success by using the essence of an idea that is over two thousand years old.

In the first chapter I shall deal with the age-old myth of the hero that probably emerged in its primary form around ancient campfires. American anthropologist

Introduction

Joseph Campbell found the story of the mythical hero in many of the world's cultures. This would seem to indicate that it has universal appeal.

I shall begin analysing Aristotle's theory of drama in the second chapter with an examination of how *Oedipus Rex*, a tragedy admired by Aristotle, demonstrates the elements of the 'proper pleasure': pity, fear and *catharsis*.

The third chapter will examine the strategies of a good plot such as recognition (*anagnorisis*), reversal (*peripeteia*), suffering (*pathos*), fateful error (*hamartia*), the climax (*catharsis*), the importance of logic, the characteristics of a good hero and the dilemma between a happy and an unhappy ending. I shall present a synthesis of Aristotle's ideal kind of drama.

In the fourth chapter I shall examine how brilliantly Shakespeare used Aristotelian strategies to create the 'proper pleasure' in his plays. I believe his use of the 'proper pleasure' (conscious or unconscious) brought about the enormous success of his work. This chapter will include an analysis of the structure of the play *Romeo and Juliet* and of the 'proper pleasure' it produces.

In 1928, a Russian folklorist, Vladimir Propp, published his research under the title *Morphology of the Folktale*. He analysed one hundred Russian folktales and quite unexpectedly discovered a common story pattern. It would seem that the world's most popular folktales were generated by the collective human mind.

In chapter five I shall use Aristotle's approach and my interpretation of his theory to analyse *Cinderella*, perhaps the world's most popular folktale. 345 versions of it were analysed in a book published in 1893. I shall apply Propp's pattern of standard events as an emotional journey and show how this pattern brings about the Aristotelian pleasure in *Cinderella*. This will give us an answer to the little girl's tears of joy.

Chapter six consists of the results of empirical studies of audiences made by Jeff Bryant and Dov Zillmann, two American scientists who created the disposition theory of the enjoyment of entertainment. They proved empirically that the moral aspect, emphasised by Aristotle, does actually play an important role in creating pleasure. The structural-affect theory of stories created by William F Brewer & Ed Lichtenstein and Peter Orton's experiments on story liking give further support to several of Aristotle's principles. It will be here that I shall discuss brain physiology with reference to the enjoyment of drama, the relevance of which was introduced to me by Julian Friedmann in his book *How to Make Money Scriptwriting*.

In chapter seven I shall examine how the 'proper pleasure' principle functions in the modern entertainment industry. I shall introduce Christopher Vogler's twelve-step outline of Campbell's Hero's Journey in successful Hollywood movies. I shall also look at how the idea of the 'proper pleasure' connects with the rules of the dramatic structure presented in screenwriting manuals written by Hollywood analysts and consultants such as Linda Seger, Michael Hauge and Syd Field.

I shall then analyse how the 'proper pleasure' functions at a general level using examples of Hollywood box office hit movies, namely the blockbuster, *The Fugitive,* and of a different genre, the supernatural romantic film *Ghost*. I shall look at how these stories could involve the audience in such a way as to make them believe in the story's world and experience the 'proper pleasure'.

Aristotle in Hollywood: The Anatomy of Successful Storytelling

The similarity and common basis of tragedy and comedy will also be considered and I shall explore the pleasure principles in art-house cinema. After this I shall deal with the structure of a scene taking as an example a sequence from Hitchcock's film *Notorious*.

The eighth chapter will look at how the 'proper pleasure' principle functions in popular fiction. I shall demonstrate elements of it in Harlequin and Mills & Boon novels and show how John Grisham's bestseller *The Firm* has an ideal plot structure from an Aristotelian point of view. I believe that the 'proper pleasure' is the secret of the huge popularity of this novel and has made the name Grisham a guarantee of pleasure for the book-buying public.

Television series also conform to the Aristotelian concept of drama and in the ninth chapter I shall look at how the pleasure principle functions and can be intensified in such series. For an analysis of the dramatic structure I have taken as my example the American medical drama *ER*.

Chapter ten is committed to the exploration of the 'proper pleasure' in cyberspace. As we enter the digital era, multimedia experiences are becoming a powerful new medium of entertainment. The video game industry is already making more money than major Hollywood studios take at the box office. Can we apply the principles of pity, fear and *catharsis* and those of the Hero's Journey to create more compelling interactive experiences?

In chapter eleven I shall present a synthesis of the ideal plot structure in popular fiction, television and film based on the theories I have propounded in the previous chapters. I shall refer to the four dimensions of my model for the 'proper pleasure': the emotional, the moral, the intellectual and the symbolic, and show how they relate to each other and form an interwoven entity in any successful story. After the realisation of the pleasure and how it can be brought about by using certain storytelling strategies, I shall suggest how it can be maximised. This is essentially the secret of success in entertainment.

In the final chapter I shall consider the future of storytelling in the new millennium. According to Dr Rolf Jensen, the director of The Copenhagen Institute for Future Studies, and some other business analysts, the global market is becoming emotionally driven. People will cease to define themselves so much through material products as their interest increases in feelings that can be elicited by stories. The market for stories in the twenty-first century will be vast and many companies will grow and become global by entering this market. That is why Dr Jensen says that anyone seeking success in the market of the future will have to be a storyteller, and he predicts that the earnings of future storytellers will be huge.

Frequent reference will be made to a model or pattern of the pleasure but my aim is to provide the reader with insights. A model refers to something that can be learned by rote. This is not what I mean. My aim is the same as Aristotle's. He presumed that when the reader understands how to build a good plot, he simultaneously realises the nature of the pleasure. This ancient insight can then be applied to the creation of new stories.

I believe and hope to show that insight into the Aristotelian concept of pleasure and the ability to intensify it to its maximum is of the greatest help to the writer or

producer who wishes to create successful stories, whether for novels, films, TV series or computer games.

Aristotle's analysis 2300 years ago of what makes a great drama might have reflected his subjective taste. The *Poetics* is difficult and at some points even contradictory, so we will never know what he really meant. But by following the fundamental logic of the *Poetics* as it is written, it is possible to reach an insight into the essence of successful storytelling.

The discovery of the 'proper pleasure' gives clues to a pleasure producing form of narrative that has adjusted to cultures and the evolution of mankind. In fact, the principles of the 'proper pleasure' are older than ancient Greece since the hero's myth of primitive cultures was capable of bringing about the magical effect in an audience. This myth is still living powerfully in our nature. It is the pattern of life and death in which our problems reach a climax before vanishing forever. The Hero's Journey gives us assurance that even the greatest difficulties can be resolved – at least temporarily and in lives that are perpetually insecure, we hold on to this belief passionately. A psychological model for survival presented through a suspense structure has provided immense satisfaction for people from the beginning of storytelling.

Mythical stories of heroes have given people answers to questions that have concerned and preoccupied human minds since our earliest, primitive societies: misfortune, bad luck, cruelty, the meaning of life, death, change, love and happiness. Through a vivid experience of the mythical journey we can find answers to questions for which science and philosophy have failed to provide answers. By immersing ourselves in the myth, we might recognise the truth.

1 Primary Source of the Magical Experience

The first stories of mankind were probably born around ancient campfires. It is likely that they were stories of danger, threat and mastery – as anthropologist Bronislaw Malinowski argues in *Magic, Science and Religion*. Maybe our ancestors' cave paintings of threatening creatures were linked to those stories. By looking at these drawings, early hunters could better cope with the fear they faced in real and dangerous situations. This is how the mathematician and philosopher, Jacob Bronowski, explains the Altamira caves' bison paintings in his book and TV series *The Ascent of Man*. In the darkness of the cave, hunters could experience the fear of hunting in safety in the same way as we today can experience fear in the safety of a cinema.

It is possible that cave drawings were linked to the hunting stories told around the campfire. It is presumed that drama originates from these stories – as Michael Straczynski writes in his book *The Complete Book of Scriptwriting*. These stories had all the basic elements of drama: a stage, flickering light, a story of life and death, an audience and a performer. Maybe these heroic stories were the origins of our myths. Perhaps an ancient hunting story followed a pattern such as this: a community of men, women and children was threatened by famine. Hunters prepared to begin the journey to track herds of bison. Such tracking was difficult and hard. It seemed as if the herds had disappeared, but responsibility for the women and children drove the hunters forward. They had become almost desperate, when on the top of a hill they beheld a breathtaking sight as they saw a huge herd of bison in the valley. Although this was a great relief to the hunters, worse was to come because hunting with spears was extremely dangerous and many men died or were wounded. Even after killing sufficient bison, further suffering had to be endured while carrying the heavy carcasses to the caves where hungry women and children waited. Not only did they have to carry and tend their wounded men, they were attacked by wolves. Finally, the exhausted men returned home and were welcomed as heroes.

Around campfires the events of the brave hunting trip were told and retold. After each telling the stories were polished into an increasingly exciting and impressive form. The first stories of mankind were accounts of courage, skill, sacrifice and duty. In the flames of night fires they created a magical experience for the audience.

As cultures developed, these heroic hunting stories developed in a way that somehow preserved and enhanced the enchanting patterns and emotional power of the old heroic tales. Heroic encounters became myths that united entire cultures. As the hunting societies evolved into cultivation societies, the hero changed from the hunter using his skill against nature into the hero dealing with human conflict over territory and possessions, between individuals, tribes and societies, and between mankind and

its supernatural beliefs. Similarly, the basic elements and dramaturgy of the campfire stories were transferred and transformed for later stories.

American anthropologist Joseph Campbell begins his book *The Hero with a Thousand Faces*:

> Whether we listen with aloof amusement to the dreamlike mumbo jumbo of some red-eyed witch doctor of the Congo, or read with cultivated rapture thin translations from the sonnets of the mystic Lao-tse; now and again crack the hard nutshell of an argument with Aquinas, or catch suddenly the shining meaning of a bizarre Eskimo fairy tale: it will always be the one, shape-shifting yet marvelously constant story that we find, together with a challengingly persistent suggestion of more remaining to be experienced than will ever be known or told.

According to Campbell, this story, which repeats itself continuously from one culture to another, is the myth of the hero. Its manifestation can vary considerably but basically it is always the same story, the hero's journey, which Campbell calls 'monomyth'.

The mythological hero's adventure regularly follows a pattern of transitional rites, separation, initiation and return. This can be called the core of the monomyth: from the ordinary everyday world, the hero ventures into the world of the supernatural where he faces legendary forces and wins the decisive victory. From his mystical adventures the hero returns with a powerful elixir which brings salvation to the community.

This journey of the mythological hero resembles the story pattern used by the heroic caveman. The distant hunting grounds become lands of supernatural wonder, bison become legendary monsters, and the prey becomes a wonderful elixir or an object of magic that saves the community, in this case from famine. As the culture has developed so has the form of the hero's journey, but in essence it is the same story that creates the magical experience.

By comparing well-known stories and myths of ancient cultures, Campbell discovered a common pattern in the different stages of the hero's journey. These are: The World of Common Day, Call to Adventure, Supernatural Aid, Crossing the First Threshold, Road of Trials, The Magic Flight, Rescue from Within, Recrossing the Threshold, Return, Master of the Two Worlds and Freedom to Live. In other words, the hero's journey follows a coherent pattern, one that has been extremely popular and dominant in all the known ancient cultures of the world.

According to Campbell, the relevant features of the hero's journey do not vary much from culture to culture and there is remarkably little variation in the morphology of the adventure. If a basic element of the archetypal pattern is missing from a fairytale, story, rite or myth, according to Campbell it has to be there indirectly one way or another.

Joseph Campbell's analysis of mythology implies that there exists a universal pattern of successful stories common to all ancient cultures. The hero's journey was not invented by any single storyteller. Stories of heroes have been born 'spontaneously' in the tradition of storytelling all around the world and they have been shaped into a

form that seems to be universally coherent. We can perhaps assume that the hero's journey represents mankind's idea of a good story and the popularity of this standardised story may be a consequence of the attractiveness of the emotional experience provided. All this indicates that there may be a connection between the story pattern and the emotional experience of the audience. One book written in ancient Greece deals with this question in a fascinating way.

Chapter Two will examine the relevance of Aristotle's *Poetics* to Campbell's views and to the idea of good stories being emotionally satisfying.

2 Aristotle and the Mystery of Dramatic Pleasure

Although the Greek philosopher Aristotle wrote the *Poetics* over 2300 years ago, it is considered by many authorities to be one of the most enduring works of western literary study. In the book, still the first known scientific study of storytelling, Aristotle considers the epic and narrative poetry, but of even more importance, he examines tragedy.

The *Poetics* is generally considered to be very difficult to interpret, partly due to the fact that large sections of this book are presumed to be missing. The form of the text is also problematic. The book may not have been intended for the general reader but could have been notes for lectures Aristotle gave at the school of Lyceum, where he would have expanded on the text to his students.

There are two definitions at the beginning of the *Poetics* that are of key importance if we wish to understand Aristotle's insights. Firstly, he gives the definition of his task:

> Our topic is poetry itself and its kinds, and what potential each has; how plots should be constructed if the composition is to turn out well; also, from how many parts it is [constituted], and of what sort they are; and likewise all other aspects of the same inquiry.[1]

Secondly, he gives the definition of tragedy that is the main object of the study:

> Tragedy is a representation of a serious, complete action which has magnitude, in embellished speech, with each of its elements [used] separately in the [various] parts [of the play]; [represented] by people acting and not by narration; accomplishing by means of pity and fear the catharsis of such emotions.

These definitions reveal two critically important things. Firstly, they tell us the aim of Aristotle's analysis: he is searching for the answer to the question: 'What kind of the pleasure is the function of tragedy?' To answer this, Aristotle says that first we have to discover the nature of the 'proper pleasure' in tragedy. When this is unravelled we can evaluate the quality of any single tragedy and compare it to other tragedies by assessing how much of this 'proper pleasure' it produces. In other words, the function of tragedy is to produce the 'proper pleasure' as efficiently as possible. Being aware of its pleasurable nature the writer has the ability to maximise this 'proper pleasure' and make the play more enjoyable. Secondly, these definitions reveal that Aristotle gave plot structure a key role in the production of this 'proper pleasure'.

As I will show later, this definition of tragedy, which has not always met with the agreement of scholars throughout the centuries, does in fact contain the secret of

success for today's entertainment industries. Instead of the word 'tragedy', it might be better to use the term 'serious drama' because unlike today, in ancient Greece a tragedy could have a happy ending.

The 'proper pleasure', which according to Aristotle consists of pity and fear followed by *catharsis*, was difficult to interpret because *catharsis*, a critical element in the definition, is neither explained in the *Poetics* nor anywhere else in Aristotle's works. Pity and fear are only indirectly considered when Aristotle describes the types of plot that are best at bringing them about. The explanation of *catharsis* might have been in the missing sections of the book. A more likely explanation might rest in the logic of the *Poetics*. It is possible that Aristotle assumed that when audiences understood how plots were constructed, they would also perceive the nature of the emotional experience those plots were intended to produce.

If we understand the *Poetics* in this way, we can also see that the significance of the *Poetics* to aesthetics is not as a theory of *catharsis* but rather as a detailed analysis of plot structure. It could be that Aristotle realised the kind of storytelling strategies that are typical of highly popular dramas. If from Aristotle's hints and clues we are able to solve the riddle of the 'proper pleasure', we can perhaps use this insight for the creation of new and successful dramas and stories.

The key to understanding plot structure, especially that of tragedy, lies in discovering exactly how it is able to produce the necessary pity, fear and *catharsis*. Knowing this, we will be able to produce the 'proper pleasure' at will and enhance the emotional response in the audience by using particular kinds of plot structure.

According to Aristotle, epic narrative poetry has the function of arousing pity and fear through its plot. A well-known epic in ancient Greece was Homer's *Odyssey*. The same principles of analysis can be applied to this epic as to a tragedy such as Sophocles' *Oedipus Rex*. This reveals that they share a common goal in producing the same kind of pleasure. As with the plots of tragedies, those of epics should also be dramatic and present a single, whole and complete action with a beginning, middle and end and thus be capable of bringing about the 'proper pleasure'. Plot structure was also probably of great importance in comedies. These, according to Aristotle, depict characters 'inferior' to the audience whereas tragedy depicts 'superior' characters.

Later in this book I will consider how plot structure and the 'proper pleasure' are the principal function of Hollywood blockbusters, bestselling novels and successful TV series.

The decisive importance of tragedy is revealed through what Aristotle said about *Oedipus Rex*, a work he greatly admired. Aristotle believed that *Oedipus*, which was a well-known myth in ancient Greece, could also produce the 'proper pleasure' in written form. In other words, it was capable of producing pity, fear and *catharsis* without having to be performed on stage, the script alone being sufficient. This principle can also be applied to films, which are dramas on the screen, or novels, which are dramas on the page.

Although Aristotle does not write much about the essence of the 'proper pleasure', when we understand the essence and nature of the plot structure in the *Poetics*, it

becomes clear that Aristotle's theory identifies aspects of pity, fear and *catharsis* as integral parts of the process of producing the 'proper pleasure'.

2.1 *Oedipus Rex*, The Master Plot

Aristotle particularly admired Sophocles' tragedy *Oedipus Rex*. Sigmund Freud, the father of psychoanalysis who studied the Oedipus complex in depth, had his own ideas about the motives that made this play so fascinating – but I believe that the excellence of the play is primarily due to its plot structure. Much of Aristotle's advice to writers in the *Poetics* is based on the analysis of this drama; therefore we can assume that *Oedipus Rex* contains many elements of the 'proper pleasure'.

The tragedy is based on the following myth. A son was born to Laius and Jocasta, the rulers of Thebes. There was a prophecy that this son would kill his father and marry his mother. In order to avoid the realisation of this prophecy, Laius pierced the baby's ankles with a wooden stick and ordered a herdsman to take the baby into the forest and kill him. But the herdsman pitied the baby and gave him to another herdsman who took him to his own land, Corinth. The King and the Queen of Corinth, Polybus and Merope, had no child of their own so they adopted the baby and because the wooden stick had damaged baby's feet, he was named Oedipus which means thick or swollen foot.

When Oedipus reached maturity he became aware of the possibility that he was not the son of Polybus and Merope. To confirm his doubts, he went to see a prophet who made the same prediction as that which was told to his parents: that he would kill his father and marry his mother. Oedipus was horrified and in order to avoid the fulfilment of the prophecy, decided to leave Corinth because the prophet had left him believing that Polybus and Merope were his real parents. At a crossroads, Oedipus was confronted by a group of men who ordered him to give way. Being the noble son of the king, Oedipus refused and the dispute resulted in a fight during which Oedipus killed all the attackers except for one who escaped. Unknown to Oedipus, the leader of the men who attacked him was Laius, King of Thebes. The man who escaped returned home and recounted how Laius had been killed by a band of robbers.

At this time, Thebes was under the tyranny of the Sphinx, a winged female monster that lured travellers and confronted them with riddles. The riddle she presented to Oedipus was: what is it that in the morning walks with four feet, during the day with two, and in the evening with three? Oedipus answered: it is a man who crawls as a baby and as an old man needs a walking stick. With the Sphinx defeated, Oedipus became the hero of Thebes. As a reward, he was made king and married the widow of the former king, Jocasta. For ten years Thebes bloomed and Oedipus' wife gave birth to two sons and two daughters. But then adversities began: there were crop failures, no children were born and a plague attacked the city. It is at this point that Sophocles' tragedy begins.

Creon, Oedipus' brother-in-law, returns from the prophet with a message of joy: their misfortunes can be ended by solving the mystery of who killed the former king. Oedipus, concerned about his people, begins the investigation in order to save the city. He summons the blind prophet Tiresias who reveals the truth: that Oedipus himself is

the murderer and is also guilty of an even more horrible crime. Oedipus does not believe the prophet but he becomes suspicious and accuses his brother-in-law of intrigue.

Jocasta tries to reassure her husband by telling him that the predictions concerning her first husband did not come true since, instead of being killed by his son, he was killed by a band of robbers at the crossing of three roads. Oedipus recognises the place and becomes more distressed and suspicious. At this stage, however, Oedipus thinks of himself as the possible murderer but not as the son of Laius, so he summons the man who is the only witness to Laius' murder.

Unexpectedly, a messenger arrives from Corinth. He informs Oedipus of the death of Polybus and relates the request that Oedipus should become the new King of Corinth. Although Oedipus' fear begins to subside with the news of his father's death that disproves part of the prophecy, he does not want to return to Corinth because Merope is still alive.

The messenger then reveals that Polybus and Merope were not Oedipus' real parents and that he was the herdsman who brought the baby to Corinth. At this moment, the witness to Laius' murder is brought before Oedipus and despite denials, the messenger recognises him as the same herdsman who had asked him to take the baby to Corinth. Now everything becomes clear to Oedipus.

Jocasta flees to her room and hangs herself. Oedipus takes two needles from Jocasta's clothes, gouges out his eyes and prepares for exile. When he arrives at the gate he asks to be accompanied by his two daughters whom he realises are the most valuable and precious things in his life. The city is saved and the play ends.

We may ask, wherein lies the pleasure of this play? To answer this question we have to look at Aristotle's other works.

2.2 Fear – Anticipation of Impending Danger

In the *Rhetoric* Aristotle defines fear (*phobos*) as the anticipation of evil, anxiety and unrest which is caused by a notion (*phantasia*) of impending danger (*mellontos*). This notion has to be strong enough to produce the emotion. In the *Rhetoric* a synonym for the term *phantasia* is expectation (*prosdokia*). Fear is caused by the expectation of an impending disaster.

In this definition of fear, Aristotle says that fear is not felt for events far in the future but only when the danger is imminent. It also includes a pleasurable element, namely the hope for safety. Fear is connected to goal-oriented action. When a man is afraid, he seeks safety and directs his actions towards this goal. Without the hope of safety, a man is not just fearful but desperate.

To summarise, we can say that fear is partly the expectation of impending danger and partly concerned with the mental effort and physical action needed to remove oneself from the situation which brings about hope. Hence fear is a special mixture of anxiety and pleasure.

Aristotle says that a good drama produces both pity and fear. His explanation of fear in the *Rhetoric* relates to a threat that is directed to an individual. But in a drama we are watching someone else (another character) being threatened; if we are able to

identify with their plight, we are able to feel both fear and pity for them even though we are sitting safely in the audience. If we examine the definition of pity, we can see a reason for such empathy.

2.3 Pity – Reaction to Undeserved Suffering

According to Aristotle, pity (*eleos*) is caused by an image or notion of some bad or fatal event that happens to someone who does not deserve it. This event must be identifiable as one that could happen to oneself or one's loved ones in the near future. Essential to the creation of the emotion of pity for another is the fact that it arises through witnessing undeserved suffering by that individual.

Fear and pity are emotionally close to each other. Aristotle says the events which produce fear when directed to oneself produce pity when they happen to others, and that the expectation of impending danger is common to them both. When a person is seized by fear they cannot feel pity because of their own distress.

In a drama it is essential that pity is felt for a person who is perceived as being morally good. According to Aristotle, one does not feel pity for bad people. Because pity is directed towards the morally good person, part of pity is a desire to relieve their suffering.

Thus for Aristotle, pity is an intense, anxious compassion that is brought about by witnessing the undeserved suffering of a morally good person.

2.4 Pity and Fear in Drama

Aristotle tells us that both tragedy and the epic should bring about pity and fear. In good drama, pity in the audience is produced by witnessing the undeserved suffering of a morally good character such as Oedipus. A bad character who does not arouse pity can, of course, cause the suffering of a good character.

Although according to the definition in the *Rhetoric*, fear is a threat to oneself, in drama the threat to the audience is illusory. In Sophocles' tragedy, for instance, the threat is directed towards Oedipus (who is not as aware of it as the audience). But according to Aristotle, it is the audience who must experience fear if the drama is to be successful.

The logical answer to this is that the plot must be constructed in such a way that the audience are able to feel the threat to a fictional character *as if* it were actually directed towards them. As mentioned above, it is not even necessary for a character in the drama to be aware of this danger, but the audience must know about it if they are to experience fear. Listening to the prophet's words the audience anticipate better than Oedipus what terrible misfortune will occur. We can therefore say that the audience are in a superior position and wish to help the character who has gained their compassion. In other words, anticipating the undeserved suffering of a morally good character induces pity and fear.

Pity evokes compassion. In modern drama we use the terms 'identification' and 'empathy'. Identification allows the audience to experience the same emotions as the character in the drama. However, empathy creates anxiety on the part of the audience for the character when they know that the character is approaching danger.

Because Aristotle talks about expectation and impending danger, the implication is that the 'catastrophe' has not yet occurred. Pity and fear are attached to future events and potential undeserved misfortune. In Sophocles' tragedy, the audience realise the truth before Oedipus: that catastrophe is unavoidable. In this drama pity and fear are involved by bringing the truth of the past into the protagonist's awareness. However, Aristotle does not consider the ending to *Oedipus Rex* to be ideal. He mentions three other tragedies that have a better kind of ending. These are: Euripides' *Iphigeneia in Tauris*, in which a sister is about to sacrifice her brother; *Cresphontes*, in which a mother is about to kill her son; and *Helle*, in which a mother is about to betray her son. In these tragedies catastrophe is avoided at the last minute. I shall consider this question of the 'happy ending' later when dealing with the nature of *catharsis*.

If the audience are indifferent to the fate of a fictional character, they will not experience fear. Fear is a consequence of compassion and in order to bring about compassion, pity is necessary. A precondition of fear is an awareness of impending danger and without pity that danger would not be experienced as threatening. Fear only arises when there is real concern for the character who is the target of the threat. If the occurrence of the impending danger would constitute undeserved misfortune, that is when, in the Aristotelian sense, pity and fear are aroused.

The audience heed the evil forebodings, begin to anticipate the possible dangers and catastrophes that threaten the hero, and start to look for hopeful solutions. The plot provides the audience with opportunities for considering ways of avoiding the catastrophe and so become involved in the events of the drama.

Sympathy and empathy are much the same thing in the dramatic context. A sympathetic character is not necessarily a pleasant character, but basically he or she is morally good. Aristotle says that the protagonist in drama has to be 'like us'. In this way the members of the audience recognise themselves in the character and can emotionally support his goals.

The audience's 'involvement' arises as the consequence of identification and suspense (which will be considered later). The audience experience emotion *through* a character but at the same time – because of their superior position and the suspense structure – they are concerned *for* that character. The concept of 'identification' in this context is sometimes thought to be the audience's ability to merge with the ego of the character. This is not helpful and it would be better to talk about emotional identification where the audience's emotions are aligned with those of the character.

Aristotle's concept of fear can best be understood by the word suspense. The audience are aware of threatening danger and would like to warn the character but of course cannot do so. All the audience can do is feel suspense. In *Literary Terms: A Dictionary*, suspense is defined as an expectant uncertainty concerning the outcome of the plot.[2] According to the dictionary, suspense in Sophocles' *Oedipus Rex* is achieved through the withholding of the knowledge that Oedipus himself has killed Laius, his father. During the play, the audience, aware that Oedipus will eventually make the discovery, share the hero's uncertainties and fears as he pursues the truth of his own past.

The dictionary definition also implies a connection between pity and fear, in other words, between identification and suspense. Suspense in *Oedipus Rex* is produced by

the fact that the hero, a morally good and noble man, is threatened by impending danger and undeserved misfortune. Had he been bad, there would be no suspense. But because the audience know that an undeserved misfortune is involved, they can feel suspense and share Oedipus' uncertainties and fears. This emotional identification and suspense produces intense involvement for the audience in that they not only experience the protagonist's emotions, but are also very much concerned for his future.

Another dictionary of literary terms[3] defines suspense as: 'uncertainty, often characterised by anxiety. Suspense is sometimes a curious mixture of pain and pleasure as Gwendolen, in Oscar Wilde's *The Importance of Being Earnest*, implies: 'The suspense is terrible. I hope it will last.' Most great art relies more heavily on suspense than on surprise. One can rarely reread works depending on surprise; once the surprise has gone, so too has the interest. Suspense – an emotional state – is usually achieved in part by foreshadowing – providing hints of what is to come. As Coleridge said, Shakespeare gives us not surprise but expectation and then the satisfaction of perfect knowledge. Shakespeare, like the Greek dramatists, often used well-known stories. Although the audience presumably were not surprised by the deaths of Caesar and Brutus, they enjoyed the suspense of anticipation. Suspense is thus related to tragic irony – a situation or utterance made by the person involved which at that time has an unforeseen significance. The tragic character moves ever closer to his doom and though he may be surprised by it, the audience are not; they are held in suspense. If, in fact, the hero is suddenly and unexpectedly saved (as in a melodrama), the audience may feel cheated!'

According to this definition, suspense is a blending of anxiety and pleasure similar to Aristotle's definition of fear in the *Rhetoric*. Pleasure arises from the element of hope within a negative feeling. Hope involves an awareness of the future and, in this sense, it is similar to suspense – Aristotelian fear – in that it also concerns the future.

In *Oedipus Rex*, Sophocles creates identification, suspense and involvement in the following way: the city's suffering is depicted in the dialogue at the beginning of the play and Oedipus is praised for having saved the city from control by the evil Sphinx. He is said to be the best of men and his courage and skill is highly praised. When he is asked for help in the name of the city, he replies that no one suffers as much as he does in seeing the suffering of the people. Oedipus recounts how he has already set in motion a rescue attempt by sending his brother-in-law to the temple of Phoibos to seek the prophet's advice.

In this way the audience know that Oedipus is noble, courageous, skilful, clever, morally good and a ruler very much concerned for his people. Moral goodness and our sympathy is intensified later when it is learned that Oedipus left Corinth in order to save his mother and father from the curse.

A clue is soon given to the audience indicating that Oedipus himself is the guilty one. Oedipus sends for the prophet Tiresias who, angered by Oedipus, declares that he, Oedipus, is the murderer and has committed an even more horrible crime. Evil forebodings are aroused in the audience that they hope will not prove to be true since they are felt to be unjust because Oedipus had tried to do everything he could to protect his parents.

As Oedipus continues his murder investigation, facts are revealed which begin to make the undeserved misfortune obvious. Emotions of pity and fear are intensified when the audience realise that Oedipus is, unwittingly through his own actions, attracting misfortune ever closer to himself. In this way the murder investigation creates strong dramatic irony and suspense.

During the play most of the audience will identify with Oedipus' emotions, especially if they do not know the play in advance. When Oedipus receives the message about the death of the King of Corinth, he feels relief and so does, at least to a certain extent, the audience. But they then come to feel the same terror as Oedipus when after a while they realise how the series of events was logically possible. Emotionally we identify with Oedipus. The plot structure elicits our feelings of anticipation which, because of our superior position and the feeling of suspense, produce the magical and timeless experience of a great play. The audience are involved both emotionally (no one like Oedipus deserves such a terrible fate) and intellectually (the riddle: how is Oedipus' guilt logically possible?). This tragedy is actually a detective story that masterfully combines mystery and suspense.

I believe that Aristotle's pity and fear are functionally the same as empathy, identification and suspense, which together bring about involvement. The more involved the audience are, the more pleasure is created. However, the audience must be released from the pity and fear in order to effect *catharsis* and thereby experience the 'proper pleasure'. Because this does not occur at the end of *Oedipus Rex*, it is understandable why Aristotle was not happy with its ending.

2.5 *Catharsis* – Release from Pity and Fear

Because Aristotle does not actually define *catharsis*, its essence in drama and the epic has to be deduced from both the plot structure and the definitions of pity and fear. It is important to note that *catharsis* only takes place after the occurrence of pity and fear. This is implied in the definition of tragedy: *catharsis* releases us from pity and fear. In other words, pity and fear are the necessary preconditions for *catharsis*. Expressed in today's language, we can say that identification and suspense are necessary for the *catharsis* that brings about the pleasure.

Catharsis is thus the emotional climax of tragedy. The term actually means purgation and its origin is in medicine, although in the context of the analysis of drama it has sometimes been suggested that Aristotle meant the refinement of emotions or man's moral healing. Generally speaking, however, Aristotle meant physiological and psychological discharge.

Many scholars of Aristotle suppose that the emotions of pity and fear build up in everyday life and then tragedy provides the opportunity for discharging them. If this interpretation is accepted, it becomes difficult to demonstrate how the mechanism of this building process functions. It would seem more logical that Aristotle simply meant that a plot must be constructed in such a way that it brings about as much pity and fear as possible. Then the plot structure has to release the audience in a pleasure-producing way – this is *catharsis*. In other words, the correct structure of a drama produces an emotional state that includes pity, fear and *catharsis*.

Aristotle might well have adapted the medical term *catharsis* to relate to the way the audience experience the intense anxiety of impending danger which creates the same physiological response – the pulse and breathing become rapid and the pupils dilate – as when we are aware of a real threat directed towards us.

In the *Poetics* Aristotle mentions that fear causes one to shudder. In other words, emotion has a physiological effect. In the *Rhetoric* he says that to induce a physiological response, the image of fear has to be sufficiently great, for example, the threat of death. In addition, the audience must feel such intense compassion for the fictional character that they feel as if the threat were directed at them personally. The audience then experience a fight-or-flight state but because they realise they are watching a fictional event, this raised state of consciousness does not result in physical action. However this can happen to children who run behind the sofa when they see something too exciting on the television.

The sudden release from a fight-or-flight state produces intense pleasure, that is, the fear-induced physiological state of suspense changes. We could say that if witnessing moral injustice produces pity and fear, witnessing the re-establishment of moral justice produces pleasure. The more intense the injustice, the greater the pleasure when moral justice occurs at the end of the drama. *Catharsis* is therefore an emotionally pleasurable experience that is also morally satisfying.

This is supported by what Aristotle says about the best kinds of endings. He states that the ultimate plot is that of *Oedipus Rex* but later he claims that the ending, in which the deed is committed without full knowledge of the character who finds out later, is in fact only second best. According to Aristotle, the best kind of emotional impact is produced by a drama in which the violent deed is averted just in time. As an example Aristotle mentions Euripides' *Iphigeneia in Tauris*, in which Iphigeneia, who as a priestess in a barbarian land is obliged to sacrifice shipwrecked Greeks, is about to sacrifice her brother Orestes when she recognises him just in time to save him.

Another example of a good ending is in *Cresphontes*. The protagonist, Cresphontes, the son of Merope and the King of Messenia, was smuggled out of the country as a child when a usurper killed the King and forcibly married the Queen. When a reward is offered to whoever kills Cresphontes, Cresphontes himself returns in disguise claiming to have killed the King's son. He deceives not only the usurper, but also Merope. She is about to kill her son's supposed murderer while he sleeps when he is saved and reunited with his mother by the intervention of the servant who had accompanied him into exile.

It is often assumed, wrongly, that this contradicts Aristotle's earlier argument that tragedy must depict a change in fortune from good to bad. In terms of general development, tragedy must certainly depict such a change in fortune if pity and fear are to be aroused. However, a play where the catastrophe is narrowly averted apparently produces the best kind of emotional effect.

It is obvious that Aristotle thinks Oedipus Rex is in many respects the best kind of drama. Elements of the plot already in place in the drama mean that it could not end in any other way. Although *Iphigeneia in Tauris* and *Cresphontes* are not as effective as *Oedipus Rex* in arousing pity and fear, the emotional impact of their endings may be

better. Aristotle's ideal drama would be one that could combine *Oedipus Rex*'s ability to produce pity and fear with *Iphigeneia in Tauris'* ability to produce *catharsis*. Such a drama would depict intense undeserved suffering and have a great deal of suspense but it would end in exultation for the audience.

On the other hand, the ending of *Oedipus* can be said to be a highly skilful, happy ending in which the protagonist heroically and admirably rescues the community and restores the moral order. The fascination of *Oedipus Rex* might be that the audience have a detached view while being disturbingly sympathetic and understanding. The guilt becomes the object of identification and sympathy and it is this that creates an intellectually fascinating experience for the audience.

One of Aristotle's important concepts of drama is *mimesis* which is the taking on of the characteristics of something else in order to arrive at a true understanding of it. It could be said that *Oedipus Rex* is about giving an aesthetic form to the basic human tragedy, the essence of which is that of *moira*, or fate, that plays a trick on the hero's good intentions. For instance, the hero commits a major offence while in the very act of doing the correct thing. Aristotle believed that in a good plot there is choice involved in any serious action, the significance of which only becomes clear for both the protagonist and the audience at the end. *Mimesis* relates to the dramatist's insight into the meaning of the story and the choice of events and characters that best tell the story. These choices are made in every scene of the drama. When they contain deep insight and are revealed to the character and the audience simultaneously, the experience is often fascinating and the *catharsis* is the more powerful.

References

1 Aristotle: *Poetics with the Tractatus Coislianus. A Hypothetical Reconstruction of the Poetics II, the Fragments of the Poets*. Translated with notes by Richard Janko. Hackett Publishing Company, Indianapolis, Cambridge (1987). Another book that has heavily influenced my interpretation of the *Poetics* is that by Elizabeth Belfiore: *Tragic Pleasures. Aristotle on Plot and Emotion*. Princeton University Press, Princeton, New Jersey (1992).

2 Karl Beckson & Arthur Ganz: *Literary Terms: A Dictionary*. André Deutsch, London (1990).

3 Sylvan Barnet & Morton Berman & William Burto: *A Dictionary of Literary Terms*. Constable, London (1964).

3 Strategies for the Good Plot

By examining Aristotle's three basic parts of a good, complex plot – recognition (*anagnorisis*), reversal (*peripeteia*), and suffering (*pathos*) – we can acquire a clearer picture of the nature of pity, fear and *catharsis*, as well as a notion of the best kind of ending.

Following Aristotle's logic, a good plot must have an intense threat of catastrophe (suffering) with its realisation being highly probable. But then at the last moment, another element of a good plot, namely recognition, occurs and prevents the terrible act from taking place. Because the audience have a superior point of view, they are aware of what is happening and might wish to warn the character of the consequences of his actions. This creates suspense. The audience want to know what will happen to the character for whom they feel compassion and sympathy as they fervently hope that the misfortune will be averted and that moral justice will prevail.

Drama engenders *pathos* because the audience are more aware than the character of the impending danger. At its best, this causes the audience to suffer unbearable anxiety linked to a hope that recognition will occur before the catastrophe takes place. In this way the audience are held in suspense.

At the last moment, misfortune is averted by recognition. Potential *pathos* creates fear in the audience because they imagine or expect some imminent danger (*phantasia*). This is exactly how Aristotle defined fear in the *Rhetoric*.

It is the character's ignorance of kinship and the results of their own actions that bring them close to catastrophe. However, the audience can foresee the consequences of what is happening and fear the worst. At the last minute – when catastrophe seems inevitable – recognition occurs and disaster is avoided. The audience experience great relief and join in the rejoicing. They are finally released from pity and fear – identification and suspense – through recognition brought about by the final twist in the plot and *catharsis* occurs.

An emotional pattern corresponding to the Aristotelian pattern of a good plot would therefore usually consist of identification, suspense and a sudden release from suspense. A good plot would also seem to have a certain kind of moral structure: undeserved suffering and the ultimate realisation of moral justice.

This might be an explanation of the importance of the ending and the pleasurable effect of *catharsis*. Because *catharsis* is a release from pity, it means that the plot has to release the character from moral injustice by the re-establishment of moral justice. The pleasure this creates heightens that induced by the release from suspense.

The third element of a good plot is the reversal (*peripeteia*), a sudden turn of action or change of fortune which is accompanied by a powerful emotional impact. Aristotle tells us that the best recognition occurs at the same time as reversal. In *Oedipus Rex* the reversal takes place when the messenger from Corinth comes to Thebes with the announcement that Oedipus' 'father', King Polybus, is dead and that he, Oedipus, has

succeeded to the throne. When Oedipus refuses to go to Corinth because he fears sleeping with his mother, the messenger tries to reassure him by revealing that he is, in fact, not the son of Polybus and Merope. This causes even greater tension and ultimately leads to the revelation of Oedipus' true identity. Recognition (*anagnorisis*) occurs at the same time as the change from good to bad fortune (*peripeteia*). In *Iphigeneia in Tauris* the recognition happens between brother and sister and causes a change in action that is the opposite to that in *Oedipus*, that is, from bad to good.

3.1 The Significance of Logic

A good plot represents action that is one, unified, whole and complete. This means that a plot has a beginning, a middle and an end. The action contains a change of fortune constructed in accordance with necessity or probability, that is, a good plot is both logical and credible. Aristotle explicitly states that two parts of a complex plot, recognition and reversal, should come about by 'necessity or probability'. It is also clear that the third element of the plot, suffering, should also come about by necessity or probability.

Aristotle explains a whole action as one that proceeds from beginning to middle to end according to probability or necessity, being one and whole and where none of its parts can be changed or removed without changing the whole. He commented that bad writers insert irrelevant episodes because of their lack of skill, implying that the construction of a good plot is a matter of skill.

Aristotle believed that good plot structure should closely follow the rules of causality, that is, any given event is the consequence of a former event, except for the beginning. According to Aristotle's definition, tragedy is the imitation of people's actions, and therefore the action in drama is the causal action of the characters. Causal action is also important for the creation of credibility so it therefore becomes a precondition for the creation of the 'proper pleasure'. It follows that plot structure is important for producing pity and fear and in order to achieve this, the audience must intellectually understand the logic of events.

In the same way, recognition (*anagnorisis*), reversal (*peripeteia*) and suffering (*pathos*) are accepted in the plot only if they are based on probability and thus are credible. A surprise is only acceptable if it is a logical consequence of the previous events. Such a surprise creates intellectual pleasure. The logic of events makes the plot believable and in so doing makes it possible for the audience to experience pity and fear.

3.2 *Hamartia* – Powerful Special Effect

According to Aristotle, error (*hamartia*) frequently occurs in a good plot. *Hamartia* has sometimes been interpreted as being a flaw or moral weakness in the character that could be used to justify the catastrophe. According to Aristotle's logic, a justified disaster would not produce pity and fear. Therefore *hamartia* must be interpreted simply as an error that has tragic consequences.

Aristotle places value on *hamartia* probably because it is an excellent means of achieving the state of undeserved suffering that in turn creates an intense emotional impact. Disaster caused by *hamartia* is the consequence of actions performed with the

best of intentions and so is effective in arousing our sympathy. Oedipus wants to save his mother and father from the curse and therefore he goes into exile, but this is exactly what brings about the enactment of the curse.

From the point of view of the logic of the plot in *Oedipus Rex*, the hero's suffering could have been caused by a deliberate act by *hamartia*, a crime committed in ignorance. If Oedipus had committed his crime deliberately and knowingly, he would have been vicious or evil but, as Aristotle says, no one pities a bad person since their punishment is justified. If, however, a morally good person commits a crime in ignorance, their suffering is undeserved. This is why we feel pity and fear for Oedipus.

Not only can *hamartia* make undeserved suffering believable, it can also make recognition and reversal believable. Events proceed towards recognition according to the laws of probability or necessity. In *Oedipus Rex* recognition leads in turn to reversal and bad fortune.

3.3 Characters in Drama

Aristotle believed plot and character to be very closely linked. Character traits in the person who experiences a change in fortune have a decisive impact on the emotional reaction of the audience. This character (the hero) must be morally good, but not perfect; the hero's mistakes make him human and understandable. It is easy to identify with such a hero, just as we can empathise with Oedipus when he realises the consequences of his deeds. If the hero were infallible and superior to us, the drama would not create effective suspense.

Aristotle says that a bad character is not suitable as a hero because his fate would arouse neither pity nor fear. Audiences do not identify with a bad character whose misfortune is deserved and who is not like us. It is important to realise that we do not like to think of ourselves as being basically bad. We often feel that in real life we are the objects of injustice and undeserved suffering. For example, we think that we deserve more money, more recognition, more love, or that other people do not realise our true value – and that is why we cannot be happy. We see life as a constant search for happiness, the achievement of which is hindered or frustrated by undeserved suffering. This is possibly why we so easily and intensely identify with a character who is the victim of misfortune. When that victim is threatened by impending danger, we experience fear because we ourselves feel threatened.

Let us consider the famous story of David and Goliath. With whom do we identify, the morally good and scorned David or the evil and superior Goliath? David's clever solution and victory over evil and power allows the audience to rejoice. Since many adults can remember this story which they probably last heard as a child, it could be that this story is remembered so well because of its strong emotional impact and pleasure.

Aristotle says that in addition to moral goodness and resemblance to ourselves, the character must be appropriate. Oedipus' behaviour is appropriate because he behaves as the son of a king should, that is, at the crossing of three roads he refuses to give way and when he is attacked, he defends himself bravely against an apparently overwhelming force.

A further requirement is that the character should be consistent. Oedipus' behaviour is consistent in that he is famous for being courageous, clever, determined and right-minded. It is these very characteristics that make him follow the murder investigation to the end without hesitation.

3.4 Goal-oriented Action

The 'proper pleasure' is most likely to be brought about by a plot that describes one whole and complete action, having a beginning, middle and end.

In the *Rhetoric*'s definition of fear there is a link to goal-oriented action. Aristotle regarded fear as a 'practical' emotion in that it involves setting a goal. Similarly, hate is a goal-oriented action because it is linked to the pleasurable expectation of revenge. Both hate and fear give rise to the pleasure linked to the thought or hope of attaining that goal. Here Aristotle is close to the modern theory of emotion.

By 'action' Aristotle means a specific action that results from the character's decision to attain a certain goal. The audience must be aware of this goal. Fear is linked to the possibility of the character's action failing to achieve the desired goal. In *Oedipus Rex* this goal-oriented action is directed by the essential question of the drama: who killed King Laius? Oedipus acts in order to find the answer and it is this action which produces fear in the audience because they know what kind of horrible shock is waiting for Oedipus if he discovers the truth.

Aristotle used the term 'whole action' for action that is motivated by an intention that is actually realised. The attainment of the goal may result in success or failure. In *Oedipus Rex* all the scenes are related to Oedipus' motive and the murder investigation. The happiness in attaining the goal lies in the city being released from suffering. Every scene brings Oedipus closer to his goal. None of the scenes is unnecessary. Ultimately, attainment of this goal reveals a huge surprise.

The connection between fear and goal-oriented action becomes clear when we examine the nature of action over time and when we consider the kind of effect it has upon emotions.

The audience feel fear when danger threatens a character who is the object of their empathy (Oedipus). Fear is linked to anticipating a catastrophe that has not yet taken place. When the audience see the catastrophe approaching, they begin to feel fear; when it occurs, their emotion turns to sorrow. As long as the audience believe in the possibility of averting the catastrophe, they feel hope. When the hope is fulfilled, as when recognition occurs in Euripides' *Iphigeneia in Tauris*, joy and then satisfaction are felt. As Aristotle realised, it is not possible to experience fear or hope with regard to something which is happening or has already happened but only to that which is about to happen or will inevitably happen. The audience cannot feel terror or relief for something that will happen in the future, or experience sorrow or satisfaction before something has actually taken place.

Aristotle believed that thought precedes emotion. For example, a precondition for fear (suspense) is anticipation, that is, the audience's ability to foresee what may take place in the future. In order to anticipate, the audience must know something that might happen or is intended to happen. If the audience do not know what the

characters intend to do, that is, what their goals or intentions are, they cannot anticipate anything. For example, it is necessary to be aware of Oedipus' goal in order to anticipate the catastrophe. Therefore the goal is revealed early in the drama. Similarly, the audience must be aware of the intentions of Iphigeneia and Merope in order to anticipate the impending danger and to feel fear or suspense. Hence goal-oriented action and fear are linked.

The action of the drama is complete when the intended goal has been attained. Fear is no longer experienced and in its place there is either sorrow or satisfaction that relates to the emotional content of *catharsis*. If we interpret the beginning-middle-end structure to be functionally the same as the motive-intention-goal structure, we can understand how it is that the structure of drama and action brings about fear and *catharsis*.

The existence of a motive sets a goal for action. Action has a beginning that is Oedipus' motive (to save Thebes and make the city-dwellers happy), and ends with the achievement of the goal of Oedipus' action (to reveal the identity of Laius' murderer and effect his punishment). Between motive and achievement, pity and fear are produced which result in goal-orientated action (intention). Every scene brings Oedipus' intention closer to its goal. Nothing is unnecessary, which is why this drama won Aristotle's admiration.

3.5 Plot Structure and the Dramatic Pleasure

Based on what Aristotle says about pity, fear and plot structure, I would like to suggest the following interpretation of the 'proper pleasure'.

A good plot needs a hero who is morally good, consistent and like us in the sense that he displays characteristics which, in similar circumstances, we may also have. He, or some other morally good character, becomes the victim of undeserved suffering. The hero acts in order to attain an important goal and the drama depicts in a series of linked scenes the attainment of that goal.

The plot must be constructed in such a way that the audience are aware of impending danger, obstacles and the goal of the action. In this way the audience may anticipate the uncertainty of the attainment of the goal. While it is necessary for the hero to attain the goal, uncertainty, threats and obstacles bring about fear and suspense in the audience as a consequence of them feeling compassion and sympathy as a result of witnessing undeserved suffering.

Action must be causal; events must follow one another logically and believably and be appropriate for attaining the stated goal. This action has a beginning, middle and end, which means there is a motive-intention-goal structure. If the plot is illogical or incredible it will not produce pity, fear or *catharsis* effectively. Believable surprises provide intellectual pleasure when the audience suddenly realise the causality and connection with previous event. Good drama must have reversals that change the direction of the action but do so in a way that is consistent with the characters and the plot. The logic and believability of events and reversals also make the plot intellectually pleasing.

When the action is complete, the goal attained, and the character is either happy or unhappy, the audience, released from fear, feel either sorrow or satisfaction. In the

resolution – the combination of *anagnorisis* and *peripeteia* – the plot releases the audience from the suspense that has been intensifying as the climax approaches. The consequence of this is relief and pleasure. The resolution also restores the moral order.

Intellectual pleasure may also be produced by the plot's function as a riddle: how a sequence of events can be possible (such as Oedipus' guilt) or how to overcome danger. The emotional experience created by *Oedipus Rex* is based on the fact that this drama is an effective combination of mystery and suspense.

Hamartia in the plot produces dramatic intensity because it makes suffering very much undeserved but, at the same time, believable. This happens in the case where a crime is about to happen between relatives (like brother and sister) who are unaware of their kinship. It is obvious that in the *Poetics* Aristotle was suggesting how dramatists could achieve the maximum dramatic impact.

In summary, a plot constructed according to Aristotle's theory will produce intense empathy, identification and suspense. At the end, when the plot suddenly releases the audience from suspense, they will experience emotional pleasure. The change from intense, morally undeserved suffering to a state of moral justice brings about moral pleasure. Intellectual pleasure is brought about by anticipation, logic, riddles, mystery and sudden insights for the audience in the reversal and recognition scenes.

Mimesis is also an element of the pleasure. It refers to the dramatist's choice of characters and events that ultimately reveal some universal insight and truth.

It is my belief that Aristotle's *catharsis* is a pleasure that contains emotional, moral and intellectual dimensions. The better the plot is in this respect, the greater the pleasure for the audience.

Now that I have presented my interpretation of Aristotle's 'proper pleasure' and suggested how it is brought about in drama, the next question is whether this can explain the success of individual stories in popular fiction and entertainment. The ancient classic pattern of the hero's journey does create the Aristotelian pleasure in many respects. There is a community or innocent victim threatened by danger (undeserved suffering), a hero who begins a journey of rescue (action in order to attain a morally good goal), facing dangers and difficulties (which create suspense), who returns victorious with the elixir which brings happiness to the whole community and the realisation of moral justice. Identification-suspense-happy ending is the emotional pattern corresponding to the standard story pattern that produces the 'proper pleasure' of the hero's myth.

I will now look at some other stories to see how closely they correspond to Aristotle's theory of drama.

4 Shakespeare and the Pleasure of Drama

William Shakespeare is the most famous playwright in the history of drama. Not only were many of his plays very successful in his own time, they have endured because the elements of dramatic storytelling that he employed are as effective today as when his works were first performed. Shakespeare's magnificent dialogue is only one element of his success. It is obvious that he had a thorough knowledge of how to create a successful play. When we examine the ways he constructed his stories and communicated with the audience we are led to the question: did Shakespeare consciously or unconsciously apply the principles of the 'proper pleasure', and do they, in part, explain his success?

Shakespeare's tragedies seem to conform to a pattern. He begins with a character trying to reach an objective, but complications intervene and the character has to readjust as the play gathers momentum and intensity. Increasingly the tragic hero is made to suffer as the society portrayed in the tragedy becomes further infested with evil. A crisis occurs when evil is defeated but only at a terrible cost, part of which is the death of the tragic hero. 'At the end of the play, the stage is littered with corpses and the action is declared over and a new figure emerges to lead the newly purged and cleansed society, suggesting that the blood-letting has not been entirely in vain.'[1] This brings about *catharsis* for the audience because they were induced to feel empathy for certain characters and then were held in suspense.

Othello, one of Shakespeare's most popular dramas, uses many of the strategies necessary for creating the 'proper pleasure'. Othello is a noble soldier, admired for his virtues, who has just married the beautiful Desdemona. He believes that all men are what they seem to be and it will be this belief that will be the cause of his downfall. His jealous confidant, Iago, persuades him into believing that Desdemona is sleeping with Cassio. The audience are informed of Iago's evil machinations and therefore experience strong feelings of suspense and anticipation of Othello's *hamartia*. The *peripeteia* occurs when Othello overhears Cassio speaking about his mistress, Bianca, and mistakenly believes that Cassio is referring to Desdemona. Othello becomes so furious, deranged and vengeful that he is compelled to murder his wife. In the *anagnorisis* Othello realises his tragic error and kills himself.

Another example of the key elements being used by Shakespeare can be seen in the story of Macbeth who with Lady Macbeth kills King Duncan in order to achieve power. Even though he is forced to commit more murders in order to secure his position and so appears as a ruthless killer, the audience are fascinated by him. This is because of his conscience. The audience are made fully aware of his enormous sense of guilt and it is this that makes him empathetic. They recognise that in those circumstances, committing the crimes was human and understandable, even if they themselves would not have done so.

Let us consider Hamlet. He is intelligent, physically competent and born into the highest family in the kingdom. He has a loving father and mother and every

21

advantage that money, rank and privilege can bring. In this respect he resembles Snow White. But then, in a short space of time, everything that he has relied on in his life is taken away from him, often by cruel force. His father dies. Hamlet discovers that his father was murdered by Claudius, his uncle, who now reigns with every sign of success. His mother shames him and the family name by a hasty remarriage to the murderous uncle, destroying Hamlet's respect for her. The girl he appears to have been in love with is found acting as a spy on Hamlet for her father and Claudius. And finally, his friends from university are discovered to be acting on the orders of Claudius. Almost at a stroke, Hamlet has lost father, mother, lover and friends, and has been exposed to ever-widening corruption.[2] This state of intense, undeserved suffering induces in the audience a feeling of pity and sympathy for Hamlet.

Hamlet makes a commitment: he swears to avenge the murder of his father. This establishes the character trying to reach an objective, but complications intervene and require him to react as the play progresses. The play contains a welter of conflicts: between Hamlet and the King, his mother, Ophelia, Laertes, Polonius and the pirates. In addition, Hamlet experiences his own inner conflicts as he is torn between self-doubt and his sworn obligation to his father. Hamlet's conflicts, being both internal and external, make it easy to identify with a plausible character and also introduce important elements of suspense.

A strong feature in Shakespeare's tragedies is the sense of inevitability that drives events towards their conclusion. This sense is the result of characterisation and circumstances that create a strong sense of plausibility. In terms of the 'proper pleasure', it can be said that in this play, Shakespeare vividly creates the emotional, moral and intellectual elements of pleasure.

There is a clever combination of *peripeteia* and *anagnorisis*. As Hamlet is not altogether sure of the new King's guilt, he has to find evidence. So when the travelling players arrive to perform at court, Hamlet persuades them to play *The Murder of Gonzago*, to which he adds 'a dozen or sixteen lines'. This interjection, which he calls 'The Mousetrap', shows a re-enactment of the murder of King Hamlet by pouring poison into his ear. Hamlet devises this scene in an attempt to reveal whether Claudius is guilty of murder. During the performance before the court, Hamlet positions himself so as to see Claudius' face. As the scene is acted, Claudius blanches, rises and flees the room. The scene has produced the desired effect by revealing the King's guilty conscience. But as Hamlet resolves his own uncertainty, Claudius is able to do the same.[3]

This scene is an excellent example of how Shakespeare skilfully used anticipation, suspense, and climax and then unfolded the consequences. A similar pattern can be found at the end of the play when Hamlet explains to Horatio how he escaped Claudius' plan for his death in England. This celebration of survival has an ironical ring because the audience know about Claudius' latest secret stratagem to which Hamlet is about to fall victim. Osric arrives to announce Claudius' wager on a proposed encounter in swordplay of Laertes and Hamlet. Hamlet indicates to Horatio that he has misgivings about the match but he intends to proceed. Foils are chosen and Claudius talks of the celebrations to follow Hamlet's victory. The initial passes in

swordplay heighten suspense but have no dire consequences. There is a pause and Claudius invites Hamlet to drink but the poisoned wine is set aside. The second bout of swordplay is also won by Hamlet. The Queen then drinks to Hamlet's health despite the King's protests. Laertes wounds Hamlet with the poisoned sword, but in the fight weapons are exchanged and Laertes is also wounded with the poisoned tip. The swordplay reaches its climax as the Queen dies from drinking the poisoned wine. Laertes, mortally wounded by his own treachery, then reveals the plot in which Hamlet has been fatally caught. Hamlet proceeds to kill Claudius, he forgives Laertes, says farewell to his mother and asks Horatio to tell his story. Fortinbras arrives, and as Hamlet dies, he discloses his preference for the Norwegian to sit on the Danish throne.[4]

Shakespeare cleverly makes a deliberate link between the trap that Hamlet sets to catch Claudius and the trap that, as a consequence, Claudius sets to kill Hamlet.

Shakespeare is a master of dramatic irony and of creating the superior position of the audience. From the time when the ghost visits Hamlet until the play is presented to the King, the audience, unlike the King, know that Hamlet suspects Claudius of the murder. As soon as Claudius realises that Hamlet knows the truth, he actively plans the Prince's death. The audience are aware of this while the Prince is not. When Ophelia comes to Hamlet to return his gifts, the audience know that she is acting on her father's orders but Hamlet is unaware of this. When Hamlet rails at the Queen, the audience are aware that it is Polonius who is behind the curtain, not Claudius. So when Hamlet thrusts his sword to effect his revenge, the audience are horrified because of their superior knowledge. This device is used again in the last scene of the swordplay.

Finally, Hamlet's *hamartia* is that he cannot force himself into action until it is too late.

As Aristotle claimed, tragedies arouse the emotions of pity and fear and then purge them. There is, however, a tremendous sense of uplift at the end of a tragedy because although the tragic hero may have been destroyed, the spirit and strength he has shown during the course of the action reaffirms the audience's faith in human nature. *Hamlet* is certainly capable of producing intellectual, moral and emotional pleasure.

4.1 Romeo and Juliet

Romeo and Juliet was originally an old story from Italy. Shakespeare added a great deal of suspense in his telling of the story because, as co-owner of the Globe Theatre, it was important to him that the plays performed appealed to a large audience. Accurately gauging the audience's reactions while writing and using his consummate skills as a dramatist, Shakespeare produced in this play another example of how the principles of the 'proper pleasure' should be used to create the desired dramatic impact on the audience.

In Verona, two leading families, the Montagues and the Capulets, have become enemies. Romeo, a Montague, is desperately in love with someone who does not return his love. The audience identify with Romeo's undeserved suffering and with this emotional bond created, they want Romeo to be happy. His friends try to cheer him by taking him to a masked ball arranged by the enemy family, the Capulets. At the gate,

Shakespeare creates the anticipation of tragic events in the audience when Romeo says to his friends:

> I fear, too early: for my mind misgives
> Some consequence, yet hanging in the stars,
> Shall bitterly begin his fearful date
> With this night's revels; and expire the term
> Of a despised life, clos'd in my breast,
> By some vile forfeit of untimely death;

As Romeo circulates among the guests he meets a beautiful girl with whom he immediately falls in love. The goal-oriented action of the play begins with Romeo asking for a kiss and getting it. As that issue is resolved, fresh anticipation is created when the girl is hurried away by her nurse. The audience know that the girl is the daughter of the enemy Capulets, but Romeo does not know this and the audience are left in suspense for his reaction.[5]

A combination of *peripeteia* and *anagnorisis* occurs when Romeo realises the identity of his beloved. He knows that if he pursues his love, he will be killed. Shakespeare has skilfully constructed the play so that at this point the audience know that Juliet is the only child of the leading Capulet family and that a young man named Paris passionately wants to marry her. The audience also know that Tybalt, a hot-tempered enemy of the Montagues, has recognised the masked Romeo and vows bloody revenge. Wanting to warn Romeo but unable to do so, the audience are compelled to follow the story in suspense, hoping for a happy outcome.

Romeo and Juliet's first meeting has created a powerful *peripeteia*. By this stage the audience have become so involved with the story that they passionately want to know the outcome of the lovers' fate. Their love will be the cause of undeserved suffering as they belong to enemy families. The audience also know of other serious threats of which the lovers are unaware. Shakespeare has brought his audience to a state of high suspense, anticipation, empathy and curiosity. The fate of the lovers is of interest because for many people, achieving true love is one of the most desirable experiences in life.

That night, unable to sleep, Romeo goes to Juliet's balcony. The audience, who feel empathy with Romeo, can sense the tension: does she love him? They already know of the intensity of Romeo's love and that this is a matter that will be one of life and death. Unexpectedly, Juliet appears on the balcony and declares her love. Here again Shakespeare uses the technique of the audience's superior position: They know that Romeo is in the dark under the balcony listening to Juliet's words. There is release from suspense as Romeo realises that Juliet loves him. She promises to marry him. Now the question is how can they make it happen, because others will not accept it.

Their love is so great that the lovers are willing to risk death – a fate quite possible because of the enmity and hatred of the two families. In the meantime the Prince of Verona has declared that anyone who disturbs the peace of the city will be executed. Prohibitions are often broken in stories, and here it is Romeo who violates the ban.

Shakespeare knew that he had to make this violation logical in order to preserve the emotional involvement of the audience. The balcony scene serves to establish the sincerity of the main characters' feelings and to make their unrequited love morally undeserved.

The lovers' marriage is arranged as a secret ceremony involving Friar Laurence. Once married, Juliet has to hurry home after the lovers have promised to meet that night. The audience are relieved; true love seems to have won.

But the master playwright does not allow his audience relief for long. The moment of happiness is quickly followed by a turn for the worse. A powerful *peripeteia* takes place on the street where misfortune arrives in the form of Tybalt, Juliet's cousin. The meeting does not appear as a coincidence because his plans for revenge were disclosed in an earlier scene, thus ensuring that the spell of credibility is not broken. When Tybalt meets Romeo and his friend Mercutio, he insults the latter. Romeo tries to prevent an escalation because of his secret marriage but Mercutio attacks Tybalt. In the struggle, Mercutio is killed. Romeo feels responsible for the death of his friend and bound by honour, he kills Tybalt.

The killing proves to be Romeo's *hamartia* because the Prince of Verona banishes him from the city. As a consequence there is a new dilemma: what will happen to the lovers now? Romeo meets his bride for a few hours of happiness before going into exile in the neighbouring city of Mantua.

As Wells Root points out in his excellent analysis of the play in *Writing the Script*, it is here that Shakespeare doubles the tension: Juliet's father decides she should marry and has even chosen her husband, the nobleman Paris. Juliet protests touchingly. Shakespeare brings irony into the scene by letting Juliet's parents believe that she is crying for her dead cousin when actually her grief is due to the fate of her banished husband. The irony is intensified by the parents thinking they will cheer her with the news of her marriage to the noble Paris. Obviously Juliet cannot confess her real objection because it would result in Romeo's death. So the wedding is arranged for three days' time. The clock is set ticking again.

In desperation, Juliet seeks help from Friar Laurence who suggests a plan. He gives her a magic potion that will put her to sleep, seemingly dead. When her body is laid out in an open tomb as custom required, the Friar will send Romeo a message to rescue her by night and together they will escape. The anxiety felt by the audience is somewhat mitigated by this element of hope.

But the message never reaches Romeo. Meanwhile Juliet takes the magic potion and her death is announced. The bad news reaches Romeo. He returns to die beside his love. Once again it is the superior position of the audience that creates the intense state of suspense.

The story approaches its climax. Juliet's body is laid out in the open tomb. Romeo arrives in the gloom to see her apparently dead. The audience are aware that Friar Laurence, knowing that Romeo did not receive his letter, is on his way to the chapel. Whether he will make it in time adds further suspense. Another shadowy male figure appears in the tomb. Romeo supposes that he is an enemy from the Capulet family. They fight and Romeo kills the man. Then he discovers that it is Paris. He is now a double murderer. He kneels by Juliet, kisses her and drinks the vial of poison.

Juliet begins to awaken. Friar Laurence arrives. Juliet sees her lifeless husband beside her. Realising what has happened, she tries to kiss the poison from his lips. It does not work so she takes Romeo's dagger and kills herself. The audience's impression at this point is that an undeserved misfortune has taken place.

Both families arrive and Friar Laurence tells them what has happened, his story confirmed by Romeo's letter to the Prince of Verona. Appalled by the tragedy, the families agree to live in peace in future.

As we can see, *Romeo and Juliet* – the classic love story – is told in accordance with the pattern of the 'proper pleasure'. Despite their earlier impression, the audience on reflection appreciate the symbolic beauty of the end of the drama in which the lovers are united in eternity. This is implied in the Romeo's words just before he hears of Juliet's death:

> I dreamt my lady came and found me dead;
> (Strange dream, that gives a dead man leave to think,)
> And breath'd such life with kisses in my lips,
> That I reviv'd, and was an emperor.
> Ah me! how sweet is love itself possess'd,
> When but love's shadows are so rich in joy!

References

1 Martin Stephen & Philip Franks: *Studying Shakespeare*. Longman York Press (1984)

2 Stephen & Franks, ibid.

3 Theodore W. Hatlen: *Orientation to the Theater*. Prentice-Hall, New Jersey (1987).

4 Anthony Brennan: *Shakespeare's Dramatic Structures*. Routledge, London and New York (1986).

5 Wells Root has demonstrated the suspense pattern of this play in *Writing the Script*. Holt, Rinehart and Winston, New York (1979).

5 The Power of the 'Proper Pleasure'

Aristotle argued that individual works of tragedy could be evaluated by the extent to which they fulfilled the potential inherent in the genre and thereby achieved or failed to achieve the full artistic effect of the particular type of construction.

In the *Poetics*, Aristotle states that the function (*ergon*) of the tragic plot is to arouse emotions of pity and fear in the audience and so produce pleasure and *catharsis*. So plot is 'the first principle and, as it were, the soul of tragedy'. Aristotle's view was that once the structure of the plot is understood, it is possible to appreciate exactly how tragedy affects the audience.

It has been argued that Aristotle thought that plot is simply the organisation of the incidents in the story. But this is only partially true because as we have seen in the preceding chapter, Aristotle was concerned with the organisation of events inasmuch as they produced a particular kind of impact upon the audience which would bring about the maximum amount of 'proper pleasure'.

Is this insight regarding ancient tragedy also universally applicable to storytelling? Can we apply the principles of Aristotle's theory to explain the popularity of certain kind of stories today? Does his theory provide us with an insight into the secret of success in the entertainment industry? Can we apply Aristotle's insight to create new successful stories?

To answer these questions we first need to examine whether the history and evolution of storytelling has already revealed specific popular story types. Because our interest is in finding out how stories achieve certain effects in the audience, we need to look at stories as a process of selecting, arranging and rendering story material.

If we can understand how popular stories affect us, perhaps we could do the same with them as Aristotle did with tragedy: discover the strategies which produce the maximum pleasure embedded in the story format and learn how to intensify them. The answer could be revealing about success in today's entertainment industries. Such insight could be invaluable in creating powerful new stories for television, cinema, books and computer games.

A universally appealing story structure should be found in classic folktales since they are the kind of stories that appear in all cultures. Such stories are the products of pre-literate societies. Unlike modern novels, they were not created by any one author. Instead they were passed on by word of mouth and in this process of retelling were polished by successive generations into optimally attractive forms. The oral tradition made for a unique intimacy between teller and listeners and the response of the audience no doubt influenced the form of the tales.

It is therefore all the more remarkable that folktales are so similar all over the world. The most popular one of all, *Cinderella*, has been found in hundreds of versions in different cultures, the first appearing in written form in China in the ninth century. Scientists have been puzzled by this similarity. One assumption is that the stories

evolved completely independently in regions of the world that had no direct contact with each other. But our existing knowledge of the spread of cultures is changing.

Stephen Oppenheimer argues in his book *Eden in the East* that the cradle of civilisation is not the Middle East as generally assumed, but the now drowned part of the continent of South East Asia, from where many dominant myths could have come by diffusion to what were to become the western civilisations. Joanna Cole says in *Best-Loved Folktales of the World*:

> To account for the existence of similar stories everywhere, some scholars believed that the world's tales originally spread from one source by diffusion; that is, the plots were thought to have originated in India and travelled via pilgrims, merchants and immigrants to local storytellers elsewhere, who adopted the stories as their own, changing details in the telling, but keeping the bones of the tales intact. Another theory was that the stories sprang up simultaneously in different countries because the material of the folktales is universal. The themes were said to be those concerning human beings everywhere and the stories were bound to be invented wherever communities developed.

Both these theories of the origins of folktales imply that there is something very appealing in certain story patterns and themes. Even if the stories come from other countries, the story pattern and theme remain the same though the characters and settings might be altered. This being so, we can assume that the pleasure embedded in the story stayed the same across different cultures even though many elements of the story content are culture specific. The setting or the profession of the hero, for instance, may change as the story travels from culture to culture.

The idea of the universal appeal of a certain kind of story material implies that the success of a story does not depend only on the plot, how the incidents are arranged, but also on certain appealing themes. The theme, which is an intellectual abstraction, can be defined as the idea which unifies the structure and is represented by the actions of the characters as a whole dramatic piece. It is also possible that story patterns and themes are somehow connected.

Whether a story travelled or whether it was told independently, it is clear that the themes and plots that are widespread are those that have been meaningful and entertaining to many people in many places. We can imagine that these popular stories, in addition to having effective patterns, express the wishes, hopes and fears of many people and like myths, deal with human dilemmas that span differences of age, culture, and geography.

When we study folktales, we are possibly dealing with universal, archetypal story patterns. Professor John G Cawelti argues in his book *Adventure, Mystery and Romance* that these universal story types probably reflect basic psychological needs and thus give us insight into the working of the unconscious mind. Bruno Bettelheim, in his influential book *The Uses of Enchantment: The Meaning and Importance of Fairy Tales*, says:

> The fairy tale ... is very much the result of common conscious and unconscious content having been shaped by the conscious mind, not of one particular person, but the

consensus of many in regard to what they view as universal human problems, and what they accept as desirable solutions. If all these elements were not present in a fairy tale, it would not be retold by generation after generation. Only if a fairy tale met the conscious and unconscious requirements of many people was it repeatedly retold, and listened to with great interest.

Concerning popular plot structure, there is one famous systematic analysis of this subject. In 1928 Russian folklorist Vladimir Propp published his book *Morphology of the Folktale* in which he analysed one hundred Russian folktales. To his surprise Propp found a formula, a common plot structure in the tales. He also found a certain number of 'functions', thirty-one in all. A function here is understood as an act of a character, defined from the point of view of its significance for the course of the action.

Propp drew the following conclusions:

- Functions of characters serve as stable, constant elements in a tale, independent of how and by whom they are fulfilled.
- The number of functions known to the folktale is limited.
- The sequence of functions is always identical.
- All fairy tales are of one type as regards their structure.

Propp noticed a limited number of combinations of narrative motifs found in the oral tradition, as opposed to the total number of theoretically possible combinations. Propp also found that while the number of functions is extremely small, the number of people constituting the *dramatis personae* is extremely large, a *dramatis persona* being a fundamental role assumable by a character.

Propp isolated seven such roles, each corresponding to a particular sphere of action:

- The hero who suffers from the action of the villain or from some kind of misfortune and who manages to rectify his or another character's predicament.
- The villain who opposes the hero and causes his or another character's misfortune.
- The dispatcher who instigates the departure of the hero on his adventures.
- The donor who provides the hero with some kind of magical agent that allows for the eventual rectification of the misfortune.
- The helper who assists the hero to solve difficult tasks.
- The princess or a sought-for person and her father.
- The false hero who pretends to have accomplished what, in fact, the hero accomplishes.

The identity of these characters, their names, features, professions, and so on can vary enormously, but not their roles which have specific functions in the story which Propp called spheres of action. For instance, the villain's function is to perform an act which is contrary to the hero's intention and which instigates the struggle and pursuit.

To simplify, a folktale can be about a hero who sets off on a journey to rescue and bring home a princess who has been kidnapped by a dragon. On his journey he has to

pass several difficult tests before he acquires the competence to defeat the dragon and save the princess. But the dragon is not completely beaten and gives pursuit to the hero. When the hero arrives home he is unrecognised. The false hero pretends to have accomplished that which the hero accomplished and makes unfounded claims (to marry the princess). In the final glorifying test, the father demands a difficult task which is fulfilled by the true hero who is then recognised by the princess. The false hero is punished and the true hero marries the princess.

Many elements of the Aristotelian pleasure producing methods can be seen at work here. For instance, there is the undeserved misfortune of a morally good character (kidnapping of the princess). There is suspense provided in the attempt to rescue the princess and the many difficult tests experienced en route to the final battle. *Hamartia* occurs when the villain receives information about his victim: for instance, a mother calls to her son home in a loud voice and thereby betrays his presence to a witch. Impending danger and suspense is created by giving the audience information at an early stage about the villain and his evil plans. There is the morally good character for whom we feel sorrow or pity. If this character is also the hero, then starting the adventure from this point makes him a victimised hero. At the last moment the audience are released from suspense when the unjustly suffering hero solves the difficult task, defeats the false hero and is finally recognised by the princess as the true hero.

Furthermore, the standard sequence of functions causes anticipation in the audience and creates expectations. The order of events is important because it has a profound influence on the emotional impact of the story on the audience. This becomes evident if the order of the same incidents is changed. Screenwriting Professor Irwin Blacker gives a good example: a woman is murdered. Her husband is arrested and charged. His girlfriend finds proof of his guilt but suppresses it at the trial. He is acquitted. They leave for the Bahamas. Compare this scenario with one where a woman is murdered. Her husband is arrested and charged. His girlfriend supports him through the trial. He is acquitted. They leave for the Bahamas. There she finds proof of his guilt.

Propp's discoveries give insight into the universal pleasure of storytelling. Like many other scholars of folktales, Propp was puzzled by the similarity of tales throughout the world:

> How is one to explain the similarity of a tale about the frog queen in Russia, Germany, France, India, in America among the Indians, and in New Zealand, when the contact of peoples cannot be proven historically?

Perhaps Propp's findings imply that the emotional impact of a folktale is embedded in the plot structure and the theme and not in the specifics of the fictional world where the situations and events vary from culture to culture. This could explain the similarity of folktales around the world. (The resemblance of the pleasure derived from the folktale pattern and a typical thriller story titled *Kidnapping in LA* is demonstrated in the Appendix).

Propp's pioneering work has been considered as marking the birth of modern narratology. Many later narratologists took Propp's discoveries as the starting point for modifying their own theories. Furthermore, modern cognitive psychologists in their

attempts to uncover the structures of popular stories have started by looking at folktales since these stories have highly specific rules and rigid formats. Like Propp many decades earlier, they also have noticed that the same kind of structures appear repeatedly in the folktales of the world.

These studies of traditional stories have shown that in addition to knowledge about specific plots and actions, people in general have a more abstract understanding of what happens in stories. Jean Matter Mandler, Professor of Cognitive Science, argues that 'from an early age people develop expectations about the overall form of traditional stories; they learn that these stories involve protagonists who have goals and who engage in attempts to achieve those goals, and that goals and events cause other goals and events in predictable ways.'

Such knowledge is abstract in that it is not dependent upon the particular contents of a story. The abstract character of such schemas means that people cannot always verbalise their knowledge of them but nevertheless such knowledge can be shown in the way it influences how they comprehend and remember a particular story.[1]

What is impressive is the fact that a particular type of story schema is found in many different populations and across cultures. For instance, the Vai-speaking population in Liberia seem to recall stories according to the same schema as people in the United States. Literacy or schooling does not seem to influence the pattern or amount of recall. In fact, it seems that certain forms of storytelling regularly emerge in various cultures around the world.[2]

The findings of cognitive psychologists suggest that there is at least one kind of story schema that is a cultural universal – a hypothesis supported by finding stories with a similar structure from all parts of the globe. Even though the content of the story varies enormously from culture to culture as does the knowledge required to understand the goals and motives of the story's characters, the story format seems to be stable and it is this which affects the judgement of story quality.

The narrative schema laid out by Propp is a goal-oriented structure, that is, there is a protagonist who wants something. This desire is based on some disturbance of the equilibrium. There are, however, difficulties in fulfilling the desire – in other words there is conflict. This results in an outcome and return of the equilibrium. Cognitive psychology has shown that this is also the story schema in the human mind.[3]

According to Wallace Martin[4] this pattern of narrative schema became conventional because great numbers of people over many years learned by trial and error that it was an effective means of storytelling. This is possibly the explanation for the uniform story pattern and recurrent themes of folktales. They have been polished into an optimally attractive form as they were repeatedly related in the oral tradition of succeeding generations. It can therefore be said that successful stories are those that consist of certain combinations of cultural information and archetypal story patterns, the embedded pleasures of which have been intensified to a maximum.

5.1. The World's Most Popular Folktale
Cinderella is the best-known folktale in the world. In 1893 a book was published that analysed no fewer than 345 versions of it. The story was first written down in China in

the ninth century. It then went round the world for centuries and made its appearance in the West in the collections of Charles Perrault and the Brothers Grimm.

Bruno Bettelheim has demonstrated the psychological value of this tale to children in *The Uses of Enchantment* and Ronald B. Tobias has analysed it as a good example of the underdog plot in 20 Master Plots.[5] We could ask if *Cinderella*'s popularity implies that it possesses the key elements of the 'proper pleasure'. After hundreds of years of retelling it has become plot perfect and maximum pleasure has been achieved.

The story opens with a strong case of undeserved suffering as Cinderella, an only child of a rich couple, is kneeling beside her mother's deathbed. The mother's last words are: 'Dear child, be good and pious and then the good God will always protect you and I will look down on you from heaven and be near you.' Every day Cinderella cries at her mother's grave. The audience see that she is morally good and deduce that she has a sweet and gentle nature. She has the audience's sympathy and pity right from the start.

A few months later Cinderella's father marries a woman with two ugly daughters who are the opposite of the good and humble Cinderella. They are extremely selfish and cruel. The stepmother hates Cinderella because she makes her own daughters appear terrible, so she abuses Cinderella and makes her work from dawn to dusk doing all the household tasks. Cinderella is teased by her stepsisters and has to sleep in a garret while the sisters have soft beds in comfortable rooms. In this way the story makes Cinderella an object of ever increased, undeserved suffering.

What happens next is a test of Cinderella's sincerity and the purity of heart. The father goes to a fair and before he leaves he asks his daughters what they would like him to bring back as a present. The sisters want beautiful clothes, pearls and jewels, but Cinderella asks only for the first branch that touches her father's hat.

The father fulfils the girls' wishes and Cinderella takes the branch to her mother's grave where she plants it and waters it with her tears. The branch grows into a tree in which there is a white bird, the spirit of her mother. Since Cinderella passed her father's test, this bird grants Cinderella's every wish. With this magical tool in her hand, Cinderella is ready for battle. This element of new hope creates the circumstances for suspense in the audience.

The King invites everyone in the kingdom to a ball lasting three nights during which his son will choose a bride. The stepsisters start to prepare themselves and force Cinderella to help them. Cinderella also wants to go but her stepmother says that she is too dirty and does not have clothes or shoes. However, she gives Cinderella a 'chance': she throws a dish of lentils into the ashes and tells her that if she can pick them out within two hours she can go to the ball. This inflicts more undeserved suffering.

But Cinderella has secret friends and she asks the birds to come and help her. They pick out all the lentils thereby offering the audience relief. But the stepmother exacerbates the undeserved suffering by refusing to honour her promise. She repeats the trick with the lentils, this time throwing twice as many lentils into the ashes. Although Cinderella is able to complete the task, the stepmother and sisters go to the ball leaving Cinderella at home. This unfairness makes the audience even more willing to see Cinderella succeed and the stepmother and her daughters punished.

As Ronald B. Tobias points out in his analysis, to achieve her objective of going to the ball, Cinderella has to take a new line of action. There is strong audience identification because of the long period of undeserved suffering.

At her mother's grave, the spirit fulfils Cinderella's wish for beautiful clothes and shoes. Cinderella goes to the ball and dances with the Prince who then refuses to dance with anyone else. The Prince wants to escort her home after the ball but she avoids that by leaving early. The second night at the ball is a repeat of the first.

On the third night, the Prince, so much in love with Cinderella that he does not want to lose her again, plans to smear the staircase with pitch so that when Cinderella steps on it, her slipper will be caught. This plan convinces Cinderella, and the audience, of the sincerity of the Prince's feelings for her.

When the Prince has a shoe but no princess, he begins his search for her. He arrives at Cinderella's house with the shoe. The first stepsister tries on the tiny shoe but she cannot even get her big toe into it. Her mother advises her to cut it off since 'when you are Queen, you will no longer need to go on foot'. This her daughter does and when the Prince sees that the shoe fits, he puts her on his horse and returns to the castle.

Further undeserved misfortune seems about to take place in that a false heroine is about to win the reward that rightfully belongs to Cinderella. But soon there is new hope. On the way to the castle they pass Cinderella's mother's grave and the birds sound the alarm. The Prince looks at the stepsister's foot that is soaked with blood and realises that she is not the real princess. In this desperate situation there is renewed hope and the suspense continues.

The second stepsister tries on the shoe but her heel is too wide. The mother advises cutting off part of her heel. Again the birds raise the alarm and the Prince, seeing her stocking soaked with blood, returns her.

The Prince asks if there are other daughters in the house and is told by the father that there is only Cinderella. The stepmother says that it is impossible for Cinderella to be the mystery princess, but the Prince insists. The shoe fits perfectly. This is the great scene of *peripeteia* and *anagnorisis*. Cinderella has the grand wedding and the stepsisters are punished for their wickedness. Cinderella's ultimate success and the recognition of moral justice bring relief and joy to the audience.

However, for adult audiences there are too many supernatural and coincidental elements in this story for the 'proper pleasure' to occur. What is enough for child audiences (and adult audiences hundreds of years ago) is not enough for teenagers and adults today who require more logic, credibility, plausibility and sophisticated intrigue or intellectual pleasure for them to experience the 'proper pleasure'.

References

1 Jean Mandler: *Stories, Scripts and Scenes: Aspects of Schema Theory*. Lawrence Erlbaum, Hillsdale, New Jersey, London (1984).
2 Mandler, ibid.
3 Mandler, ibid.
4 Wallace Martin: *Recent Theories of Narrative*. Cornell University Press, Ithaca and London (1986).
5 Ronald B. Tobias: *20 Master Plots (And How to Build Them)*. Writer's Digest Books. Cincinnati, Ohio (1993).

6 Enjoyment of Drama: The Scientific Evidence

Is there scientific evidence to support the principles of the 'proper pleasure'?

Jennings Bryant and Dolf Zillmann are American Professors of Mass Communication who since the 1970s have conducted fascinating empirical investigations with audiences on the enjoyment of drama and entertainment. Based on their empirical research they have created the disposition theory of the enjoyment of drama.

Other fascinating empirical research has been carried out at the University of Illinois where Professor William F. Brewer and Edward H. Lichtenstein outlined the structural-affect theory of stories.

There are also the recent findings of Hollywood screenwriter and IBM consultant Peter Orton's doctoral dissertation at Stanford University. He tested experimentally how the manipulation of story strength (protagonist likeability, importance of protagonist goal, time pressure, satisfying ending) affects audience interest in and liking of stories.

In 1975 Bryant and Zillmann created different versions of an audiovisual adventure story for children. In the story, two boys were on an African safari with their fathers who sent them out on their first lion hunt without adult supervision. Different versions of the hunt were created in which the level of suspense varied (low, intermediate and high), as did the resolution of suspense (unresolved and resolved).

> The variation in level of suspense was achieved by presenting the lion as varyingly dangerous. He was described as just a wild lion under 'low', as a rather vicious one under 'intermediate' and as a most ferocious beast that had killed men before under 'high'. The audiovisual depiction differed analogously; showing the lion at a distance, close by, or in close-ups that featured enormous roars and displays of the lion's teeth. Several 'close calls' were shown as the boys stalked the lion. The boys' anxiety reactions to these happenings were also manipulated, with the least fear shown under 'low' and the most under 'high'. The variation in resolution was achieved by the boys' successful completion of their mission (i.e. they killed the lion) under 'resolved' and by their being unsuccessful under 'unresolved'. In the latter condition, the boys managed only to wound the lion, which escaped and could be heard roaring nearby as the boys made it safely back to the camp. Suspense thus was made to linger on to the very end of the story, and the 'resolution' was expected to be rather nonsatisfying.[1]

Subjects were shown one of the six versions on a television monitor and were then asked to rate their enjoyment of the show on a scale devised for children. The result was that enjoyment of the drama increased with the level of suspense. Providing there

was a satisfying resolution, the more intense the induced empathetic distress, the greater the enjoyment.

In 1977 Zillmann and Cantor conducted another interesting investigation.[2] They presented films with different versions to second- and third-grade children. These films featured a protagonist who was presented either as a most pleasant and helpful character or as obnoxious and hostile when interacting with his peers, pet and younger brother. The findings showed that children came to like the 'nice' protagonist and dislike the 'bad' one. This supported the notion that a person's behaviour is judged in terms of this approval or disapproval. The researchers concluded that affective dispositions toward a person are formed on the basis of this approval or disapproval.

These films were given different endings. In the version with a happy ending the protagonist jumps with joy as he is given a new bicycle. In the other ending, the boy rides off on his old bicycle, loses his balance, crashes and is badly hurt. The audience felt empathy only for the 'nice' character. Reaction to the bad character was discordant: a happy ending for him was disliked because it was perceived as unfair and unjust whereas the ending with the accident was perceived as appropriate and deserved.

In 1978 Bryant conducted another investigation in which various versions of a mini-drama were written and produced. The audio-visual story featured a woman who was depicted as very obnoxious, or as most sympathetic, or as someone to be met with feelings of indifference. The variation in these affective dispositions toward the protagonist was accomplished by various interactions with other characters in the initial part of the plot. After the protagonist's character was thus developed, a rather standard suspense treatment was employed: the woman was shown shopping at a late hour while being watched by a man who follows her to her car. Frightened, she seeks refuge in a nearby tenement building but is assaulted as she reaches it. The ensuing struggle terminates as one party is pushed down a flight of stairs and is severely injured in the fall.

The level of suspense was manipulated through the variation of both the apparent threat posed by the assailant and by the reactions of fear displayed by the victim. In the condition of high suspense, the assailant was portrayed as an extremely sinister person and his victim was shown in extreme fear. The resolution of the suspense was accomplished either with the protagonist's victory over her assailant (satisfying ending) or with her becoming the unfortunate victim of the assault (dissatisfying ending).

The results indicated that the version in which the female character was made sympathetic and the level of suspense was highest with a satisfying resolution, was the version most enjoyed (different audiences saw different versions).[3]

From these and other experiments Zillmann and Bryant were able to draw interesting conclusions. They noted that unpredictable plots may generate heightened suspense but they do not produce greater appreciation. Drama that produces an extremely high level of suspense can be too disturbing to be enjoyable. However, drama with a rather predictable macrostructure or theme and with numerous unpredictable storylines of actions involving suspense is the form that creates the optimal conditions for enjoyment.

They also noted that the suspense-induced empathetic distress should be viewed as feeling 'for someone' rather than 'with someone'. The audience should be made to witness impending danger of which the victim is unaware (a heroine walking into an ambush by a rapist). The structure of the narrative allows the audience to anticipate the danger and thereby causes the emotional effect called suspense. A certain cognitive-affective process takes place in that regardless of the protagonist's limited comprehension of the potential danger, the audience utilise all the information available, make an appraisal, and respond accordingly. If a protagonist is liked and deemed undeserving of a particularly deplorable treatment, the imminence of that treatment proves disturbing.[4]

Based on their experimental findings, Bryant and Zillmann further noted that although the enjoyment of drama, comedy and sports is influenced by a multitude of variables, none seem to control enjoyment as strongly and as universally as do affective dispositions toward interacting parties. Conflict in drama is indeed needed but it is only the starting point. The description of an intense and dramatic conflict does not necessarily lead to enjoyment for the audience. Their enjoyment relies more on the resolution of the conflict and on its meaning for the characters involved depending on how much those who win are liked and those who lose are disliked.

Empirical investigations support the idea that the audience bring moral considerations into the enjoyment factor. Affective dispositions toward protagonists and antagonists derive in large measure from moral considerations. The function of describing protagonists as 'good' is to make them likeable.

It is the actions of characters that reveal their true natures and are the basis for the audience's approval or disapproval. Once the audience have placed their sentiments with or against particular characters, enjoyment of conflict and its resolution in drama depends on the ultimate outcome for these characters. Positive affective dispositions inspire hope of positive outcomes and fear of negative ones. Protagonists are deemed deserving of good fortune and undeserving of bad fortune. These hopes and fears lead the audience to empathise with the emotions displayed by protagonists. The villain's joy is the audience's distress; the audience delight in seeing the villain's suffering and him being brought to justice.[5]

Finally the Professors asked the question of the contradictory, even paradoxical nature of the enjoyment of suspense-ridden drama: how is it that such drama is enjoyed despite the fact that the liked protagonist is seen in peril? For much of the time the protagonist is tormented and threatened with being overpowered and destroyed by evil forces and extraordinary dangers. Dreadful things are almost continually imminent. Distress is relieved when the feared and seemingly inevitable events fail to materialise and in the resolution when the protagonist, usually against all the odds, is able to destroy the evil forces. Although the dominant affective experience is empathetic distress, in terms of time there is much more suffering than enjoyment for the audience. How can anybody enjoy this?

The answer to this is that the more intense the distressful experience, the more enjoyable is the satisfying resolution. In other words, drama will be the more enjoyable

the more the audience are initially made to suffer through empathy with the endangered protagonists. Great enjoyment rides on the back of great distress.

Traditionally, in narrative theory, the story is defined as communication that comprises of goal-directed behaviour for resolving a problem and a series of causal changes. It includes descriptions of the following elements: information about the setting and characters, the initiating event, the protagonist's internal response, the protagonist's attempt to achieve a goal, the consequence of the outcome of the protagonist's attempt, and the protagonist's reaction to the outcome. These are definitions of the story feature theory. However, this theory only relates to the story and ignores the audience. It does not include any particular audience response as being intrinsic to the story definition.

The structural-affect theory criticises this approach. It states that while the protagonist's goal is indeed a necessary element of the story, it must be a goal important to the audience or else the audience are not likely to be interested in the trivial desire of achieving that goal. 'A narrative which features a desire to obtain sugar for a cup of coffee, for example, would constitute a boring scenario which would nonetheless still conform to the story grammar schema.'[6]

Brewer and Lichtenstein argue that narratives eliciting an emotional response such as curiosity, surprise and/or suspense are understood as stories by the audience even if some of the story elements are missing. For example, in one of their experiments they used a narrative about a tank of nerve gas that explodes and the cloud of gas rolls down a hill toward a sleeping village. The subjects considered this to be a story even though there was no resolution.[7] This academic approach claims that if a story fails to stimulate an emotional response, the audience are unlikely to say that it is much of a story, if at all. Several experiments with adults and children support these claims.[8]

For his doctoral dissertation in 1995, Hollywood screenwriter and IBM consultant Peter Orton experimentally tested how manipulation of an index of story strength affects audience interest in and liking of pictorial stories. The story strength index comprised four distinct elements commonly believed to enhance a story: protagonist likeability, importance of protagonist goal, time pressure and a satisfying ending. Seventy-two Stanford University undergraduate and graduate students individually watched a videotaped story in one of the two story-strength conditions (weak or strong).

As predicted, subjects who watched the strong story rated it significantly higher than the weak story in evaluating their liking and interest. Orton confirmed that the narrative elements used to enhance the story which were consistently cited throughout the theoretical and instructional literature were found experimentally to do exactly that.

Orton also tested the effects of perceived choice on the liking of and interest in a story. The three choice conditions were Choice (being able to affect story outcome), No Choice (the typical film-watching experience), and Source Choice (being told that the ending had been chosen by someone else). The result was that audiences found a pictorial story more interesting and liked it better when they were not required to make choices regarding the story.[9] Obviously this finding will have implications on

creating interactive stories, but I will deal with this issue in the chapter 10, The 'Proper Pleasure' in Cyberspace.

Orton concludes his study by stating that just as narrative theorists have generated a 'story schema' that people of the Western culture are said to follow and which enhances their understanding and enjoyment of story content, then perhaps we could also develop and use a similar framework for the process of experiencing stories.

Orton further argues that our understanding of the ubiquitous communication phenomenon called 'story' can be enhanced by expanding the notion of 'story schema' that focuses exclusively on the processing of story content, to include the structure and function of the experience itself. He suggests that this experience could be called 'audience schema' which could, in fact, be understood as another term for the 'proper pleasure' that we are trying to trace in this book.

These empirical results would all seem to indicate that Aristotle's ideas about the pleasure of drama are also valid in modern entertainment.

6.1 Why is Sport a Billion Dollar Business?

One important and profitable form of entertainment is sport. The disposition theory of the enjoyment of drama may also explain its huge popularity as entertainment.

Zillmann, Bryant and Sapolsky[10] set up a test on the enjoyment of watching tennis. They manipulated the commentary of identical play by creating three versions:

1. A commentary giving a strict description of the visible play.
2. In addition to the commentary provided in (1), two reporters gave information about the players who were described as best of friends.
3. In addition to the commentary provided in (1), two reporters presented the players as embittered rivals who felt intense hatred for each other and sought to destroy and humiliate their opponent.

The three test audiences were then asked how much they enjoyed watching the game. The data showed that the audience who had the third version of the commentary enjoyed the game much more than in the other two groups, despite the fact that they were watching the same game. Those who thought that they were watching tense and hostile play found it more exciting, interesting and involving than the others. Witnessing a favoured or even beloved individual or team humiliate the resented opposition constitutes the ultimate in sports enjoyment. A home team's victory after a close, tense game should be more enjoyable than a similar victory decided early in the contest. This assumption has been supported experimentally.[11]

What brings about pleasure in sport is the conflict between individuals or teams. When we interpret a contest as a hard battle for victory, we enjoy it. The greater the conflict, the more pleasure it provides. This pleasure can potentially be increased if we bring in the element of identification. When the threat of losing becomes an impending danger the game provides a high level of suspense. If it is a tough and even game with several plot points, say goals, at both ends of the field and the opponents are very strong, say England vs. Brazil, and the game is crucial, say the World Championships,

then victory in the last minute will bring a huge *catharsis* for the supporters of the winning team. In this way a sports event can be compared to drama. The elements of identification, suspense, goal-oriented action, reversals, climax and *catharsis* belong to both sport and drama experiences in their ideal forms.

Furthermore, on a purely emotional level, the intensity of the experience in sport is often higher than in drama, because sport is real: the story is unfolding as we watch, nobody knows the ending. When people buy tickets to sporting events they are in fact buying the potential promise of a desired intense emotional experience.

Regarding sport as pleasure-producing drama opens up possibilities of intensifying the pleasure. Sport events should be constructed as being fierce battles for honour or high sums of money. By giving a sympathetic image of themselves, sportsmen can increase audience identification. The commentators' role of setting the right tone for the audience is obviously of great value. These ways of enhancing the pleasure of a sports event for an audience and the idea of the 'proper pleasure' can also be used when creating entirely new, potentially popular sports events.

6.2 Brain Physiology

There are definite physiological and chemical changes that take place in the body as we undergo different sorts of experiences while watching a film, drama or a sports contest.

When watching a film sequence in which a woman is walking in the street unaware of a rapist in the shadows around the corner, we might experience fear for her just as we might experience fear or suspense when watching preparations for a last-minute penalty kick against our team in a soccer game. This fear results in physiological changes: our heart rate increases, our palms become sweaty.

In his book *How to Make Money Scriptwriting*[12] Julian Friedmann explains what happens in the suspense process from a physiological viewpoint:

> The brain is the key to emotions. It is part of the nervous system which, together with the cardiovascular system (blood) and the endocrine system (hormones), make up the complex physical and chemical network we need to understand if we are to make sense of our emotions.
>
> The surface of the brain is the cerebral cortex. This is where the higher-level processing of information happens and probably gives rise to consciousness. Embedded deeper in the brain is an area that includes the hypothalamus. This deals with the basic emotions – pleasure, fear, anger, and so on.
>
> Nerve cells in the hypothalamus, when receiving electrical impulses from other cells, prompt the release of the chemical known as phenylethylamine, or PEA. This is colloquially known as 'the happiness drug', a derivative of which is what we call 'speed'.
>
> When this washes over the other cells of the brain, positive and relaxing thoughts are encouraged and at the same time various physical processes are slowed down, like the heart rate and blood pressure, which are reduced to less stressful levels. In short, watching a film can bring about a feeling of elation and well-being. Several stimulants are released, the effects of which are similar to those of illegal drugs.

If you hear a window in the next room smash and you think that someone has broken in, you will, without thinking about it, move into what psychologists call 'fight-or-flight' mode. You will be prepared in an instant to defend/attack or to run away. This response is the result of the sympathetic nervous system becoming dominant. One of the hormones released during 'fight-or-flight' is adrenaline. It is released into the bloodstream and travels around the body affecting the cells it reaches, altering their activity.

As the body prepares for an emergency, certain adjustments occur: heart rate and blood pressure rise; blood flow is directed more towards brain and muscle where it is most urgently needed; pupils enlarge; muscle tension increases. This primitive physiological and biochemical arousal is a survival mechanism that evolved to allow humans to flee from predators and to hunt for food. A sudden release from it will cause pleasure.

Friedmann continues:

But if you suddenly discover that the window was broken by a child's ball, the parasympathetic nerves, triggered by the realisation that you are not in danger, signal the organs to slow down. Blood vessels constrict in order to lower the amount of blood your heart needs to pump and if this braking process is very sudden you may even faint (extreme relaxation).

This physiology of emotions thus helps us understand the essence of the 'proper pleasure' from a biological point of view and it might also explain why Aristotle used a medical term, *catharsis*, to describe the pleasure of a good drama. Perhaps Aristotle observed his own and audiences' physiological reactions while watching the best kind of dramas.

We can assume that the more efficiently a story is able to bring our bodies into a state of stress, the more pleasurable is the sudden release from that state. This is in accordance with Aristotle's logic and this notion is also supported by empirical experiments with audiences. Possibly because of this pleasure-producing mechanism, stories in the oral tradition – perhaps from the times of ancient campfires – evolved into a certain pattern which brought about the greatest pleasure for audiences. That is why we have conflict and climax, intensifying suspense and a sudden release from suspense, in all good stories.

So classical drama, folk tales, empirical experiments and brain physiology give support to the idea of a universal 'proper pleasure' of storytelling.

References

1 Dolf Zillmann: *Anatomy of Suspense*. In Percy H. Tannenbaum (ed.): *The Entertainment Functions of Television*, Lawrence Erlbaum, Hillsdale, New Jersey (1980).

2 Dolf Zillmann: *Empathy*. In Jennings Bryant & Dolf Zillmann (ed.): *Responding to the Screen: Reception and Reaction Processes*, Lawrence Erlbaum, Hillsdale, New Jersey (1991).

3 Dolf Zillmann: *Anatomy of Suspense*.

4 Dolf Zillmann: *The Logic of Suspense and Mystery*. In *Responding to the Screen: Reception and Reaction Processes*.

5 Jennings Bryant & Dolf Zillmann (ed.): *Media Effects: Advances in Theory and Research*. Lawrence Erlbaum, Hillsdale, New Jersey (1994).

6 P. E. Jose & W. F. Brewer: *Early grade school children's liking of script and suspense story structures*. Journal of Reading Behavior, 22(4), 355–72 (1990).

7 W. F. Brewer & E. H. Lichtenstein: *Stories are to entertain – A structural-affect theory of stories*. Journal of Pragmatics, 6, 473–86 (1982).

8 For example, P. E. Jose & W. F. Brewer: *The development of story liking – Character identification, suspense, and outcome resolution*. Developmental Psychology, 20, 911–24. (1984); W. F. Brewer & E. H. Lichtenstein: *Event schemas, story schemas, and story grammars*. In J. Long & A. Baddeley (eds) *Attention and Performance* (Vol. 9, 363–79). Lawrence Erlbaum, Hillsdale, New Jersey (1981).

9 Peter Orton: *Effects of Perceived Choice and Narrative Elements on Interest in and Liking of Story*. Doctoral dissertation, Stanford University, Department of Communication (1995).

10 Dolf Zillmann & Jennings Bryant & Barry S. Sapolsky: *The Enjoyment of Watching Sports* . In Jeffrey H. Goldstein (ed.): *Sports, Games, And Play: Social and Psychological Viewpoints*. Lawrence Erlbaum, Hillsdale, New Jersey (1979).

11 J. Bryant & S. C. Rockwell & J. W. Owens: *Degree of Suspense and Outcome Resolution as Factors in the enjoyment of a televised Football Game*. Unpublished manuscript, University of Alabama, Tuscaloosa.

12 Julian Friedmann: *How to Make Money Scriptwriting* (second edition). Intellect Books, Bristol (2000).

7 The 'Proper Pleasure' in Hollywood

In previous chapters we have seen how the 'proper pleasure' functions in classical drama and folktales. Experimental research and brain physiology have shown the existence of an emotional state caused by the conjunction of pity, fear and *catharsis* that might reveal something relevant and universal about the pleasure we desire from stories. Today storytelling has, to a large extent, taken an electronic form in cinema, television and computer games. Can we therefore apply the principles of the 'proper pleasure' to explain success in the entertainment industry?

7.1 The Mythical Journey of the Hero

At the beginning of the book, I looked at the universal myth and story pattern in primitive cultures found by the American anthropologist Joseph Campbell. This pattern he called 'the hero's journey'. It is interesting to note how closely this follows the pattern of popular Russian folktales discovered by Vladimir Propp. The journey can be shown to have a deep, psychological dimension, which may help to explain its appeal.

Christopher Vogler is a Hollywood story executive and consultant who has contributed to such top-grossing feature films as *The Lion King* and *Beauty and the Beast*. In his book *The Writer's Journey – Mythic Structure for Storytellers and Screenwriters*, he has applied Campbell's discoveries to Hollywood movies. Having analysed thousands of screenplays for major studios, Vogler recognised the connection between good movie stories and the ancient story pattern. Later he showed that the model of The Hero's Journey can be found in the majority of successful movies.

According to Campbell's theory, these movies usually begin with an introduction to the 'Ordinary World'. In *Star Wars* we first meet Luke Skywalker as a bored farm boy in a remote corner of the universe. In *The Wizard of Oz* we see Dorothy's normal life in Kansas before she enters the wonderworld.

Just as in ancient myths, the stories of many successful films then move on to the phase 'Call to Adventure' in which the hero is confronted by a challenge or a problem. This prevents the hero or heroine from continuing to live their normal life. In *Star Wars*, Princess Leia's holographic cry for help to Obi Wan Kenobi is the 'Call to Adventure', and it is he who asks Luke to help rescue her from the evil Darth Vader.

In the myth, the phase of hesitation, familiar to us all, is called 'Refusal of the Call'. We all fear taking risks and the hero reacts in the same way. It seems for now that the protagonist will continue living their unfulfilling life. Luke refuses to respond to Obi Wan Kenobi's call. He returns to the farm of his uncle and aunt but finds them killed by Darth Vader's troops. Now he cannot refuse the Call anymore. According to the theory of the 'proper pleasure', it can be said that the function of this stage is to put the protagonist into a state of undeserved suffering thus creating pity and sympathy for him in the audience.

The fourth phase of the journey is the meeting with 'The Mentor'. In Star Wars it is Obi Wan Kenobi who gives Luke his father's light sabre. In *The Wizard of Oz* it is the Good Witch who gives Dorothy the ruby slippers that will finally take her home. 'Crossing the First Threshold' follows. The hero is ready to enter the new world and ready to meet the challenge that was posed earlier. This is the beginning of the story's real action.

Vogler calls the sixth phase 'Test, Allies and Enemies'. Luke learns about the Force, wins Han Solo to his side and fights the Imperial Force. This is also a very typical phase in many folktales.

Next we have 'Approach to the Inmost Cave' which is the ultimately terrifying place in the other world. The hero has to descend into this hell in order to rescue his loved one. In Star Wars this place is the giant spaceship, the Death Star, where Darth Vader is holding Princess Leia hostage. In Dorothy's case, she is kidnapped and taken to the Wicked Witch's castle.

The eighth stage of the journey is 'The Supreme Ordeal'. By now the audience have come to both sympathise and empathise with the hero so intensely that this ordeal, as in most folktales, is a time of immense suspense. There are treasures in a cave for which the hero has to face his greatest fear. Luke and his friends are trapped in a giant rubbish compactor. Dorothy is trapped by the Wicked Witch without a chance of escape. In many ancient folktales this is the moment when the peasant fights the dragon.

This extreme experience is followed by 'Reward'. Luke rescues Princess Leia. In Aristotelian terminology, it is *peripeteia*.

However, before the hero is able to return home safely, he has to face another extreme ordeal that is about life and death. In the final battle scene of Star Wars, Luke appears to die but miraculously survives. He has command of the Force and it is this that saves him. It is a great moment of *peripeteia* and *anagnorisis*.

The last stage of the journey is 'Return with the Elixir'. The journey would have been insignificant without a gift or treasure that has a healing power. Luke's destruction of Darth Vader restores peace and order to the galaxy. Dorothy learns that she is loved and that 'There is no place like home'.

Christopher Vogler's model of the protagonist's journey in Hollywood movies largely follows the hero's journey pattern of many primitive cultures. Vogler does not want us to take this journey model too literally. The different stages are just symbols of universal life experiences familiar to us all. The symbols can be changed without losing the power of the myth. The hero's journey lives in all of us and therefore it speaks to us over and over again and holds its appeal in ever-new forms. The hero's journey of Luke Skywalker in a fantastic world can be thought of as a metaphor of the inner journey in search of self-knowledge that we have to make in order to know ourselves.

The importance of the myth in popular stories is also recognised by Celia Brayfield. In her book *Bestseller – Secrets of Successful Writing* she says:

> All popular culture tells stories, and the stories which are told are about ideas which are important to very large numbers of people. They are stories which are superficially about

fictional characters, invented places and fantastic scenarios, but which in fact are about ordinary life. They pretend to be nothing but entertainment, but in fact address the hopes and fears of the whole human race. They present themselves as modern stories, even stories about the future, but when analysed and compared with the literature of the past, they are revealed as very old stories; most of them have been told for as long as people have used language, certainly long before the invention of writing. They are myths.

In her book *Awakening the Heroes Within*, Carol S. Pearson, on the other hand, says that we find in stories about heroism a model for learning how to live. In the preparatory stage, we are challenged to prove our competence, our courage and our humanity. We are frightened of taking the risk even though we know that only by doing so can we change our frustrating lives. On the journey we leave the safety of the family or tribe and embark on a quest where we encounter death, suffering and love. Most importantly, we ourselves are transformed. In myth, the transformation is often symbolised by the finding of a treasure or sacred object. On our return from the journey, we become rulers of our kingdoms that are transformed as a result of our own transformation.

So the power of the hero's myth is based on its psychological truth. How can we not identify with a story which, at a symbolic level, is our own journey? The hero's journey brings to the pleasure model a new, psychological dimension that I call the 'symbolic' level of the 'proper pleasure'. In other words, the pleasure of any story can have four components: emotional, moral, intellectual and symbolic.

7.2 The Structure of a Successful Movie

In his book *Narration in the Fiction Film*, Professor David Bordwell defines a typical Hollywood film in the following way:

> The classical Hollywood film presents psychologically defined individuals who struggle to solve a clear-cut problem or to attain specific goals. In the course of this struggle, the characters enter into conflict with others or with external circumstances. The story ends with a decisive victory or defeat, a resolution of the problem and a clear achievement or non-achievement of the goals. The principal causal agency is thus the character, a discriminated individual endowed with a consistent batch of evident traits, qualities, and behaviours. The most 'specified' character is usually the protagonist who becomes the principal causal agent, the target of any narrational restriction, and the chief object of audience identification.

As we can see from this definition, the story format of the film conforms closely to the universal story schema that can be traced back, as we learnt in previous chapters, to the oral tradition of storytelling. The typical narrative which early Hollywood filmmakers and studio moguls found appealing to audiences, supports the idea that the 'proper pleasure' is embedded in this particular story format.

But is his definition really complete? It is interesting to compare it with the advice Michael Hauge gives to screenwriters in his book *Writing Screenplays That Sell*:

45

> Enable a sympathetic character to overcome a series of increasingly difficult, seemingly
> insurmountable obstacles and achieve a compelling desire.

Bordwell's and Hauge's definitions are similar in many ways but differ in one crucial
respect: Hauge takes into account the audience's emotional reaction. He talks about a
sympathetic character. Bordwell talks about psychologically defined individuals. It is
in this difference, I think, that the secret of successful movies lies.

Bordwell's definition actually deals only with the first part of Aristotle's definition:

> Tragedy is a representation of a serious, complete action which has magnitude, in
> embellished speech, with each of its elements [used] separately in the [various] parts [of
> the play]; [represented] by people acting and not by narration…

Hauge's advice, on the other hand, also takes into account the latter part of Aristotle's
definition: '… accomplishing by means of pity and fear the *catharsis* of such emotions.'

So Bordwell gives a general definition of a typical Hollywood film that conforms to
the narrative schema, whereas Hauge gives the definition of a successful movie. Hauge
says that his definition applies to almost every successful feature film. And from
looking at the *Poetics*, ancient tragedies, folktales, Shakespeare's plays and the evidence
of experimental research and brain physiology, it can be seen that Hauge is right.

Successful films continue the tradition of the 'proper pleasure' of storytelling. First
of all, a sympathetic character creates the possibility for identification by the audience.
This is needed in order to make the audience believe in the necessity of achieving the
goal that is set up in the story. As was stated previously, the narrative prototype is a
goal-oriented structure with a conflict. This implies that the audience will feel suspense
when the protagonist's intention meets obstacles. Screenwriting consultant Linda Seger
says in *Making a Good Script Great* that the more the audience identifies with the
character's need to achieve the goal, the more it can connect with the character. She
also says that the screenwriter can raise the stakes throughout the story by keeping the
goal out of reach and making it look throughout as if the character will not achieve it.
According to Seger, if we do not believe in the necessity of the character gaining that
goal, we shall not be able to root for the character. The story must also convince the
audience that a great deal is at stake if the audience's emotions are going to be deeply
affected.

Hauge's definition includes, in a compact form, all the key elements of Aristotle's
theory of drama: pity, fear, completed action, suffering, rising action and climax. He
says that the primary goal for the screenwriter is to elicit emotion both in the audience
and also in the person who reads the screenplay. If the screenplay fails to get an
emotional response from the producer, executive, agent or star, it will never become a
movie. All the conventional elements involved in being commercial – big stars,
budgets, special effects and marketing – will not help if the movie fails to create an
emotional response in the audience.

Most of Hollywood's screenwriting consultants (Seger, Hauge, Field, McKee, et al.)
seem to be unanimous about the importance of the three-act structure in successful

movies. Some (Truby) suggest that there are more stages than three, although the three-act structure remains the dominant form. This structure can, for example, be seen in terms of the 'goal' of the main character. In the first act, the character sets the goal. In the second act, he endeavours to achieve that goal. In the third act, the hero usually achieves the goal thus creating the happy end. The beginning-middle-end structure in Hollywood movies corresponds to the motive-intention-goal structure in Aristotle.

The three-act structure applies to all genres probably because it is the structure that is needed to create the 'proper pleasure'. Creating a hit movie is about intensifying this pleasure. Aristotle said that individual tragedies could be judged according to how well they are capable of bringing about the 'proper pleasure'. In the same way, a movie can become a blockbuster by maximising the amount of pleasure from the story.

In *The Art of Adaptation* Seger writes: 'Most successful American films have a main character who is likeable, sympathetic, and identifiable. While watching a film we like to cheer for the protagonist, wanting the best for this character and wanting them to achieve specific goals. We want the protagonist to win at the end. As audiences we expend considerable emotional energy wishing this character success.'

Michael Hauge introduces a list of five qualities without which he claims no movie can succeed. First of all, a movie needs a hero whose visible motivation drives the plot. Secondly, the audience must identify with that hero; they must experience emotion through the main character. In order to achieve this, the audience need to feel sympathy for and empathy with the hero. Thirdly, there must be a clear, specific motivation or objective that the hero hopes to achieve. There must be something the hero desperately wants. The story concept must be expressed in terms of hero and objective. Fourthly, the hero must face serious challenges and obstacles in pursuing his objective. Something has to stand in the way of reaching the objective or there is no conflict and no movie. Fifthly, the hero must be able to exhibit his courage when facing the challenges. If nothing is at stake for the hero or if the hero does not regard the challenges as frightening on some level, the story will not work and the audience will not be emotionally involved. Whether the hero ultimately finds the courage is what the audience will want to find out.

I would like to analyse one film, in the light of the above, to demonstrate how the 'proper pleasure' of popular storytelling, with its emotional, moral, intellectual and symbolic dimensions, functions in a successful movie.

7.3 Analysis of *The Fugitive*

The Fugitive was a Hollywood blockbuster in 1993, when it took $184 million at the US box office. The starting point of this analysis is the proposition that the movie succeeded because it was capable of eliciting the 'proper pleasure' through specific storytelling strategies.

The film opens with black and white flashing images of a woman. Soon we realise that we are watching the woman being murdered. The film starts with an emotionally charged riddle: who is this beautiful woman and why is she being assaulted so brutally? After the beginning credits, we return to 'the present day' and see a bearded man (Harrison Ford) sitting and looking shocked. There is blood on his neck. From the

report of a TV news journalist we learn that the man is the well-known surgeon Richard Kimble who is being taken to a police station for questioning. His wife Helen Kimble has been found murdered. So the emotionally and morally charged riddle for the audience is: can the pleasant and respectable looking surgeon really be the killer of his own beautiful wife?

From the report of the journalist we discover that Helen Kimble had dialled 911 to report an intruder. The reporter goes on to say that the couple had been attending a charity dinner for a children's foundation earlier that evening. There is a flashback to that event which gives the audience a chance to know the doctor and his wife better, and it also provides clues for solving the shocking mystery. The flashback provides an image of Doctor Kimble as a respected and popular man with a sense of humour and an attractive, elegant wife. This is necessary to create the sympathy, empathy and identification that are needed later.

Another man wearing a tuxedo returns some car keys to Doctor Kimble, who asks with a smile whether the man has left any petrol in the car. The other man then introduces Kimble to someone called Alec, but his last name is not revealed to the audience at this stage. Viewers are not aware that here they are actually being given important clues for solving the mystery.

This early scene, as we find out later, is the key to solving the mystery of the plot and provides the credibility of the final act. The audience have been given the clues but the significance of these characters' roles and their dialogue only becomes clear towards the end of the story. *The Fugitive* is a mystery charged with considerable suspense and it is this skilful combination of mystery and suspense that creates its success.

On the way home Kimble receives a phone call from Doctor Stevens who needs his help in surgery. Helen says that she will wait for him at home.

Next we see the absent-looking Richard Kimble at the police station. He is sitting in a T-shirt covered with blood, stroking his beard nervously. Then we move to a flashback in which Kimble is operating on a patient. The function of this scene is to make Kimble plausibly absent from home. It is his *hamartia* in that by not staying with his wife, he unknowingly makes a fatal error. The scene's function is also to demonstrate how morally good a character and skilful a surgeon Kimble really is. In this way our sympathy for him is intensified and it becomes even more difficult to accept the idea that he is the murderer of his wife.

During questioning at the police station, it becomes evident that the doctor claims to have struggled with a one-armed man. The evidence (blood on his neck, no signs of burglary), however, speaks against him. Disclosure is also made of his wife's quite substantial life insurance. The doctor bursts into tears when he realises that he is being held as a suspect.

In the courtroom, the strongest evidence against Richard Kimble is the recorded 911 call in which the dying wife mentions her husband's name. This message, however, is misunderstood in that she is not identifying him as the murderer but instead, hearing him arrive, is calling out to him. This information is delivered to the audience in flashback, but the people in the courtroom are under the impression that the wife is accusing her husband of the murder. A large part of the audience interprets the

flashback as presenting what happened, which exonerates Kimble and the audience experience relief through *anagnorisis*. However, the flashback can be interpreted as Richard Kimble's subjective view of the events that night. In this case, suspicion about his guilt remains.

Following the audience's *anagnorisis*, during the next courtroom scene the audience are overwhelmed by pity when the innocent Kimble receives capital punishment for the brutal murder of his wife. This reaction is both a moral judgement in that Kimble's punishment is utterly undeserved and an intense emotional reaction because of the superior position and privileged information of the audience. Since the other characters in the film are unaware of the truth, the audience want to tell them that Kimble is innocent and that his tears are genuine.

The fascination of the movie for the audience is further enhanced by the fact that they are not totally sure of Kimble's innocence. The flashback could have been Kimble's subjective version of the episode. So could Kimble, after all, be guilty of the killing? The audience long for an answer for which, of course, they have to wait until the end.

The flashback scene demonstrates that the 'proper pleasure' model is a flexible tool in the hands of the writer. If it is used too literally, the consequence is too predictable. Slight deviations from the pattern enhance the intellectual challenge of the story and it is this that today's sophisticated audiences want. A slight uncertainty as to Kimble's innocence increases the tension.

The audience are now able to feel pity for Kimble. Sympathy is a prerequisite for identification. The audience need to support emotionally the character's intentions and want him to achieve his goals. Pity and identification lead to empathy, which means that the audience can put themselves into the shoes of Kimble, sharing his feelings and suffering when he is shackled and escorted to the death cell. The emotional intensity is related to the moral judgement that the audience are making.

Another prerequisite for the audience's involvement is intellectual acceptability in that the events leading to the fate of Kimble must be based on logic and plausibility. Without this credibility, the emotional reaction desired by the scriptwriter and director is not possible. This is not so important in fairy tales for children (like some of the events in *Cinderella*), but in stories for adults the requirements for the 'proper pleasure' experience are much more demanding. Adults' stories also need a riddle which is intellectually challenging and for which there has to be a logically satisfactory answer. While the audience are trying to solve the riddle, they are inadvertently being pulled into the emotional world of the story.

The beginning of *The Fugitive* fulfils the required function of *hamartia* in that there is a state of plausible, undeserved suffering. Kimble's fateful error was to go to the operation on the patient. However, the hero has to be morally good, so he could not have refused. But it is exactly this altruism that causes the catastrophe. In *The Fugitive*, *hamartia* enables us to feel that the hero is like ourselves which is why we can so easily imagine ourselves in his situation.

It should be said that *hamartia* is not evident in the Hero's Journey model, and it is only partly evident as 'delivery' in Propp's model of functions. However, *hamartia* creates a powerful effect in a story.

The function of the beginning of this film has been to prepare the audience for a ride filled with suspense and they are now about to move from pity to fear.

Other prisoners have planned to escape while being transported in a prison bus. In a violent struggle, the bus runs off the road and crashes on to a railway track. One of the police officers needs first aid so Kimble is given the keys to unlock himself. At that moment they notice an approaching train and realise that they are in imminent danger. The other prisoners and the unhurt police officer run away and refuse to assist Kimble who is trying to help the injured police officer. Apart from increasing the suspense, the function of this scene is to convince the audience of Kimble's moral goodness and heroism making his death penalty appear even more undeserving. Concern for Kimble is increased and the idea of him being the murderer seems even more implausible than before. The tension increases.

Kimble is no longer a victim of circumstances but has become an active agent. A *peripeteia* has taken place in that the action has suddenly changed course. Screenwriting manuals use the term 'inciting incident' or turning point and it is this which moves the first act into the second, and subsequently the second into the third.

Kimble takes off into the woods and has at least some hope of avoiding execution. Conveniently the story introduces the fascinating antagonist, Sheriff Samuel Gerard (Tommy Lee Jones). Like the villains in folktales, his function is to create sufficient and effective fear in the audience. Gerard's intelligence, professionalism and toughness increase the concern felt for Kimble.

Hungry and exhausted, Kimble flees to a hospital where he is almost caught. He takes an ambulance and drives into a tunnel but Gerard has men at the both ends. The suspense is intensified as Kimble's chances of escape look slim. But when the police officers reach the ambulance, Kimble has disappeared. Relief for the audience occurs when they realise that Kimble has escaped into a drain.

But the tension is released only temporarily because without it the audience would lose interest. The story moves on to an even more intense phase of suspense. Gerard enters the drain and catches up with Kimble who is then forced to jump from the edge of the dam and vanishes into the water. It is not clear if he is alive or dead. Anxiety in the audience is increased by not knowing whether moral justice has occurred and by the unresolved mystery. In due course, the audience are informed that Kimble survived the jump, which provides further evidence of his courage and heroism. But he is not allowed to rest and again has to run for his life. He sleeps under a tree and dreams of his wife. On waking he realises that since the police are not trying to catch the real killer, he himself has to do it.

The audience are then misled into thinking that the police are preparing to catch Kimble by seeing police officers approaching a lonely house. Actually they are about to catch another prisoner who escaped from the same bus as Kimble. The audience are in a state of suspense believing that it is Kimble who is in the house. Surprise and relief are experienced as the truth is revealed. All good drama needs this kind of sudden surprise.

This sequence serves to depict Gerard as a courageous, intelligent and persistent man who kills a prisoner even though a police officer is being held by him as a human

shield. When the shocked officer says that he could have been killed, Gerard replies that he does not negotiate – ever. This further convinces the audience of his danger to Kimble and increases the concern for him.

The action takes a new direction when Kimble calls his lawyer. The police are tapping his call and so Kimble unknowingly reveals not only that he is alive, but also his whereabouts.

Kimble needs money so he stops the car of his friend, Dr Charles Nichols, who helps him.

Kimble starts his investigations at a hospital manufacturing artificial arms. We are now on a path aimed at solving the mystery of who killed Helen and why. Thrillers usually need suspense in most scenes so the audience have to be reminded frequently of impending danger. Here there is a scene where a police chief announces that the search for Kimble will be expanded. The mystery of the killer's identity and his motive and the suspense of the search form the prerequisite for the 'proper pleasure'.

Charles Nichols, a good friend of Kimble's from their days as medical students, tells police officers that Kimble is very intelligent and he doubts that they will catch him.

Suspense returns as police officers run into the house where Kimble is staying. Desperately he looks for a way out. The audience, emotionally identifying with him, feel his desperation. But again the story has cleverly misled the audience to anticipate wrongly. The police have come to arrest the son of Kimble's landlord who is accused of drug crimes. So once again Kimble and the audience can sigh with relief. Functionally speaking, this is a form of *anagnorisis*.

Disguised as a hospital cleaner, Kimble enters an office in the hospital to search computer files of patients with artificial arms. A suspicious researcher appears about to enter the room.

Next there is a new *peripeteia*: The landlord's son has recognised Kimble's picture at the police station. Kimble is unaware of this new impending danger but the audience, because of this new piece of information, are in suspense. The police enter Kimble's apartment, discover the hospital where Kimble is searching and the sense of impending danger intensifies.

At the hospital Kimble notices that a doctor has misdiagnosed a boy hurt in an accident and writes a new diagnosis on the patient's papers. The function of this scene is to restate Kimble's moral virtue and so enhance the sense of undeserved suffering, and to increase suspense since it is known that the police are on their way to the hospital.

Kimble succeeds in escaping again and the police realise that he was able to obtain the list of patients with artificial arms.

Kimble goes to a prison to meet one of the men on the list. The audience know that Gerard and his men are also going to that prison. Kimble realises that the prisoner is not the person with whom he fought at the time of his wife's murder, but on the staircase he runs into Gerard. During the chase Gerard shows how merciless he is by shooting at Kimble.

In the following scene Kimble enters the apartment of the next person on the list and from a picture recognises him as the man with whom he fought. As Kimble

searches the photos, he recognises someone else, Alec, the doctor to whom his friend Nichols introduced him the night of the murder. Alec's surname is Lentz. Kimble recalls that it was Lentz's patient whom he was called to operate on that night. He then remembers the other doctors talking about some miracle drug on which Lentz was working. The truth begins to dawn. This moment of *anagnorisis*, as we later find out, is partly misleading. There are more surprises awaiting the audience.

Kimble calls Gerard from the apartment and the police trace the call. Kimble leaves. It looks like the police are now about to catch the real killer. It's a moment of relief.

Kimble calls his friend Charles Nichols and tells him that he knows who killed Helen. He has realised that he himself was the real target of the killing. Lentz, who was heading the RDU 96 experiment, had found out that Kimble knew of the medicine's serious side effects. Nichols tells Kimble that Lentz has died in a car crash and asks him if he is able to prove Lentz's fraud. The audience become suspicious about Nichols' motives when the police show him a picture of Lentz and the one-armed man and Nichols denies knowing them.

Back at the hospital Kimble discovers that Lentz has fraudulently forged Kimble's own reports and that Nichols is Lentz's boss. Gerard simultaneously discovers the same fact. It's a moment of *anagnorisis* as the identity of the killer is suddenly revealed. All remaining suspicion of Kimble's guilt disappears. What was bad has become good.

During discussions among the police officers, one of them discloses that on the night of the crime someone had called Sykes (the one-armed man) from Kimble's car. This is a turning point for the action. It is also revealed that Sykes has fled from the police shadowing him. The mystery of the killer's identity and the motive has been solved. But the suspense continues because Sykes, who has appeared, is now a threat to Kimble. Will justice prevail or will Kimble be killed after all his heroic action?

There is a reversal and recognition in Gerard's action. Gerard's and Kimble's *anagnorisis* and *peripeteia* coincide with each other in order to cause a new turn in the action of the whole movie. Sykes is about to shoot Kimble. Suspense is thus intensified at a moment when rescue appears to be so close. In the incident Sykes accidentally kills a police officer but the Chicago police think that Kimble is the killer. This changes the situation completely and now it is Gerard who is trying to save Kimble in time because he knows that the other police officers will shoot Kimble on sight.

We are approaching the big recognition scene of the movie. Kimble runs into a large, luxurious hotel where a medical conference is taking place, the main speaker at which is Dr Nichols. The Chicago police are following Kimble. Kimble enters the hall where Nichols is giving his speech about his new medicine and he tells the audience that Nichols has forged research data and murdered Lentz. The false hero is exposed but the revengeful Chicago police are still after Kimble.

Suspense is prolonged in scenes where Nichols and Kimble are fighting on the roof and in the laundry where Gerard calls out to Kimble that he knows him to be innocent because it was Nichols who borrowed Kimble's car when the phone call was made to Sykes. Nichols gets hold of a police gun and is about to kill Gerard when Kimble knocks him out and saves Gerard's life. Through cameras flashing, Gerard escorts Kimble into a police car in front of the hotel. In the car he unlocks Kimble's handcuffs.

Finally there is recognition of a victimised hero and the triumph of moral justice. It's a happy end (although touched with sadness in that Helen had died).

The Fugitive is almost the ideal Aristotelian drama in that it totally involves the audience, it brings about intense suspense through a plausible chain of events and catastrophe is avoided at the last moment.

The Fugitive is not only a mystery but also a very effective drama with a great deal of suspense. The audience want to know the identity of the murderer and the motive for killing a beautiful and clever woman. As they are trying to solve this riddle, they are emotionally held by suspense. The riddle is further complicated by the insurmountable-looking obstacles Kimble faces in solving the crime of which he is accused while being chased by the police.

The film creates an intense state of undeserved suffering and ends by achieving moral justice. It has several combinations of *peripeteia* and *anagnorisis* with the most powerful of them occurring towards the end. The action proceeds with alternating misfortune and good luck, suspense and relief. All the events and characters belong to one action. In order to save himself, Kimble has to find the murderer of his wife. This search provides the motive for his actions and all the scenes are causally related, each scene being a reaction to that which happened previously. In this way, events occur by necessity or probability as Aristotle demanded. The logic of the chain of events makes the story credible and brings about the audience's involvement through the emotions of pity and fear. There is impending danger not only at the level of the entire drama but also at the level of individual scenes, most of which contain conflict and suspense.

7.4 Analysis of *Ghost*

Ghost, a blockbuster from 1990, clearly demonstrates how the 'proper pleasure' functions in a movie that is a romantic comedy. At the US box office it took over $200 million and its screenwriter, Bruce Joel Rubin, received the Oscar for the best original screenplay. Like *The Fugitive* it follows many Aristotelian rules and like *Star Wars*, it also closely follows Propp's pattern of popular folktales.

The film opens with a scene when Sam (Patrick Swayze), his girlfriend Molly (Demi Moore) and their close friend Carl (Tony Goldwyn) are repairing Sam and Molly's new apartment. Carl admires the apartment and says that they could sell it tomorrow and double their money. Molly laughs and remarks: 'Carl, you are obsessed.' Carl replies: 'A little bit.'

In the next scene Sam and Carl are on their way to the bank where they work. Carl says that he has taken care of some repairs to Sam's apartment. While walking, Sam tries to read a negotiation memo since he has an important meeting that morning with some Japanese businessmen. When the men pass a beautiful sports car Carl says: 'Oh, man. Look at that Testarossa. Wow!' Sam replies: 'You ought to pay off your Mustang first.' This dialogue hints at a character trait of Carl's that is relevant to the story.

The next scene shows how events must follow each other causally in order to appear credible.

When Sam and Carl arrive at the office, Rose, the secretary, informs them that the Japanese are waiting in the negotiation room. Recently the audience was informed that

Sam was very nervous about this meeting. At the same time, Rose tells them that Andy Dillon called and asks Sam to transfer $900,000 to Albany by ten o'clock. In his haste, Sam does something that turns out to be his *hamartia*.

As Sam hurries to the meeting he asks Carl to make the transfer and gives him his bank code. Earlier scenes have established that Sam and Carl are very close friends, almost like brothers, because otherwise giving the code would not have been believable and without this, the emotional aspect of the story would not work.

The description of Sam and Carl as brothers is important for another reason. According to Aristotle, a crime or betrayal that is committed between friends or relatives creates a more effective dramatic impact resulting in a greater emotional reaction in the audience. Sam being rushed and nervous explains his bad judgement.

The function of the next two scenes is to confirm the attractive qualities of the main characters, create the anticipation of something bad being about to happen, and make credible the ways of solving problems that will occur later.

Two workers are moving a statue of an angel but cannot manoeuvre it through the window. Molly is trying to reach for it when Sam, who has just come home, saves her from the dangerous situation. He demonstrates his resourcefulness and courage by swinging himself out of the window, kicking the statue, which then swings towards the window so Sam and the workmen can grab it. Later in the bedroom Sam reveals that he is superstitious and afraid that as so much good has happened (moving in together with Molly, about to be promoted), he will suddenly lose everything.

Next day at work Sam realises from the computer that there is too much money on one of his accounts and mentions this to Carl. He also tells him that he has changed his bank code. Carl offers to take care of the overpayment but Sam wants to do it himself and doesn't tell Carl the new code. Before Carl leaves the room, he asks what Sam and Molly are planning for the evening. Sam says he is going to the theatre because Molly wants to see *Macbeth*. He invites Carl to join them but Carl declines.

That night when Sam and Molly are walking home from the theatre, Molly says that she wants to marry Sam and wishes that instead of always replying 'Ditto', Sam would clearly say: 'I love you.' Just then a dark figure appears behind them who threatens them with a gun and demands Sam's wallet. He hits Molly who is hysterical. Infuriated, Sam attacks the man. In the fight the gun goes off. The man runs away and Sam dies. (Actually he has become a ghost, invisible to human beings.)

A *peripeteia* has taken place. The direction of the story has suddenly changed its course for the first time in the film. Just a moment ago Sam and Molly's lives were heading for common happiness. Now they are separated and instead of a wedding, there is going to be a funeral. Feelings change from happiness to sorrow. Their falling victim to casual street violence creates strong compassion and pity for their undeserved misfortune. At this stage the audience are unaware that Carl arranged the incident.

The first act has established the story. It has introduced the relevant characters with their key traits: morally good Sam, Molly (the princess) and Carl (the villain, although his function has not yet been revealed to the audience). The helper Oda Mae Brown (Whoopi Goldberg) will be introduced later. This act has also introduced the

relationships of the characters, the situation, the mood of the story and those character traits that will make the later solutions of conflicts plausible. It has also started the identification process for the audience.

At the beginning of the second act Carl asks the bereaved Molly to go for a walk. Meanwhile the robber, Willy, enters her apartment with a key. The surprised ghost of Sam looks at the intruder. Now there is a new riddle: it seems as if Sam did not fall victim at random. What is Willy looking for? Unexpectedly Molly enters the apartment to take a shower. Willy smiles from around the corner as he watches Molly removing her clothes. The audience can sense Sam's emotions when he, as a powerless spirit, watches the scene. The situation is resolved when the cat jumps on to Willy's neck and he runs out of the apartment.

Sam follows Willy home and discovers that someone had hired Willy to rob him. Perplexed, Sam wanders aimlessly in the street and sees a sign 'Spiritual Advisor Shop'. He enters and finds himself in a spiritual medium session. The swindler medium called Oda Mae Brown is actually able to hear Sam. The scene is comical as Oda Mae's client, Mrs Santiago, thinks that the medium is talking to her husband. The audience's superior position affords them amusement whereas Mrs Santiago and Oda Mae's assistants are terrified. This comical scene provides a moment of relief.

At first Oda Mae refuses to help Sam but she eventually relents. There is conflict. It is hard for Molly to believe when Oda Mae says that Sam, as a spirit, is standing right beside her. When Oda Mae says 'Ditto', Molly finally believes her and again there is another moment of relief for the audience.

Sam follows Carl through the streets to Willy's apartment. Sam now solves the riddle. Carl is using the bank's accounts for transferring drug money and has hired Willy to find Sam's new bank code. This is Sam's *hamartia*. Had he not given his code to Carl, he would not now be dead. In this scene the audience realise why there was too much money on Sam's account and what Willy was doing in Sam and Molly's apartment. A minor *anagnorisis* occurs here as suddenly there is insight and the answers to many questions, providing a moment of emotional and intellectual pleasure for the audience.

Molly goes to the police station where she is told that there is no file on Willy Lopez. They do however have a thick file on a well-known swindler called Oda Mae Brown. Molly thinks of her as just a swindler. Sam, having been close to victory, seems to be thwarted.

The feeling of undeserved suffering is intensified immediately as Carl tries to seduce Molly on the couch. Bitter Sam is sitting beside them commenting on the scene. When Carl kisses Molly, outraged Sam knocks a picture off the table. He recalls meeting a ghost on a train who was capable of moving things. Sam looks for this angry ghost and learns the same skill from him. In this way, the ghost in the train gets a relevant function in the story and Sam learning a new skill is made credible.

When Willy comes to kill Oda Mae, she finds herself helping Sam for her own sake. Oda Mae's forged IDs make it impossible for the police and Molly to believe her story. But they do make it plausible that she can easily adopt someone else's identity. So pretending to be Rita Miller, she and Sam swindle Carl out of his illegal money. Carl

discovers that it was Oda Mae who swindled him. The second reversal of the story occurs when Carl threatens Sam that he will kill Molly if his money is not returned. Sam's emotions plummet from a sense of victory to that of fear.

The third act begins with Carl and Willy arriving to retrieve the money from Oda Mae. Willy, frightened by the ghost of Sam, runs into the path of a car and is killed. Sam and Oda Mae rush to Molly's apartment. Once again we have an *anagnorisis*. Molly recognises Carl for what he is, that Oda Mae is speaking the truth and that Sam, as a loving spirit, is standing beside her. Tears flow down her cheeks and many viewers react in the same way at this touching moment of recognition.

But the danger is not yet over. The climax has Sam and Carl fighting. Carl causes his own death and dark shadows appear to take his soul away with them.

In the last emotional scene Sam becomes visible to Molly and Oda Mae. He says he loves Molly, which were the words he was not able to say in his lifetime. They kiss and agree to meet later. Sam disappears surrounded by beautiful light.

Sam's story follows the pattern of the hero's journey. Because of intense undeserved suffering, the superior position of the audience and the logic of the plot, the film creates effective suspense and identification even though the story leaves realism and enters a world of fantasy. The scenes move the story forward efficiently and are closely linked to Sam's intentions.

From an Aristotelian perspective, there is a complex plot with several combinations of *peripeteia* and *anagnorisis* and it also has *hamartia*. The plot functions as a riddle that brings about intellectual pleasure. The strategies of identification and suspense create the desire in the audience that Sam should succeed in achieving his goal. The climax relieves the suspense and the sense of undeserved suffering. On a symbolic level, something important has been learned about love. The writer's choice for *mimesis* has created a sudden insight for the audience into the significance of earlier events. In every respect therefore the film has brought about the 'proper pleasure' and hence its popularity.

7.5 The Resemblance of Tragedy and Comedy

Dramatic suspense is the dominant principle of the romantic movie *Ghost* (will Sam be able to confess his love to Molly; is he able to save her in time; can he fend off the rival suitor; will Carl succeed in his betrayal?), but the humorous scenes skilfully located in the plot give the audience relief from the suspense. They also provide the audience with an opportunity to prepare emotionally for even more suspense to come. Humour also enhances the audience's pleasure in the story and their liking of the characters. Even Shakespeare's tragedies such as *Hamlet*, *King Lear* and *Romeo and Juliet* have scenes and characters whose functions are to create humour and so involve the audience more deeply in the story.

An example of just such a comic scene in *Ghost* is when during the session with the medium, an impatient ghost enters the body of Oda Mae who falls into a trance. The ghost, who is now speaking through Oda Mae's body, asks if his wife Ortisha is present. When the nervous Ortisha arrives there is an increase in suspense. Suddenly there is a terrified look on the ghost's (Oda Mae's) face and he screams at his wife who

has recently dyed her hair: 'Baby, what have you done to your hair?' For most viewers, this surprise causes laughter.

In his book *The Dramatic Experience*, J. L. Styan explains this reaction of laughter as being the release of tension. He refers to a sequence of events namely:

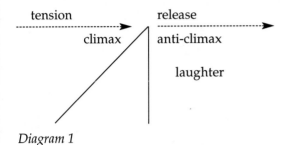

Diagram 1

In the previously mentioned scene from *Ghost*, the atmosphere is at first serious and the events seem to be proceeding towards a dignified outcome. A surprising and illogical comment that is in contradiction to the atmosphere and the audience's expectation causes the audience to laugh.

In *Orientation to the Theatre*, Theodor W. Hatlen emphasises the importance of structure in telling a joke. First the teller has to create expectation in the listener. This produces tension. At the climax, in the decisive line, a surprising reversal results in release from tension, which is expressed as laughter. Without tension there is no release. Just as in drama, the 'proper pleasure' in comedy consists of tension and release.

The difference between serious drama and comedy lies in the opposite nature of the climaxes. In the anti-climax of comedy, dignity is suddenly lost and tension released. In the climax of serious drama, dignity is not lost but found, for example, in the *anagnorisis*, the peasant turns out to be the real prince.

According to Aristotle's definition, tragedy is the imitation of serious and dignified action. He says that the principal difference between tragedy and comedy lies in the characters. In the former, characters are usually shown as being superior to the audience (or to the average person), and in the latter, as being inferior to ourselves. However, in both cases the structure of the plot is the same. Originally the *Poetics* consisted of two books but the second book, which dealt with comedy, has disappeared. All that has remained for future generations is the definition of the difference between tragedy and comedy. This allows us to conclude that tension and release are a common feature in both, the difference being in the nature of the climax and characters.

For instance, in Molière's play *Tartuffe* we laugh as Tartuffe deceives Orgon in many ways. We are amused because the writer has made Orgon blind to Tartuffe's hypocrisy that we can see only too well. This is one of the most important suspense-producing tactics in comedy. The audience want to shout at the characters not to act so stupidly. It is this strategy, emotional involvement between audience and characters that Hitchcock uses to perfection in his thrillers.

In *The Hollywood Scriptwriter*, the writers of *Airplane* and *Naked Gun*, Abrams and Zucker, say that writing a comedy is actually a very scientific process. They spend a great deal of time not only on jokes, but on creating the correct structure and sequence of the story.

Just as in a drama, the audience's pleasure in comedy is brought about by the combination of structure and character. Chaplin, Buster Keaton and the characters in *Some Like It Hot* played by Jack Lemmon and Tony Curtis are lovable and they are inferior to us. The comic effect can also be based upon dramatic suspense in that the protagonists in comedy often have an important goal and serious conflict. The more serious the conflict and the more suspense it produces, the more intense is the audience's reaction in the form of laughter when an embarrassing misunderstanding occurs or there is a major reversal. For instance, if we regard a character as sympathetic, we can sense his excitement when he is preparing for his first date. Then when in the fine restaurant he utters exactly the lines he had been trying to avoid, our laughter is the more intense due to the suspense preceding the disaster. The comic reaction is contributed to by our recognition of the situation in that we can recall our own nervousness in the company of the opposite sex and we can see someone else making the very mistakes we tried to avoid.

Suspense engenders a thriller-like fear as well as laughter. In her book *How to Write for Television*, Madeline DiMaggio tells of two very successful sitcom writers who said that the writer should never try to be funny. Instead, the sitcom writer should create a story with so much conflict and with so many obstacles that it is the situation itself that is funny.

Expressed in the terms of the 'proper pleasure': the stronger the need to achieve the goal, the more complicated the crisis, the greater the misunderstandings and the more embarrassing the situations, the more pleasure the proper resolution will give the audience.

7.6 Hitchcock as the Master of Pity and Fear

Cinema's master of suspense is Alfred Hitchcock. He said that it is possible to achieve almost unbearable suspense even if the audience know the identity of the murderer from the beginning of the movie. Viewers experience a need to shout warnings to the other characters. These strong feelings will induce them to remain watching in order to see what happens to the characters at the end. In other words, Hitchcockian suspense is a combination of intense impending danger and the superior position of the audience.

Hitchcock gives another example to describe the mechanism of suspense. There is a meeting between two people who are ignorant of the fact that a time bomb is planted under the table where they are seated. If the bomb explodes, shattering the room and killing both of the characters, that, says Hitchcock, is surprise. In order to create suspense you need the following elements: the audience must know that there is a bomb under the table and they have to see the ticking clock. Functionally speaking, this is the impending danger that according to Aristotle is an essential element in bringing about fear. Something may yet happen to prevent that explosion because, according to Aristotle, fear also includes an element of hope. Tension is very high when we know that there are just a few seconds left before the explosion and it is increased if

we are also aware that someone is running towards the room hoping to be in time to get the people out.

By having an understanding of the nature of the 'proper pleasure' we can also understand how to intensify the involvement and suspense of the audience: it is to make the viewers care as much as possible about the characters in the room. Were the characters two brutal gangsters, the audience would not feel very much for them because, according to the argument propounded in the *Poetics*, bad characters deserve to be punished. But if we like the characters or if they are morally good, they do not deserve to suffer. Furthermore, if we really care for the characters, the emotion of suspense is intensified. For instance, if the character is a woman with whom we have fallen in love and the bomb explodes just after she leaves the meeting, we can easily identify with her emotions of relief as she realises how close to death she had been. If she dies in the explosion, we feel deep grief as the suspense gives way to feelings induced by the tragic ending of a lovely character.

A good thriller should be able to create a suspense-relief-suspense structure in most of its scenes and sequences with the suspense in each being higher than in the previous one in order to create the pattern of increasing dramatic tension right up to the climax. One of Hitchcock's finest achievements was the film *Notorious* (1946). The story is as follows:

> In a US court a Nazi spy is sentenced to prison. His daughter, Alicia, (Ingrid Bergman) is a fun-loving girl who had nothing to do with her father's activities. One day an FBI man named Devlin (Cary Grant) contacts her and asks her to accept a secret mission. Eventually she agrees and together they travel to Rio de Janeiro. They fall in love but Devlin remains suspicious about the former party girl and keeps a certain distance between them.
>
> Alicia's assignment is to become acquainted with Sebastian (Claude Raines), her father's former friend, whose mansion is the meeting place of high-ranking Nazi refugees. Sebastian also falls in love with Alicia and proposes. Alicia hopes that Devlin will express his feelings for her but when he does not respond, she agrees to marry Sebastian.
>
> Despite opposition by Sebastian's hostile mother, Alicia becomes the new lady of the Nazi house. Devlin asks her to steal the key to the cellar and during a party Devlin and Alicia search the cellar and find uranium hidden in a wine bottle.
>
> Sebastian realises that Alicia is a spy but being afraid that his Nazi associates will murder him if they discover his error, he begins giving Alicia poisoned coffee which will eventually kill her.
>
> Devlin becomes worried when he fails to hear from Alicia so while the Nazis are holding a meeting, he enters the house and finds the seriously ill Alicia. After confessing his love for her he carries her to his car and as he drives away, Sebastian turns timidly towards his Nazi friends who close in ominously.

Inga Karetnikova has made an excellent analysis in her book *How Scripts are Made*[1] of how Hitchcock skilfully created suspense in the film's cellar sequence. This sequence can also be evaluated in terms of the 'proper pleasure'.

As the 'ticking clock' in this sequence, Hitchcock uses the butler who notices that the champagne is running out. The audience have identified with Alicia and Devlin who have a morally good goal (revealing the evil Nazi plot), and they know that the couple are in love with each other although, due to misunderstandings, they are unable to confess it.

Alicia secretly takes the key to the wine cellar from Sebastian and during the party gives it to Devlin. They enter the wine cellar. While Devlin investigates, Alicia stands guard as the party continues upstairs.

Joseph, the butler, counts the bottles. We know that he is considering when he needs to go to the cellar. The suspense intensifies; the clock is ticking.

Alicia hears the sound of glass breaking and rushes to Devlin who has discovered uranium in the broken bottle. Relief is felt as the heroes find what they were looking for but now there is fear of being caught because of the noise.

Joseph realises that there is only one bottle left. He hesitates for a moment and then begins to look for Sebastian. In this way suspense is prolonged. As Karetnikova notes, the author cleverly chose this point to establish the shortage of champagne immediately before Devlin and Alicia produce a mess requiring time to clear it up. This increases the tension.

Joseph informs Sebastian of the need for more champagne. Together they make for the cellar. The audience are now in a state of high suspense as they anticipate the moment when Sebastian and Joseph will reach the cellar.

Devlin finishes clearing up and as they leave the cellar it looks as if the suspense is over. But there is only temporary relief as Devlin and Alicia hear footsteps. What follows next is a surprise: Devlin tells Alicia that he is going to kiss her and tells her to push him away.

Paradoxically Devlin is obliged to tell Sebastian the truth about his feelings for Alicia. Sebastian accepts the explanation but then realises that the key to the wine cellar is missing.

This is another example of how the audience are offered only momentary relief from suspense before suspense starts anew. The audience are held by the anticipation of undeserved suffering and impending danger. The structure of the sequence creates an effect by suspense and relief following each other: the wine bottle falls from the shelf but in so doing, reveals the uranium; Alicia and Devlin do manage to leave the cellar in time but are caught by Sebastian and Joseph; Sebastian seems to believe Alicia and Devlin but then he realises that his key is missing. The events tightly follow the causal logic of reaction and counter-reaction, which makes the situations credible and the plot enjoyable.

Karetnikova also notes that although the search for the uranium was an important element of the plot, Hitchcock said that *Notorious* was actually a story of a man in love with a woman who, in the course of her official duties, has to go to bed with another man and even has to marry him. This film, full of suspense, is in fact a variation of *Romeo and Juliet*.

7.7 Art Cinema

The Fugitive and *Ghost* are movies that are able to create the pleasure inherent in traditional storytelling. The classic Hollywood narrative is only one of many

possibilities. It became a paradigm because it was obviously popular among audiences. But other forms of narrative can be used to provide different kinds of film experiences.

The Hollywood narrative is regarded as having been formed on the basis of the 'well-made play'. This three-act model of dramatic construction was developed in the early nineteenth century by Eugen Scribe and other French playwrights, who tried to please and entertain the easily bored middle-class. The model used several principles of Aristotelian drama such as maximisation of suspense and well-prepared surprises.

As a counter attack against the entertainment that was seen to reflect mediocre bourgeois values, Bertolt Brecht created his own model that intentionally challenged many aspects of the dominant drama form. While the well-made play model appeals to emotions, scene builds upon scene, interest is in what will happen and a climax is sought, the Brechtian epic model tried to achieve exactly the opposite: the drama appeals to the intellect, episode follows episode, interest is in what is happening and a climax is avoided.

In Europe, especially in the 1950s and the 1960s, a group of directors created narratives for films that in many respects were contrary to the Hollywood convention. In these films tight causality of narrative was replaced by a more casual sequence of events. Chance or coincidence played important roles. Characters were often aimless wanderers who did not have motives, goals or clear traits, and behaved inconsistently. These existentialist wanderers expressed moods by static postures or long glances. Landscapes and associated objects were used to express emotions or manifest metaphysical ideas. The endings were open or ambiguous. These film auteurs aimed at personal artistic expression. Their aesthetic came from a literary tradition other than Hollywood.

As David Bordwell notes, art cinema has more interest in character than in plot: 'If the classical film resembles a short story by Poe, the art cinema is closer to Chekhov. Indeed, early twentieth century literature is a central source for art-cinema models of character causality and syuzhet [plot] construction.'[2]

The most powerful art house films are the source of endless interpretation (as is Aristotle's work). They provide pleasure because they can be seen as a counter attack on conservative middle class values or because they provide an alternative way of looking at 'reality'. Some would claim that they even tell the 'truth' about the essence of life. There can also be pleasure derived from a new experience that questions the story schema that is normally used for making sense of stories. These films, it was said, 'make you think'. Such pleasure is as valid as the 'proper pleasure'.

However, art films often provide ambiguous experiences requiring high-level reading that many people do not seek from stories. The majority of people cannot understand the inconsistent realities or accept the pessimistic views as metaphors for life.

But some of the most powerful and popular of the art house films would appear to rely more on the 'proper pleasure' experience than we might think at first glance. I would like to consider two examples from true auteurs of European film: François Truffaut and Ingmar Bergman.

Aristotle in Hollywood: The Anatomy of Successful Storytelling

Truffaut's largely autobiographical *The 400 Blows* (1959) is considered one of the most influential films of the French New Wave. It is regarded as one of cinema's most sincere, lyrical and sensitive evocations of childhood. The film won the main prize at the Cannes Film Festival in 1959.

Typical of art-cinema, *The 400 Blows* does not have a tight narrative structure; there is no clear task or goal. Instead its structure seems rather casual. Unlike Hollywood movies, the film has an open ending in that we do not know what happens to the 13-year old protagonist whom we see running along the seashore as he escapes from a remand centre. These deviations from the conventional construction can allow us to experience the film as more 'real' and believable. Obviously the creator aimed at depicting a 'slice of life' that reveals something universal about being a child. But on taking a closer look, it is possible to see that several narrative strategies have been used that are common to the Hollywood narrative.

First of all, *The 400 Blows* is a story of a series of ever-increasing undeserved suffering for the protagonist: The film begins in a classroom where a calendar-girl picture is being circulated. When it goes to 13-year old Antoine, he is caught by the schoolmaster and made to stand in the corner. Although all the boys in the class committed the same 'crime', he is the one who pays the price. And when he writes his protest against the punishment on the wall, he is caught again. As the story progresses, we realise that Antoine is neglected by his parents (more undeserved suffering and empathy). His mother, Gilberte, is selfish and deceitful and is not interested in her son. His father, Julien, is a weak coward.

The next day Antoine, who has failed to finish his school work, plays truant from school with his friend René. On their way home they see Antoine's mother kissing another man (more empathy and injustice). Later that night Antoine pretends to be sleeping and hears his parents arguing about her late night out with her boss and about Antoine's lies. He also hears that in fact he is not Julien's son (a revelation that causes us to pity Antoine even more).

The following day Antoine excuses his absence the previous day by claiming that his mother has died and he receives much sympathy from the teacher. But later when his parents appear at the school, he is publicly humiliated. (Because of strong empathy, suspense and anticipation, this scene produces a powerful emotional reaction).

Fearing the inevitable punishment, Antoine runs out of school. His parents are worried and when he returns, he is hugged by his mother. But later that night we realise (to our disappointment) that her chief concern is whether Antoine will expose her affair with the other man. The family go to the cinema and have a good time together.

But the next day he is accused of plagiarising Balzac in his essay and is thrown out of school. Afraid to go home, Antoine goes into hiding in the town. To support himself, he and René decide to steal a typewriter from his father's office (we know it's a really bad idea). But they do not succeed in selling it and Antoine is afraid that his father will find out that he took it.

Antoine's *hamartia* is in returning the typewriter. In trying to do a good thing, it turns out to make things much worse for him and becomes the ultimate injustice

because his father decides to report him to the police. Since we know his true motive, we are able to feel sympathy and empathy for him.

Antoine is arrested, spends the night in jail, and is finally sent to a remand centre. He is not allowed to see his friend anymore. He escapes during a soccer game and keeps on running until he reaches the seashore. In the final scene we see him still running.

The ever-increasing injustice to Antoine causes the audience to feel sympathy for the protagonist. Being able to foresee the consequences of Antoine's actions creates anticipation and suspense from which there is only temporary relief before the next reversal. Hope and fear alternate. We want Antoine to be loved by his parents and to succeed, but misunderstandings and bad choices prevent this from happening.

The film does not have a clear goal for the action, but as so often is the case in art-cinema, it is the enquiry into the character's state of being that is the source of suspense and interest. It creates an appealing emotional experience by combining many elements of the 'proper pleasure' with the novelty of deviations from conventional storytelling. Because the film appears more like 'real life' than 'commercial' films, it is capable of bringing about – for some of the audience – a higher level of intellectual pleasure which in turn makes possible a stronger experience of pity and fear. Involvement and identification may also occur because many of us as children might have felt as Antoine did about adults. But does such a film tell the 'truth' anymore than a Hollywood movie does?

The Swedish filmmaker Ingmar Bergman created several dark and pessimistic films in which he investigated human nature. His farewell to film directing was *Fanny and Alexander* (1982) which many consider to be one of his finest achievements. It is a very personal film which offers a reappraisal of the themes and soul-searching questions that had been dominant in nearly all his work but with a more uplifting message than, say *The Seventh Seal*, *Persona* or *Cries and Whispers*.

The film is a haunting family saga set in the early 1900s in Sweden and begins with the Ekdahl family coming to celebrate Christmas at grandmother's house. The first part of the film depicts the family as loving, passionate, eccentric, sympathetic, funny and humane. All the characters are lovable in their own way. Ten-year-old Alexander and his younger sister live in this idyllic, warm world until their father Oscar dies. Alexander finds his father's death hard to bear but becomes aware that he has an ability to see and talk with dead people (like the boy in the film *Sixth Sense*).

After a while the children's mother Emilie decides to marry Bishop Vergerus. We sense that the bishop dislikes Alexander. When Emilie is asked by her husband to forsake her former life, we are sure that Emilie is about to make a disastrous mistake. For Fanny and Alexander this is the beginning of a journey into a dark world.

Our fears are confirmed at the first family dinner in the mansion when Emilie, the bishop's sister and mother argue about how Fanny and Alexander should be raised. We anticipate several forthcoming conflicts.

But things become much worse. The extent of Emilie's *hamartia* is clear when the bishop is revealed to be a sadistic tormentor.

While their mother is away the children are locked in a room. When the housemaid Justine brings them food, Alexander tells her that he had seen the ghost of the bishop's former wife who accused her husband of imprisoning her and the children in a tower. They drowned in the river trying to escape. Justine rushes to the bishop and tells him of Alexander's tale. He reacts strongly and seems anxious and tormented: perhaps this is indeed what really happened.

Suspense is prolonged as we see Oscar, the dead father of the children, telling his own mother that he is worried about Fanny and Alexander.

The next scene is of the children at the inquisition by the bishop. With dramatic and powerful dialogue the bishop breaks Alexander's will and makes him to confess. The profound wickedness of the old man who commits the ultimate sin of disguising hatred as love and lies as truth, is revealed. The bishop then whips the boy because 'it will teach him to love the truth' and continues whipping until Alexander apologises. Finally he sends Alexander to spend the night in the attic even though he knows that the boy is afraid of the dark.

While Alexander is being punished, Emilie visits her former godmother and admits that she has made a terrible mistake by marrying the bishop for she believes her husband is jealous of her son. The godmother advises her to leave him. But Emilie announces that she is pregnant and that her husband has said that if she tries to divorce him, she will lose and he will keep the children. Her lawyer friend had confirmed this. She is trapped and so is Alexander.

Alexander lies on the floor of the dark attic. We can see his complete humiliation in the cave of his deepest fears. He senses something moving and says that he is afraid of ghosts. 'Why do I always see the dead even though I cannot stand it?' And then someone in the dark whispers his name. The dead girls appear from the shadows and tell 'the truth' that they drowned while skating on thin ice and now they have come to scare him so badly that he will be sent to a mental hospital.

Emilie comes home and rushes towards the attic. The bishop's sister tries to hide the key but after a struggle Emilie acquires the key and sees the horrific condition of her son. Emilie says that she hates her husband so much that she could kill him and adds that their child will not be born. This leads the bishop to hold her as a prisoner in the mansion.

This series of events with ever-increasing injustice and suspense has led to a most desperate state of affairs – time for the Ekdahl family to launch the rescue operation. Isak, an old Jewish antique dealer and a close friend of the family, is able to smuggle the children out of the mansion in a trunk. His home and shop is full of mysticism and magic. One night Isak's assistant takes Alexander into the basement to meet his insane brother who magically knows that at that very moment the bishop is burning to death in his house.

Happiness is restored as a new baby is born and the Ekdahl family is reunited and celebrates.

Many questions remain unanswered and at times it is not clear what in the film is symbolism, dreaming, imagining or 'reality'. We are not quite sure how to interpret the experience. Nevertheless, the film does have many tight cause and effect links and

highly dramatic scenes. As a protagonist it has an innocent child who reluctantly has the ability to see dead people and who becomes the victim of unspeakable moral, psychological and physical terror at home. He faces a series of ever-increasing incidents of undeserved suffering and, for the audience, he functions as a source of intense hope and fear. There is a fascinating, complex and credible antagonist who cleverly exploits his social position. And there is the *hamartia* of the mother that was clearly foreseen. The plot structure is a journey from a happy world to a dark world of horrors and then back again.

By combining artistic expression, substantial characters, thematic weight with classical storytelling, Bergman creates a fascinating intellectual and emotional experience which is accessible to a wide audience. This, his last feature film, was both an artistic and a commercial success. *Fanny and Alexander* won Oscars for the best foreign language film, costumes, art direction and cinematography, and Bergman was nominated for best director.

References

1 Inga Karetnikova: *How Scripts are Made*, Southern Illinois University Press (1990)
2 David Bordwell: *Narration in the Fiction Film*, Methuen & Co, London (1985)

8 The 'Proper Pleasure' in Best-selling Fiction

James Patterson is an American fiction writer whose thrillers *Kiss the Girls, Cat & Mouse* and *Along Came a Spider* have appeared at the top of the *New York Times* bestseller list. *Kiss the Girls* has also been adapted for a major motion picture by Paramount. The protagonist of these novels is Alex Cross, a black detective who tracks down twisted serial killers. In an article in *Variety* (November 1997) Patterson, who was chairman of an advertising agency prior to becoming a full-time writer, says that there is only one thing that drives him: he just wants to write a page-turning novel.

In the same article Patterson reveals something very interesting about his working methods. He has test readers who assess his books before they are published. Such 'market research' resulted in a change of the ending of *Cat & Mouse*. The editor had changed the original ending to make it more of a cliff-hanger. A version of the book with this amended ending was sent to the readers who reacted negatively. The feedback resulted in the reinstatement of the original ending that had a definite resolution.

A similar well-known example from Hollywood is the movie *Fatal Attraction*. In the film's original ending the psychopathic character played by Glenn Close committed suicide, but the test audience did not like this, so the ending was changed to the one in which the wife of the character played by Michael Douglas shoots the Glenn Close character. The film was a box office hit in 1987.

Many literary agents claim that amongst the most successful authors are those who are open to suggestions and constructive criticism. Carole Blake, one of Britain's foremost literary agents, says in her book *From Pitch to Publication* that professional authors see themselves as a member of a team that has one common goal: the successful marketing of the author's career. Agents and editors who offer constructive criticism will be welcomed by these writers who realise that they will be the principal beneficiaries.

Even if the writers are not receiving explicit feedback, the most popular ones probably have the reader in mind anyway. In *Bestseller – Secrets of Successful Writing*, Celia Brayfield says that the most successful writers have a very strong sense that when they write they are communicating with someone, an inner reader who responds to their words. This inner reader functions emotionally, giving the author a gut feeling for how the story is being heard and reacted to. Authors express this sense when they say that they write for themselves because their inner reader is formed instinctively. Often it is these writers, whom we see as talented and unique artists, who say that one cannot really learn to write. They appear to be intuitively in touch with the spirit of dramatic storytelling. They know how to intensify the dramatic experience in order to increase the pleasure of their readers. They then have readers – be they agents, editors

or friends – to check and provide feedback in order to further polish their stories, so that all the dimensions of pleasure are brought to their full potential. A similar process takes place in the evolution of classic folktales, but instead of the few months it takes to write a novel, it might take centuries of telling to perfect the story. For those whose instinct is not so well developed, it is possible to learn the nature of this process through an analysis of best-selling novels.

In this book I have already dealt with film, which is a powerful but much younger form of storytelling than the novel. Aristotle assumed that the essence of the story would remain constant despite changes in the medium, such as print or dramatic presentation, or changes in the form, such as direct quotation. In this chapter I shall explore how the 'proper pleasure' is achieved in a novel and how it differs from that in a film. I shall do this by analysing John Grisham's popular novel *The Firm*, which made Grisham a brand name with the promise of a desired emotional experience. This unspoken promise – which he has managed to deliver – has kept his subsequent novels high on the bestseller lists around the world ever since. In the 1990s in the United States alone he sold more than 60 million books, which makes him by far the most successful writer of the decade. Stephen King was the second most successful with 38 million copies, Danielle Steel third (37 million), Michael Crichton fourth (27 million) and Tom Clancy fifth (26 million).

The challenge for a writer of fiction is how to create from scratch the desired reading experience for the reader, how to write a page-turning novel that people just cannot put down. The writer has in front of them three hundred blank pages that need to be filled with a text that millions of people will love.

As discussed in earlier chapters, it is quite possible that we 'know' story structure even before we can read. Stories are part of our DNA. In his book *Human Communication as Narration*, Professor Walter R Fisher argues that all humans are essentially storytellers and all forms of human communication need to be seen fundamentally as stories. From infancy, Fisher argues, we interpret and evaluate new stories against older stories acquired from experience. Later we learn more sophisticated criteria and standards for assessing a story's fidelity and coherence, but constructing, interpreting and evaluating communication as 'story' remains our primary, innate, species-specific 'logic'. Therefore Fisher proposes a reconceptualization of humankind, not as *Homo sapiens*, but as *Homo narrans*.

In *Writing the Blockbuster Novel* Albert Zuckerman describes how Ken Follett starts with the plot. Follett consciously begins his novels by constructing an outline which contains high stakes, larger-than-life characters, a strong dramatic question which creates suspense, a high concept, intense emotional involvement between key characters, and an exotic and interesting setting:

> Follett uses the outline form gradually to enrich and complicate his plot while at the same time to narrow and sharpen its focus. But character is equally crucial. And Follett, from outline to outline, adds and eliminates dramatis personae, as well as their past histories and unique idiosyncrasies – all with a view toward building up the stature of his people, making them interesting, exciting and enhancing our feelings for them.[1]

Follett creates the basic pleasure first and only then is he ready to start writing the book. He knows, intuitively if not consciously, that the 'proper pleasure' is there.

Books about writing successful novels usually emphasise the importance of a basic and clear central conflict in order to create suspense. There needs to be a major unresolved conflict and at least one sympathetic character who is put into a situation of danger. The reader's concern for this character must be maintained throughout the story. The narrative in a thriller needs to be built on highly dramatic situations that lead from one powerful confrontation to another. To sustain the suspense, the protagonist should pass progressively further points of no return, facing greater dangers and increasing pressure.

Like the viewer of a film, the reader of a thriller lives the story emotionally and is looking for a climax, a *catharsis*, which will completely discharge the intense emotions aroused by the story.

Celia Brayfield says:

> With the central characters they [the readers] have made a long and dangerous journey. The climax of the book will make final emotional demands on them, and a period of reso-lution will allow them to gather their strength as well as increasing the feeling of suspense to the maximum.[2]

According to Brayfield the central character of a bestseller must be both a real person and an archetype. As a person this character should be so recognisable that the truth of the story is beyond doubt. As an archetype, this character carries the reader into the emotional experience of the story. In this way the reader identifies with the character and can feel the whole story as if it were a personal experience.

The same idea can be applied to the plot. The writer might start from the traditional, archetypal plot that contains the elements of the 'proper pleasure'. After that the writer can concentrate on making it plausible and realistic.

People have become increasingly demanding in their expectations of stories. Formerly the correct sequence of events might have been enough to create a satisfying experience but nowadays audiences want more 'realism'. Contrary to conventional notions, 'realism' in fiction can be seen as a technique for achieving the desired effect. In her book *Origins of the Novel*, Marthe Robert proposes that storytellers who have been accused of indulging in idle fancies have instead been attempting to produce more believable characters. The result of this is not a substitution of truth for fiction, but simply better disguised fiction. An even earlier theorist of narrative, Victor Shklovsky, claimed that the realism of fiction is a product of technique, not a scientific observation of reality.[3]

With the evolution of culture and increasingly sophisticated audiences, writers in certain genres have been forced to create more believable fictions. It can be argued that the alternative to conventions in literature is not simply a transcript of reality, but better-concealed techniques. This means that the writer who wants to depict unusual actions needs to find plausible reasons for doing so. In *Jurassic Park* Michael Crichton needed something to make his exciting vision of dinosaurs in modern day plausible.

The answer was advanced gene technology. Stephen King's technique is to create a sense of reality by the skilful use of dialogue and details of everyday life, which then makes the impact of horror very powerful. The same principle might also explain the popularity of the 1999 blockbuster movie *The Blair Witch Project*.

Literary theory has traditionally presumed that the story (what is told) exists first and the plot (how it is told) refers to the arrangement of this story material. A BBC documentary or a story in *The Reader's Digest* can indeed work on this basis and the myth of Oedipus did precede the tragedy for which Sophocles created a magnificent plot.

But if we consider this distinction from the point of view of producing narrative, it can be said that a successful narrative cannot be created out of any story; the dimensions of the 'proper pleasure' need to be present. For instance, the story needs the hero's journey (as so often in the stories in *The Reader's Digest*) and if it is not there, it has to be constructed.

Consider James Cameron's *Titanic*. We are all familiar with the true story: on its maiden voyage from Liverpool to New York on the evening of 14 April 1912 the huge ocean liner hit an iceberg and sank with more than fifteen hundred passengers on board. Cameron's audience knew the story beforehand and there had been several films made and books published about the tragedy. Cameron knew that he needed to intensify the dramatic potential embedded in this legendary disaster. So he added a fictional *Romeo and Juliet* story. In this way Cameron made us first care about – even love – some of the characters in the story. Once lured into a beautiful classic story about two young people who have just found true love, the disaster hits the audience with enormous emotional power (although Cameron can be criticised for creating such stereotypical characters). Once emotionally on board, the fear of the bottomless ocean can truly be felt. Cameron clearly knew how to prepare and manipulate the audience to achieve the maximum dramatic impact.

The disaster that befell the Titanic was a reality; awareness of this fact affects the audience's reaction. If we believe (whether or not consciously) that a story might well have happened, we may become absorbed in it in a more intense way.

'Reality' can be used as a component in creating the 'proper pleasure'. Like Cameron, any writer can have a sketch of a story based on an incident from 'reality'. But then the writer starts to add new events and characters according to the collective pleasure principle of storytelling: the narrative might need more dramatic reversals and recognition scenes; the writer might need to add new personality traits to the characters according to the requirements of the plot. The writer shapes the characters to make them more interesting, sympathetic and realistic. For instance, when Patricia Cornwell was creating the character of the forensic investigator Dr Kay Scarpetta, she probably knew that just making her clever would not be enough. So she also made her divorced and childless, experiences that would make her more realistic and empathetic to readers at a deeper psychological level.

Similarly, J. K. Rowling might have sensed that in order for readers to become fully involved in Harry Potter's adventures, she needed the Cinderella beginning. *Harry Potter and the Philosopher's Stone* opens with Harry's intense undeserved suffering: his

real parents are dead and his foster parents make him sleep in a cupboard under the stairs while their own son has two comfortable rooms. Harry is constantly teased by his older nephew and unfairly punished by the parents for no apparent reason. But the readers know that Harry is a special child with magical powers of which he is not aware. Waiting for the recognition scene increases sympathy and empathy for the protagonist. It can therefore be concluded that there is no story material preceding the plot but rather that one of the requirements of the 'proper pleasure' – enabling the audience to identify with the character – affects the creation of the narrative in terms of both character and story.

Although the nature of the pleasure in film and novel are essentially the same, the methods of achieving it differ.

Part of the power of the film *Titanic* is due to the fact that people tend to believe what they see, especially after they have suspended their disbelief. Readers of a novel also need to visualise the fictional world. The fiction writer, like a film director, should create an observable world, a sequence of scenes on the viewing screen of the reader's mind. When readers can see the fictional world, its setting and characters, created by the writer's convincing description of physical details, they are pulled into that world and believe in it. But the picture has to be right. Factual mistakes will destroy the credibility and break the spell of the entire story. Many best-selling writers are very precise about factual detail (Tom Clancy is a good example). In novels, words should do the task of the *mise en scène* in films.

The principle of 'show, don't tell' is important for another reason. By describing in detail what the character sees, hears, feels and senses, the writer can take the reader inside the character's world to experience that which the character is experiencing. This is a way of intensifying empathy and the dramatic impact in scenes. The fiction writer is thus able to create a world with powerful emotions. In film, on the other hand, the camera is being an observer and shows what the character experiences.

The novelist's access to a character's consciousness opens a new dimension for creating tension and suspense. Inner conflict is an efficient way of involving readers emotionally. Apart from the advantage of providing interesting conflict, a character who has complex desires and passions and who can experience guilt and remorse, seems like a real person. If a character seems merely to serve a function in the plot, the reader becomes cynical and the story has difficulty in providing the 'proper pleasure'. Inner conflict is one of the most important strategies for creating intense emotions and for giving a story three-dimensional characters.

The goal of a novel is to provide an emotional experience in which the reader can become totally involved and absorbed. That is why many best-selling novels are dramatic in that they have a structure built on scenes, just as in a film. The scenes should open at the moment when action is already moving towards a climax.

As Zuckerman points out, one efficient way of enhancing the dramatic impact is by the use of multiple points of view. A novel should not have only one central character but several other important characters. By using this technique the author can focus on the character who has the largest emotional stake in any one scene or chapter and can maximise the suspense by depicting their inner conflicts, intentions, doubts, fears and

anticipations. Readers must also be able to understand the villain's point of view in order to make the story believable and more emotionally satisfying.

Dramatic scenes are also useful for delivering necessary information, for instance, in a dialogue between two characters. When readers are emotionally involved, they do not notice that they are actually being informed. By holding the reader in a state of suspense, the writer is able to present several pages of non-dramatic information without losing the reader's attention.

Although novels occasionally hook the reader from the beginning with the presentation of intense undeserved misfortune, it is important to remember that this kind of beginning must be justified and relevant to the subsequent story. However, the first scene should never be too gruesome because this could make the readers feel that they are objects of the writer's manipulation. By focusing too much on the moral level, an unskilful writer can destroy the intellectual dimension and thereby much of the pleasure of the story.

The fiction writer's access to the consciousness of the characters opens up the possibility of creating a higher level of symbolic pleasure in novels compared to films. This compares to the story of the inner journey of the mythical hero. The protagonist needs to face their worst nightmares before reaching the elixir: the self-discovery. This familiar mythological path functions as a model for our lives. In the elementary form of story such as the folktale, it is about beating the dragon or the witch, but in more sophisticated stories, such as 'realistic' novels, it is about the psychological journey and the meeting with inner demons of the mind. If the character does not change and learn from the journey just taken, the pleasure will not be completed.

The advantage of the fiction writer compared to a film director lies in the ability to use inner conflict as a method of providing suspense and tension, and in the ability to explore the hero's inner journey in a more profound way. As with the film director, the fiction writer needs to create a visual, fictional world and the essence of the 'proper pleasure' remains the same. It could be said that a writer of a novel has similar functions to both the writer and the film director.

I should now like to explore how John Grisham created pleasure in his novel which was made into a film starring Tom Cruise.

8.1 Analysis of *The Firm*

We are immediately introduced to the hero of the novel – Mitchell Y McDeere – through the resume being read by a senior partner of a high-profile law firm. We learn that Mitch looks very good, at least on paper. He is a top law student from Harvard and even though he has been given an opportunity to cheat in a crucial exam and declined, he still made the highest grade in the class. He has been offered cocaine, but refused. He is also good at football. His father was killed in a coalmine; his mother is an alcoholic living in a trailer with a violent truck driver and his brother was killed in Vietnam. He is married but his wife's upper-class parents boycotted the wedding.

Right from the beginning we know that Mitch is clever, good at what he is doing and has suffered undeserved misfortune. We can also see in the first chapter that he is very much in love with his wife, Abby. Her function is to be his confidante through

whom Mitch will reveal his human side to the readers and thus make him more empathetic, credible and real.

As the point of view, Grisham has chosen the third-person narration to give the reader access to the minds of a few characters. As the partners interview Mitch for the lucrative job and discuss salary and other benefits, we switch quickly from one mind to another:

> They focused on his lips, and waited for the wrinkles to form on his cheeks and the teeth to break through. He tried to conceal a smile, but it was impossible. He chuckled.

Only after this kind of dramatic tension is created and the reader is hooked does Grisham give the necessary information about The Firm itself. But here and there we learn something mysterious about the company: it has only once hired a woman who was then killed in a car crash. The Firm does not allow drinking and chasing women and no one has ever left the company alive. From these hints readers will realise that something is wrong; and as they start anticipating and guessing, they pay attention to what they are reading. Giving hints is a subtle way for the writer to make readers intellectually and emotionally interested in the story from the beginning.

By giving visual information about the setting and the characters and the inner thoughts of those characters in the interview situation, Grisham is able to create an emotionally powerful, fictional world:

> They sat around a shiny mahogany conference table and exchanged pleasantries. McDeere unbuttoned his coat and crossed his legs. He was now a seasoned veteran in the search for employment, and he knew they wanted him.

We can see the scene and feel the tension. In good novels even the mere physical description is capable of affecting the reader's senses and creating an emotional response.

In the second chapter the narrative continues as Mitch and Abby arrive in Memphis. We are reminded of how successful and talented Mitch is and are given more sinister facts about The Firm. We are informed that the company demands extreme loyalty. Through the wife of one of the lawyers, Abby learns that the company has much to do with the personal lives of its employees. Although Mitch is given these warning signals, he is lured by the lucrative salary, beautiful house and new BMW. The reader is even more convinced that there is something wrong with The Firm and can anticipate that Mitch is about to make a tragic mistake. But it is easy to see why Mitch chooses as he does and refuses to hear the alarm bell ringing.

In the third chapter the readers' fears are confirmed and Mitch's *hamartia* is evident as we learn that The Firm has placed secret microphones in Mitch and Abby's room. We discover that the senior partner and head of security are in fact villains and that they are planning to kill two of The Firm's lawyers who have contacted the FBI. We realise that Mitch's greed for success and money has blinded him from seeing reality. On the other hand it is easy to empathise with him; anyone could have made the same

choice in his situation. Suspense is heightened as we begin to wait for Mitch's *anagnorisis*.

This chapter also reveals the power of dialogue as we realise Mitch's destiny through the conversation between senior partner Oliver Lambert and the security chief DeVasher. Their words have strong dramatic impact and contribute considerably to the telling of the story. Their dialogue in the secret room of the law firm portrays their characters dramatically:

> 'Sex?'
> 'Every night. Sounded like a honeymoon in there.'
> 'What'd they do?'
> 'Nothing kinky. I thought of you and how much you like pictures, and I kept telling myself we should've rigged up some cameras for old Ollie.'
> 'Shut up, DeVasher.'
> 'Maybe next time.'

Sympathy for Mitch and Abby is increased considerably as the men's dialogue shifts to the elimination of the two lawyers and we realise the potential danger for Mitch. Since Grisham has been able to create a fully believable world with many factual details and convincing dialogue, the dramatic impact of this reversal in the story is powerful. Although the writer has revealed the villainous nature of The Firm, many questions remain to be answered: what is The Firm really doing? Why do they want to kill the two lawyers?

When we return to Mitch's point of view in the fourth chapter we see everything in a new light. His thoughts and action are now coloured with dramatic irony: we know that the happy Mitch is in fact approaching his tragic destiny. Soon we learn that The Firm really did kill the two lawyers but made it look like an accidental explosion on a boat. We are still wondering why The Firm would do something like this.

The effect of dramatic irony is intensified as we see Mitch beginning work at 5:30 in the morning and continuing until late at night in order to impress his employers. He is unfairly given a disproportionate amount of complex work for particularly difficult clients even though he should be preparing for his crucial bar exam. Furthermore, since he is unable to spend time at home with his wife, she feels neglected and is becoming lonely and distracted.

The call to adventure comes in the form of the FBI special agent Tarrance who, in the Proppian sense, appears as the helper figure. He approaches Mitch at lunch in a Greek deli and warns him about The Firm. But just like the mythological hero, Mitch refuses to accept the first call. Instead, ironically, he informs his superiors at The Firm about the approach. After this meeting between Mitch and the senior partners, the author changes the point of view and we now witness the villains planning to kill the FBI agent and to provide closer surveillance of Mitch who has made a fatal mistake. The function of changing the point of view here is, of course, to intensify suspense.

Next we find out that Mitch has another brother, Ray, who is in prison for killing a man in a bar fight in self-defence. He directs Mitch to a former cellmate, Eddie Lomax,

who is now a private investigator in Memphis. By visiting his brother, Mitch reveals his brother's whereabouts to the villains. The reader becomes curious when the security chief of The Firm orders a partner to send Mitch on a business trip to the Grand Cayman.

Now we see the hero taking action. Mitch visits the next helper figure, Eddie, and becomes acquainted with his shapely blond secretary Tammy. Mitch asks Eddie to look into the suspicious deaths of the former lawyers. At home, Mitch's marriage is falling apart although we believe he still loves his wife.

On the Cayman Islands where The Firm does much business, Mitch becomes drunk and is seduced by a beautiful local woman. We follow Mitch's inner battle against temptation but on the lonely beach his self-control fails and he makes love to the woman. No one will ever know, he thinks. Although this incident tarnishes Mitch morally in the eyes of many readers, it does nevertheless make him more human and realistic.

On the island Mitch secretly visits the owner of the diving lodge whose son was killed in the boat explosion along with the two lawyers. The visit has the function of providing Mitch with further evidence that the lawyers were actually murdered and also the opportunity of making the acquaintance of the diving lodge owner, who is important at the resolution of the plot. The owner is also a helper figure who has a good motive for helping Mitch, his son having been killed in the same incident.

Under this kind of analysis, it would seem that the author constructed all the necessary motivations and links between characters in order for them to help Mitch resolve the mystery. Eddie and the owner of the diving lodge are somewhat functional figures created for the smooth advancement of the plot. But, by making them real and three-dimensional, the reader's suspension of disbelief is hopefully not disturbed and it is possible to continue following the story in suspense and with curiosity.

Mitch's first meeting with Abby on his return increases our empathy and tension as the author lets us know about Mitch's struggle and feelings of guilt. Mitch pretends to Abby that nothing happened on his trip and thinks he has been convincing. But in the very next scene, the author takes us to the villains' office where we discover the tragic magnitude of Mitch's mistake: they have photographs of Mitch making love to the woman who is in fact a local prostitute. The whole trip was a trap set by The Firm. They now have material with which to blackmail Mitch and we as the audience have something else to anticipate. Our reaction is probably somewhat mixed: Mitch deserves to be punished for being unfaithful, but we can still pity him because he is guilt-ridden (as we did with Shakespeare's *Macbeth*). Furthermore, we love to hate smart villains.

Through Abby we are given more information about the disintegrating marriage and Mitch's exhaustion from the huge amount of work at the office. He has no time for his wife anymore. Mitch is given evidence by Eddie that the dead lawyers were most probably murdered. Mitch tells Abby in a restaurant that their phones are bugged and their home is wired by the law firm, but he does not know why. We also see Mitch going to visit his alcoholic mother whom he only watches from a distance. In the same chapter we are shocked when Eddie is suddenly shot.

On a trip to Washington Mitch gets a message from the director of the FBI and a secret meeting is arranged immediately. The director is the wise old man of the tale

who reveals the mystery of The Firm to Mitch and the readers. We discover that The Firm is a money-laundering front for a notorious Chicago Mafia family. Halfway through the book the mystery is finally revealed and from now on we are in suspense: how will Mitch save himself and his marriage? The director gives Mitch a difficult choice: either help the FBI or stay with The Firm, in which case he will go to prison with the rest of the lawyers when The Firm is finally exposed. If he helps the police, his and Abby's lives will be always in danger because the Mafia never forgets. At home Mitch tells Abby of the insurmountable dilemma and they become allies in fear. This is a very important point in the story because now the protagonist is faced with a crucial choice under huge pressure. How he chooses will reveal his true character. The reader's interest is considerably intensified.

Mitch meets with agent Tarrance in a shoe shop but they are seen by some Mafia men. The partners now become very suspicious and blackmail Mitch with the photographs of the lovemaking on the Cayman Island. They send Abby an envelope containing some photographs. When Mitch arrives home and sees the opened envelope, the author gives us Mitch's reaction:

> His heart stopped first, then his breathing. A heavy layer of sweat broke across his forehead. His mouth was dry and he could not swallow. His heart returned with the fury of a jackhammer. The breathing was heavy and painful.

We can see and experience Mitch's feelings in this scene. Access to Mitch's mind enables the author to maximise the dramatic impact of the scene. When we discover that the envelope was in fact empty, the author again gives us Mitch's inner reactions that would have been difficult to convey in a film:

> He could almost hear DeVasher laughing at this very moment on the fifth floor. The fat little bastard was standing up there somewhere in some dark room full of wires and machines with a headset stretched around his massive bowling ball of a head, laughing uncontrollably.

Soon the narrative informs us that the villains know about Mitch's meeting with the FBI director and preliminary plans are made for Mitch's elimination. Meanwhile Mitch meets again with the FBI and they make plans that are not revealed to us, keeping us in a state of anticipation.

Finally Mitch makes the deal to help the FBI. He will receive a large sum of money and his brother Ray will be released from prison. Now there is no turning back. Mitch has made his choice.

The villains want final proof of Mitch's betrayal and the suspense is enhanced as they discuss a plan to have their source within the FBI confirm their suspicions. They will be notified in two weeks. The clock is ticking.

Tammy, Eddie's secretary, was also his lover, which establishes her motive for helping Mitch. On Grand Cayman she pretends to be a hot babe and manages to enter one lawyer's apartment where there are boxes of secret documents about The Firms's

Mafia clients. With Abby's help she is able to copy them while the drunken lawyer is asleep. The plan, which the readers do not know in advance, works but at the end of the chapter the sense of impeding danger is enhanced again as we learn of a secret telephone recorder in the attic.

There is a meeting of one of the Mafia with the FBI traitor. Since the readers have access to the inner thoughts of the traitor, they know that Mitch has been exposed. But the traitor asks the Mafia man for two weeks to deliver the information. The pace of suspense and action is accelerating.

We learn more about Mitch's plans to acquire secret documents through Tammy who works at night as a cleaner at The Firm. Again, the author has not informed us about this in advance so we are made to put the pieces of the plot together for ourselves. We also learn that Mitch, through Tammy's contacts, intends to obtain new IDs, passports and visas for himself and Abby from a master forger. We also know that the villains have found Tammy's fingerprints on the secret documents.

The action goes into high speed in chapter thirty-four when the FBI traitor exposes Mitch to one of the Mafia in a hotel room. But the FBI catch their traitor immediately and discover Mitch's exposure. The Mafia decides to kill Mitch the same day but Mitch receives warning from Tarrance and rushes out of the office. Since his doubts about the FBI's trustworthiness have been confirmed, Mitch does not reveal his whereabouts to anyone. He puts into action a clever plan that we try to follow and anticipate as it unfolds. He takes the money from the FBI but also devises a plan to obtain ten million dollars from The Firm's account. He sends part of the money to the accounts of Tammy and his mother. Abby is then almost caught in a hotel by the Mafia but is saved by Ray.

Mitch, Abby and Ray hide in a hotel room in Panama City Beach. Both the FBI and the Mafia have launched massive searches to find them. They are checking all the hotels in the area but Mitch, Abby and Ray are lucky in that the man working at the front desk happens to be a small-time criminal and does not expose them to the police. This is a most fortunate coincidence that Grisham was obviously not able to work around. It disturbs the plausibility of the plot but we are now so involved in the high suspense action that the story can survive this flaw. Mitch has been videotaping himself in the hotel room and after some delay, we find out that he has made fourteen cassettes of witness material for the court.

After some action in which the three heroic figures are almost exposed, we are informed about the climax of their plan: during the night they go to the beach and give light signals to a boat out at sea. But the Mafia suspected that the group would try to escape by sea so they have their men waiting on the beach. One of them attacks Abby but Ray hits him and then deliberately drowns him. This is an unnecessary killing and detracts from our feelings of sympathy for the main characters.

Now Mitch's plan is fully revealed to readers: for the rest of their lives they will live in the Caribbean hiding from both the FBI and the Mafia. There, sitting under a palm tree drinking rum punch, they read newspaper reports about the indictment of The Firm's lawyers and the Chicago Mafia family. Mitch now has all the time in the world for his wife and they decide to have a baby.

The Firm became a huge bestseller and made John Grisham a brand name whose subsequent novels sold in millions.

The suspense in the novel comes from its structure of dramatic scenes and the serious impending danger for a character for whom we feel sympathy and empathy. The narrative constantly informs the reader of what it is that the characters want and the danger that lies ahead.

Grisham skilfully creates a visual world and then intensifies the emotional power of many scenes by giving us access to the characters' inner tensions, doubts and fears. The overlapping of various points of view functions to enhance the suspense and the emotional stakes. We are constantly concerned about the character who finds himself and his loved one in a predicament facing seemingly insurmountable obstacles. We want to know how he will resolve this situation. We celebrate when we realise that the underdog is able to fool and beat the two large organisations, which thought they had the better of him. The villains of the story, the criminal lawyers, are not one-dimensional, because from their point of view they had no choice: they had been lured into The Firm when they were young and innocent. But they had not had the courage of Mitch and instead had sold their souls and had let themselves become part of the conspiracy. This we can easily understand: to protect themselves and their families and to earn big money. But in so doing they had become murderers.

Access to Mitch's mind enables the writer to present him as a dynamic character who has conflicting emotions and desires. His occasionally inconsistent behaviour helps to create the impression of being a real person but at the same time it is used as a way of intensifying suspense and empathy. In having the factual details correct about law practices and settings and by making the dialogue naturalistic, the writer enables us to see and believe in the world he has created.

Finally Mitch, the protagonist, has to make a critical choice, which changes him from a man greedy for success and money into the ultimate husband with all the time on earth for his wife and family on a beautiful tropical island. It is a new start in life with new values. But the ending contains both good and bad in that we know that they will never be totally safe.

There is one element in the plot that adds considerably to the page-turning power of the novel: the protagonist's *hamartia* and the plot structure which enables the reader to witness the sequence of fatal choices with dramatic irony as in *Oedipus Rex*. This sequence creates an intense state of undeserved suffering and provides a moving reading experience on an emotional, intellectual, moral and symbolic level.

With *The Firm* the publishing world came to the same wrong conclusion that Hollywood does so often. It thought that people now wanted legal thrillers. But that was not the case. They were no more interested in law than before. It was just that John Grisham had been able to tell a truly dramatic story and had given the reading audience an experience of the 'proper pleasure'.

8.2 Suspense of Love

Mainstream novels, when compared with genre novels, use the same basic story pattern but they are more complex and sophisticated. Like *The Firm*, mainstream

novels have greater moral ambiguity, many more factual details, and characters who are more three-dimensional. Consequently, the overall impression is that such novels are more realistic than genre novels.

In *Adventure, Mystery and Romance* Professor John G. Cawelti argues that the adventure story is perhaps the simplest fantasy archetype. Appearing at all levels of culture, it seems to appeal to all classes and types of person, and particularly to men. He claims that the feminine equivalent of the adventure story is the romance with the moral fantasy being that love, triumphant and permanent, overcomes all obstacles and difficulties. The romance has become one of the most popular genres.

Canadian Harlequin and British Mills & Boon publishing houses do not advertise their authors but instead, their brand name. According to one study, eight out of ten British women recognise the name Mills & Boon. Aimed at women, these novels are very formulaic, romantic stories each of which brings about exactly the same kind of emotional experience. There are about 200 million such experiences sold every year, many women buying dozens of the novels annually. The books have a standard story pattern with only the characters and settings changing. If the story were told differently, without the lovers winning each other, there would be many disappointed readers. Obviously the emotional experience brought about by the Harlequin formula is so appealing that millions of women all over the world want to repeat it over and over again – just like the little girls who love the retelling of the story of Cinderella or Snow White.

Like the fairy tale or hero's myth, the Harlequin or Mills & Boon novel is a story of self-discovery with a suspense structure. What is applied to the Mills & Boon novel is Lubbock's Law – deriving from the literary critic Percy Lubbock – which states that stories should be written from the heroine's point of view, enhancing reader identification and heightening suspense. Experience also shows that first-person narratives are not liked among readers. Surprisingly few differences have been found between readers in different countries. The only significant difference between readers in Europe, Asia and Africa, is mainly related to the notion of what constitutes a romantic background rather than the plot itself.

In her book *Reading the Romance*[3] Janice A. Radway has analysed the narrative structure of the ideal romance:

1 *The heroine's social identity is destroyed. She is removed from a familiar, comfortable realm usually associated with her childhood and family. The details are different but the mood of the romance's opening pages is nearly always set by the heroine's emotional isolation and her profound sense of loss. She is stripped of her sense of herself as being of a particular place with a fixed identity.*

This sounds very much like the beginning of the Cinderella tale. From the point of view of the 'proper pleasure', the function of the start is to create sympathy and empathy. Psychologically this represents the beginning of the hero's journey on a quest for the lost identity.

Making the heroine resemble an ordinary woman often enhances identification, at least to some extent. She might be beautiful, but not perfect; her eyes are too close or

her mouth is too wide, or her face is slightly bony. Her former love affairs have been unhappy. If she has talents, she does not recognise them herself. She underestimates herself in many ways. The events in the novel, however, will show that she is able to bring about a wonderful, passionate love.

2 *The heroine reacts antagonistically to an aristocratic male. Aristocratic in this context means a man who is handsome, bright, courageous, rich and desired by many women.*

This is of course the refusal of the call. It is the start of the reader's anticipation process, it being obvious that the man and woman belong with each other.

3 *The aristocratic male responds ambiguously to the heroine.*

The man is the mystery in the narrative, the puzzle demanding a resolution. This is where the obstacles start to mount. In folktales and adventure stories the obstacles are typically physical, but in romances these suspense-producing difficulties are doubts and misunderstandings.

4 *The heroine interprets the hero's behaviour as evidence of a purely sexual interest in her.*

In Propp's folktale pattern, the sincerity of the male's love was tested before he was able to save the damsel. Similarly Cinderella at first runs away from the prince and makes him search arduously for her and prove the moral purity of his interest in her.

5 *The heroine responds to the hero's behaviour with anger or coldness.*

As Radway points out, the narrative structure often allows the reader greater knowledge of the hero than the heroine possesses. Because readers are given access to his true feelings and intentions by omniscient narration, they can reinterpret the action in functions 4, 5 and 6. Readers know that the man's ambiguous behaviour is actually caused by the emotional turmoil prompted by his feelings for her.

6 *The hero retaliates by punishing the heroine.*

Here we often meet a rival female figure who in the Proppian sense functions as the villain or false heroine of the plot. She is naturally a master in the art of seduction. There are many variations on the theme. For instance, the rival female might join the hero on a journey and send out invitations to their forthcoming wedding as Francesco Alberoni demonstrated in his book *L'Erotismo*.

7 *The heroine and the hero are physically and/or emotionally separated.*

The success of the rival and the distance from the man convinces the heroine of her own defeat. She gives in, sinks into despair and disappears.

8 *The hero treats the heroine tenderly.*

After the crisis there is hope and a reversal for the better.

9 *The heroine responds warmly to the hero's act of tenderness.*

10 *The heroine reinterprets the hero's ambiguous behaviour as the product of previous hurt.*

Actually the heroine is convinced that he does not love her. It is only about sympathy, friendship or even adventure. So once again the woman withdraws, protects herself, promotes a quarrel and leaves. This causes obstacles for the man who is in fact deeply in love. It is a double misunderstanding. The reader knows they are in love with each other but they both think that their love is not returned. The story unfolds like a detective novel with a suspense structure and dramatic irony. The heroine finds out that the man is married to an attractive woman. Or the man leaves the heroine alone in the middle of a dark forest. Or it may happen that the heroine finds the man in bed with the rival female. Or she finds other woman's clothes in the man's wardrobe. As in the formula of the detective story, everything points to the man's guilt. This serves the same function as in Propp's folktale pattern where the hero's rescue by the witch was followed by betrayal at home and separation from the maiden. In the romance genre the suspense is prolonged and intensified: all hope is lost at the moment when happiness would appear to be so close.

11 The hero declares his love and demonstrates his unwavering commitment to the heroine with a supreme act of tenderness.

At the same time, the heroine realises that the man was innocent. He had never been romantically interested in the other woman. He had never been married. Yes, he had abandoned the heroine in the forest, but only in order to get help. Everything had been one huge mistake from the beginning. It is the final recognition scene.

12 The heroine responds sexually and emotionally.

13 The heroine's identity is restored.

From this pattern we can conclude that the reader becomes involved in the narrative through identification and suspense. The recognition scene at the end brings about relief and pleasure for the reader and symbolically demonstrates the way to harmonic life as the man and woman unite. In her study, Janice Radway found that many women who read the romances identified very easily with the loss and emptiness that

the heroine experiences at the beginning of the story. The state of being ignored by others is an emotional state difficult for women to bear. She compares the standard story of the romantic heroine to the pattern of female personality development studied by the psychoanalyst Nancy Chodorow in *The Reproduction of Mothering*, and says that there is a remarkable similarity between them. If the romance formula is an account of a woman's journey to female identity (within a patriarchal society), it is easy to understand its appeal on a symbolic level. Basically the heroine of the romance is the folktale's damsel in distress (although more active), for whom the ideal hero is prepared to sacrifice everything.

The Harlequin and Mills & Boon books are only read by women. Folktales, on the other hand, are possibly able to provide an object of identification for both genders. In his book *Men are from Mars, Women are from Venus* Dr John Gray claims that in a relationship man wants to be admired by the woman for his deeds, talents and unique characteristics. He wants to be needed. A woman on the other hand wants devotion from the man. In addition, women want caring, understanding and respect. Men want trust, appreciation and admiration because deep inside, every man wants to be his woman's hero or knight in shining armour. The signal that he has passed her tests is her approval. If Gray's analysis is correct it is easier to understand why Propp's folktale pattern is psychologically satisfying for both genres.

A Mills & Boon novel is a promise of a certain kind of an emotional experience that is familiar to many readers from earlier books of the genre. The heroine is morally good but not perfect, and in many ways she psychologically resembles her readers. On her journey from emptiness to acquiring a new identity, she meets several obstacles and, in the form of many misunderstandings, becomes a victim of undeserved misfortune. Suspense is prolonged and heightened until the moment of total despair. Then suddenly there is a reversal and recognition as the man confesses his love. The moral justice and happy ending bring about considerable pleasure for the readers who have suffered in empathy with the heroine. A Mills & Boon novel is also a mystery: the riddle of the story is the man; his emotions, intentions and behaviour are objects of constant surmise because the tale is told mainly from the woman's point of view, (although the reader often knows more about the real intentions of the man).

A romantic story can create a much higher level of suspense than an adventure story or a thriller. This is because suspense depends upon our caring for the characters and our emotional support for them in achieving their goals. A manly adventure novel or film that concentrates mainly on violence and high-speed action but lacks empathetic characters is unable to create such suspense.

The storytelling strategies of contemporary bestseller writers are nothing new; they were already being used in ancient Greece. One of the earliest extant novels is Chariton's *Callirhoe*. Professor Maarit Kaimio has shown how this writer created suspense and anticipation.[5] For instance, he gives the reader true or false clues, or clues which prove to be true in a way other way than expected. Reader superiority is used to create dramatic irony, as for example in Chaereas' farewell monologue before his attempted suicide because Callirhoe loves another. Here readers are fully aware that

Callirhoe does indeed love Chaereas. The scene also creates empathy and pity for the unhappy, heartbroken hero.

When Chaereas falls to the ground in shock and grief on hearing of Callirhoe's alleged infidelity, readers are aware that it is untrue and they feel secret gratification knowing that things are not as bad as they seem. During many other changes in fortune for the characters, the author informs readers about the true state of affairs of which the characters are unaware. Sometimes they are made to share the distress and uncertainty of the hero, particularly when dealing with the great moral dilemmas faced by the characters. For instance, Ataxerxes' conflict between his love and his position as the supreme judge: he cannot act against his own laws. Chariton also uses readers' access to the minds of his characters in order to express contrary emotions and create inner conflict.

Professor Kaimio concludes that the emotional pleasure brought about by this early novel is quite similar to the pleasure found in ancient Greek tragedy. This novelist obviously knew how to use narrative techniques in order to create the emotional reactions he desired for his readers. Successful contemporary writers usually do the same.

References

1 Albert Zuckerman: *Writing the Blockbuster Novel*. Writer's Digest Books, Cincinnati, Ohio (1994).

2 Celia Brayfield: *Bestseller – Secrets of Successful Storytelling*. Fourth Estate, London (1996).

3 Wallace Martin: *Recent Theories of Narrative*. Cornell University Press, Ithaca and London (1986).

4 Janice A. Radway: *Reading the Romance. Women, Patriarchy and Popular Literature*. The University of North Carolina Press, Chapel Hill and London (1984).

5 Maarit Kaimio: *How to Enjoy a Greek Novel – Chariton Guiding his Audience*. ARCTOS. Acta Philologica Fennica (1996).

9 TV-series and the 'Proper Pleasure'

The moral dimension of the 'proper pleasure' has an important role in any episode of a television series. If an empathetic character is on the point of entering a room in which a bomb is about to explode, the audience want to see what happens next. Only when the scene is over with a happy ending can they walk away from their television sets. But if you are the programme maker, that is exactly what you do not want to happen. You want to stretch that type of audience response throughout the entire episode, to keep the audience in a state of undeserved suffering for as long as possible, not to be released from the suspense until the climax.

Columbo is a detective series that has been very popular in many countries. It is not however a typical detective series because the identity of the murderer and the manner in which the crime was committed is known from the beginning. But there is a great deal of identification and suspense because we want to see the moral order restored: the sympathetic underdog detective catching the arrogant criminal who thinks he has committed the perfect crime.

In a television series this desire of the audience to witness moral justice can be exploited in another powerful way. In the analysis of *Romeo and Juliet* it was shown how the suspense was intensified as the play progressed. As in a blockbuster movie, the play followed a tension-release structure. If the play had been a television series, individual episodes would have ended at points where the audience were most eager to discover the outcome. We want and need to know how a crisis is resolved in order to sigh with relief.

In his book *Screenwriting*, Professor Richard Walter gives an excellent example of the meaning of release from tension:

> A tale, no doubt apocryphal, is told of the young Mozart. Like most teenagers, he liked to sleep late. And like most teenagers' mothers, Frau Mozart forever nagged him to arise. On a particular day when he was especially reluctant to stir, she conceived a brilliant notion. Instead of poking his ribs and scolding, she hurried downstairs to the harpsichord and played an incomplete scale: *do, re, mi, fa, so, la, ti...Ti?*

> The sequence hung motionless in the air, aching to be resolved, the tension had to be relieved, the score settled. The octave had to be struck resoundingly. Anybody with ears would have been eager for the resolution of that incomplete scale but for one so keenly attuned as young Wolfgang, it represented a special agony. He leaped from the bed, took the stairs four at a time and struck the final, calming *doooo*, sighing, no doubt, with monumental relief.

In a television series the audience's need for relief from tension and suspense can be exploited by ending each episode with an intense cliff-hanger. This will oblige the

audience to return for the next episode seeking intellectual and emotional relief. But naturally a skilful producer will give the audience only temporary relief.

With a continuing serial, the audience can be kept in a state of undeserved suffering for weeks, months or years. There is always the promise of moral justice that is never quite achieved. For *Moonlighting*, the hit series of the 1980s, the ratings were very high until Maddie and David made love, whereupon the ratings fell dramatically. There was no longer any romantic tension at the personal story level. The same principle can be applied to undeserved suffering.

As Jürgen Wolff and Kerry Cox say in *Successful Scriptwriting*, it is important in any television series to give the protagonist a goal, whether it be solving a case, finding a missing person, or avenging the death of a partner. The rest of the episode should be about making the achievement of that goal as difficult as possible.

Like any other good story, an episode of a television series follows the classic drama's arc of rising action, this main arc having smaller arcs representing smaller conflicts. As one conflict is resolved, there is always another, greater one waiting. After experiencing joy and relief, the audience are ready for the next conflict and being better acquainted with the characters as is possible in a series, they will be even more interested in the outcome of events. Further on in this chapter I should like to demonstrate how this works in a sample episode of the highly popular American series *ER*.

Television serials are ongoing programmes in which the stories continue into the following episode. Television series, on the other hand, are programmes in which the main characters appear in each episode but the stories are different each time. In a series the nature of the pleasure is similar to that derived from movies; the viewers return each week because they know the programme will give them pleasure.

Touched by an Angel is an episodic series that has become a hit in the United States. In each episode a beautiful angel comes to different people as they face a crisis and helps them find the right way. The episodes deal with subjects such as marital problems, relationships between mothers and daughters and alcoholism, all matters that are familiar to us from real life. In the series they are dealt with through dramatic structure. The angel does not interfere with the destinies of the desperate characters but she shows them another way. Her message is that every person's life is meaningful and each of us can be forgiven. In the recognition scene at the end of each episode audiences have been moved to tears. If the episode has provided strong pleasure (emotional, intellectual, moral and symbolic), the audience are likely to return the following week with the expectation of the same kind of experience. Then, if the following episode doesn't bring disappointment, the beginning of a loyal audience has been established.

Similarly, small girls want to hear the story of Cinderella repeatedly and older girls buy every new Danielle Steele novel. Pleasure motivates the audience to use their time to watch the programme each week and that is why the format of the series should stay the same.

If a television series can make us love the protagonist, care for the other characters and provide a happy ending through its suspense structure, then emotional satisfaction occurs. The pleasure is even stronger if the story has a crucial riddle that is surprisingly

solved by an insight at the end of the episode. And if we have learned something relevant about our own problems, time spent watching a television drama does not feel like time wasted.

One of the most popular television formats is the ongoing melodramatic serial, the soap opera, which has an ensemble of characters and allows for the possibility of a multiplicity of conflicts and relationships with several storylines going on at any one time. Suspense is maintained by overlapping the stories of different characters and by using techniques of interruption and delay.

Soap operas can also effectively create suspense by making the audience aware of the intentions and counter-actions of the antagonist. An episode of *The Bold and the Beautiful* opens with a scene in which Sally, the caring mother, is gently talking to her baby, telling him how much she loves his father. The next scene shows her husband, Clarke, by the pool with Kristen with whom he is discussing his deceitful plans. The audience want to warn Sally of the threat of undeserved misfortune but not being able to communicate that information, is captured by the desire to see how the matter is resolved for her.

The beginning of this episode sets the timer on the bomb ticking: from the dialogue between Clarke and Kristen we find out that in a couple of days Clarke and Sally will have been married for two years and that Clarke will then be entitled to half of Sally's substantial property. Clarke then intends to divorce Sally and marry Kristen. There is an innocent victim and a villain, as in many folktales, and the audience are made aware of the villain's evil plans.

Marriage with Clarke is Sally's *hamartia*, tragic error. She receives warnings of her husband's betrayal but does not take them seriously. When finally Sally becomes suspicious and is about to call her lawyer, the audience are ready for a sigh of relief since the villain is about to be punished. But at the last moment there is turn of events when Clarke gives Sally a gorgeous necklace and tells her that the reason he disappeared the previous night was to buy it for her. Undeserved suffering has returned and now the suspense is even greater because justice had been so close. Undeserved suffering, impending danger and the audience's omniscience are the elements that involve viewers and create the desire to know more.

In his office Clarke phones Kristen but he does not know, as do the audience that one of Sally's employees is also in the room. This leads to the episode's big recognition scene in which the employee tells Sally what she heard Clarke say on the phone. At first Sally does not believe what she is told but eventually she has to recognise that her husband is dishonourable. *Anagnorisis* is followed by *peripeteia* as Sally contacts her lawyer who confirms that Clarke has to commit adultery in order for the marriage to be dissolved. Time is running out so Sally starts to plan how to catch Clarke red-handed and this is where the episode ends.

Tension for the audience is intensified by overlapping several similarly structured storylines in any given episode. For instance, one storyline is about a male character who is trying to keep secret that he is simultaneously dating two women. He does not know that these women are mother and daughter but the audience are aware of this dramatic irony and do not want to miss the recognition scene. Often the audience are

allowed to sense that a romance is doomed but suspense is enhanced by allowing the romance to advance further.

According to the principles of the 'proper pleasure', merely having the correct suspense structure is not enough for the audience to experience suspense. The audience also need to care for the characters or sense that the crisis is familiar from their own experiences. The undeserved suffering in soap operas and in many hour-long drama series usually deals with the ups and downs of relationships. This is also cost-effective in that it does not require big budgets and special effects. What it does require are good scripts.

It has been said that soap operas have broken the Aristotelian notion of the three-act-drama. This is not true. Soap operas just delay the third act, sometimes even for decades. The audience are constantly kept in the second act. *Touched by an Angel* offers a resolution and high emotion at the end of each episode and it is this pleasure and the promise of its recurrence that brings the audience back the following week. In daytime serials, on the other hand, the constant expectation of the climax and moral justice are what make the audience return. The serials offer us temporary relief as some storylines come to satisfactory ends; however, at the same time there are other stories whose resolution we want see but we are kept in the second act. So we are never offered the final and complete moment of relief that would enable us to stop watching.

Television programmes like the American soaps *Touched by an Angel* and *The Bold and the Beautiful* seem rather naive and unbelievable on the surface. The former is about angels on earth and the latter about rich people in cardboard scenery. In her empirical study *Watching Dallas*, Ien Ang discovered that audiences watch serials for their 'emotional realism', their underlying reality, and it is of no consequence if the events, characters and action are unrealistic at other levels. In these programmes people recognise something meaningful for their own lives: they are attracted to the psychological appeal of the hero's journey. From daytime serials viewers are able to recognise the same fears, problems and hopes that they face. They want to see how these characters succeed in attaining love, harmony and balance in life, and how they react and deal with familiar problems.

If a serial has a fascinating villain in addition to sympathetic characters, then its appeal will increase considerably. When we watch Shakespeare's *Othello* we want to see Iago's evil plans exposed before it is too late. Shakespeare was a master at making his villains human and understandable. Iago's motives are obviously jealousy and envy, traits that we all recognise and usually dislike within ourselves. In recognising our own dark side in Iago, he is made to seem human, not just one-dimensional. Possibly it was for the same reason that audiences all over the world found Dallas' JR character so fascinating. But whether it is a play by Shakespeare or an American daytime serial, the story appeals to us if it has characters we care about and those whom we dislike.

9.1 Analysis of *ER*

The medical drama *ER* was the most successful series on American television in the 1990s. It was created by Michael Crichton who was also the executive producer with

John Wells. *ER* depicts life in the emergency room of a large Chicago hospital through the personal lives of key members of its staff: Doctors Greene, Ross, Benton and Carter and Nurse Hathaway. The staff are underpaid and the work is extremely demanding, dramatic and full of surprises. An emergency room offers an excellent frame for an exciting series full of action. It is easy to overlap individual stories and to move fast from one life-or-death crisis to another. The hospital environment is credible and interesting because we can easily identify with it and with the fate of the patients. We appear to have a great need to see how people deal with these extreme crises.

The doctors in *ER* are particularly sympathetic because they are underpaid and undervalued heroes of modern society, saving people in a city hospital and never really receiving the recognition they deserve (from their bosses, spouses or relatives). People who commit their lives to saving other people and can reject large salaries and other symbols of success are true heroes earning our admiration. However, other people's reactions and the protagonists' personal flaws keep them from being happy. They are heavily criticised by their bosses, they have marital problems and they do not find personal fulfilment and harmony. And yet they can save other people and bring happiness to them. They are like fairy godmothers but they are not able to achieve happiness in their own lives. We react to that with sympathy and empathy and support their desires, dreams and actions. The doctors of ER can be compared to the omnipotent gods of ancient Greece who had their personal flaws and miseries, their stories being the prime-time series of that era.

Not only should the main characters be loveable, fascinating, empathetic and three-dimensional, they should also have flaws so that they are more credible. It is in conflicts that these character traits are revealed: character is action and action is character. When we see the doctors of *ER* under pressure and in action, we learn about their heroism; but when they make mistakes in their personal lives, we can empathise. Because we care about them, we want to spend time week after week with them.

Another reason for *ER*'s popularity was its ability to combine two forms of the 'proper pleasure'. Firstly it offered the episodic pleasure like *Touched by an Angel*, with its stories related to patients, and secondly, by having the continuing personal stories of the doctors, it created the expectation of pleasure, like the daytime serials, to come in each subsequent episode.

By analysing one episode of *ER* scene by scene we can see how the different levels of the 'proper pleasure' – the emotional, intellectual, moral and symbolic – function effectively and in so doing, provide a satisfying experience for the audience. The episode *The Gift* is from the first season of *ER* in 1994. It was written by Neal Baer and directed by Felix Enriquez Alcala.

Montage of Recent *ER* Clips
The function of this 'teaser' is to remind viewers of the most dramatic events and turning points that are relevant for the day's episode.

1. ER Lobby

Carter wakes an Afro-American Father Christmas who has come to hospital suffering from dizziness. The man realises he is keeping children waiting so even though Carter tries to prevent him from doing so, he leaves.

The beginning awakens our interest because it entails a contradiction and comical situation in the form of a snoring, black Father Christmas. It also introduces the theme of the episode that is Christmas. Today's audiences are so television literate that they know Father Christmas will return. Thus the first expectation has been established.

2. Hallway

Dr Mark Greene complains to Dr Susan Lewis that he can never think of any good Christmas presents for his wife. Last year he bought a dust buster. He says he has to have time to go shopping today. Lewis says that she can cover for him. Greene asks if he can borrow her car but she says her sister Chloe has taken it. Nurse Lydia informs Dr Peter Benton about an incoming head trauma and also announces a patient coming in with electrical burns and a dizziness attack. Jerry gives Lewis a gift from 'a secret Father Christmas'.

From earlier episodes viewers recall that Greene is not very perceptive about women. This characteristic, of which the audience must be reminded occasionally, makes him seem vulnerable so that we feel more sympathetic towards him. We want him to succeed in buying something more appropriate than a dust buster. Again we have something to which we can look forward. The scene also reminds us of Lewis' loyalty. Lydia's communiqué creates an expectation of the medical cases to be dealt with in the episode. The scene also sets up an interesting mystery: who is the secret Father Christmas?

3. Hallway – Dressing Room – Trauma Room

Greene grabs his coat and passes the desk. Jerry offers him a sweet. At this moment a man carrying a boy in his arms rushes in shouting: 'Please help me, my son is dying!' Greene takes the child and reports: nearly drowned, frozen. Resuscitation begins with full force. The father gives an account of what happened. It looks critical. He recites Ave Maria beside his son and prays that his son will not be taken from him.

This is obviously a case of intense, undeserved suffering. We feel pity for the loving father. Losing his child would be a morally undeserved misfortune and we want to see the situation resolved. One of the possible reasons for the popularity of *ER* is that the happy ending does not always take place. Since the father and the son are not main characters, the death of the son would not affect the series. And yet we would feel a strong sense of grief about his death because it is easy to empathise with the father. The fate of the father and son becomes one of the most suspense-inducing storylines of the episode and overlaps with other storylines and it is not until the end of the episode that we find out what ultimately happens to them.

The minor events preceding this major crisis were important because they allowed the audience to tune into the fictional world. If the father had rushed into the room in the first scene, the audience might have had some difficulty in orientating themselves to the situation. As a general rule, it is important to have a case of undeserved suffering near the beginning of an episode of any television series because it is efficient

in capturing the audience. This is even more important in television than in movies because television audiences can easily switch channel if they are not interested.

Opening Credits

These credits appear after the episode has hopefully established the intense undeserved suffering and the audience have been emotionally hooked.

4. Kitchen – Hallway – Trauma Room

Nurse Carol Hathaway takes bags from a microwave oven and hurries into the examination room where the nearly drowned boy is being resuscitated. His condition is critical.

The audience know that time is running out. Once the audience have been reminded of the gravity of the boy's worsening situation, the episode can move to the next storyline.

5. Helicopter Landing Area

Dr Peter Benton and Dr Carter rush to the helicopter. A rescue team member reports on the condition of the patient, a young man who has driven a snowmobile into a tree causing brain damage resulting in coma.

More suffering. This time we do not know much about the patient so our emotional connection to him is not particularly strong. In this storyline the patient merely becomes part of Dr Benton's episodic story.

6. Trauma Room

Dr Doug Ross, Greene and Hathaway are still trying to resuscitate the boy. His condition looks as if it is worsening.

The clock is ticking and the suspense is intensifying. However, there is hope because of the skilful and brave action of the doctors. Once reminded of the suspense, we can again be moved on to the next story.

7. Hallway – Trauma Room

The coma patient is being taken into the examination room. Benton orders Carter to make the diagnosis. Carter lists the probable damage. Benton adds, 'Practically dead.' He tells Carter to continue with the evaluation of the patient. Benton sends the patient to head tomography, tells Jerry to contact the relatives and Carter to diagnose the blood type.

This is the preparation for Benton's episodic story that will have a clear suspense structure. Based on his actions, we know that Benton is morally good and therefore we are made to feel concern for him.

8. Trauma Room – Hallway

The resuscitation of the boy continues. Finally the heartbeat returns and his condition stabilises. Hathaway leaves. Greene asks Doug if he has been invited to Carol Hathaway's engagement party. Doug says he has not received any invitation. He says he is going dressed in a tuxedo to Linda's parents' house to eat goose. Greene replies that it could be worse and says that he is now going shopping. In the hallway the father of the boy comes to express his gratitude. Greene says

that the danger is not yet over. Greene makes for the door but a nurse asks him to see Regina, a psychiatric patient.

The boy being out of acute danger is a relief but the suspense is prolonged by the possibility of permanent brain damage. Audiences know nowadays not to rely on easy and early resolutions. Greene and Doug's dialogue starts a new storyline about the latter's relationship with Carol.

9. Examination Room

Regina is restless. Lydia and another nurse are singing to her. Greene also starts to sing but to the nurses about the prescription.

This is a disconnected but comical scene, the function of which is to offer release from the tension created so far, particularly after the previous sensitive scene. This opportunity to laugh further involves the audience emotionally and prepares them for the next episode of suspense.

10. Hallway – Examination Room

Benton and Hicks are discussing the coma patient; Carter is with them. The patient is brain-dead. Hicks orders the patient's vital functions to be sustained until permission for organ donation has been received from relatives. She stresses that their consent is necessary even though the patient has made a will donating his organs.

This is the interdiction familiar in many folktales and, as in folktales, so it is in television stories that interdictions are always violated. The scene is the start of Benton's suspense story.

11. Hallway

Greene has his coat on and hurries towards the door. He glances at the clock on the wall. Carol stops him and tells him of a patient with an incised wound. Greene tries to avoid taking the case but Carol says that he is on the shift and Lewis is busy.

Again there is an obstacle for Greene. Sewing an incised wound would be easy for any doctor. Viewers know how important it is for Greene to find a proper Christmas gift for his wife, so the scene engenders more empathy for Greene and increases the hope that he will find her something special.

12. Examination Room

Lewis is taking care of the patient with electrical burns (which Lydia mentioned earlier in the episode). The patient tells Lewis about his magnificent Christmas lights. Every year people come from far away just to see his lights. Though his wife would like to charge the people a fee, he thinks that sometimes one has to give without taking. He recounts how he tried to obtain electric power from the city's transformer and that is how the accident occurred. Lewis says that she will send him to have a cardiogram to see if his heart is damaged. He asks whether the machine would detect a broken heart.

Another eccentric and comical character is introduced. There is a reminder of the theme of the episode: the real meaning of Christmas. The scene also sets up a story that will remind us of Lewis' integrity.

13. Curtained Area

Lydia, Doug and Carol are attending the nearly drowned boy. His body temperature has risen but they still have to wait to know if his brain is damaged. Fortunately the water was cold. The boy's father is beside the bed. The boy opens his eyes a little but does not react to his name. He looks around. Doug wishes him merry Christmas. The father smooths down his son's hair.

Again there is suspense: what's happened to the boy's brain? He did not react to his name. The father shows his love. The audience are induced to feel compassion and be concerned.

14. Hallway – Lobby – Hallway – Examination Room

Greene is walking in the hallway. Lydia stops him and kisses him. She points to the mistletoe under which they are standing. It is followed by several wishes of 'Merry Christmas'. Lewis tells Greene that he is five minutes late. She asks what he bought. He says that he has not yet been able to leave, grabs his coat and asks if she could cover for him for a little longer. Lewis says that he should be back before lunch break. At the desk Haleh announces a case of stabbing is on its way. The rescue team rush in with the patient. Greene swings into action. The stabbed man's wife panics.

Here again we have a touching moment, a comical situation and an impending catastrophe. Again Greene fails to manage to leave the hospital to buy the gift because, as a true hero, he is committed to helping other people.

15. Intensive Care Unit

Benton, Carter and nurses are in the coma patient's room. Benton tells Carter what to do to save the organs. Haleh says that the wife has been reached and is on her way to the hospital. Suddenly the cardiogram gives a warning signal and everybody starts to act fast to save the organs. Benton resuscitates the patient. He realises that he has just resuscitated a dead man.

The scene prepares for the meeting between Benton and the dead man's wife. It involves a crisis situation that results in a strange consequence: the resuscitation of a dead man.

16. Examination Room

Greene is putting stitches in Patrick's head. Carol asks him about his helmet. Patrick says that it has disappeared. He refuses to explain how he arrived at the hospital.

Patrick, a young, retarded black man, is introduced. The situation provides some intrigue and its humorous aspect affords the audience some relief from the tension.

17. Examination Room Desk

Benton asks Jerry if the connection to the organ network is open. Benton searches for suitable recipients for the coma patient's heart and kidneys. He finds ideal matches from the computer. As Benton picks up the phone he tells Carter that a couple of people are going to get some special Christmas gifts.

Benton is about to violate the interdiction and the audience should anticipate that something bad is going to happen, particularly after the ideal matches have been found, because they know that in stories nothing should go this smoothly. Benton's

suspense story is being developed. His intention is morally good thus making his action his *hamartia*.

18. Examination Room

Lewis is examining a woman with stomach pain who thinks it is appendicitis or something worse. Lewis says that there is nothing to worry about but that she will carry out a couple of tests anyway.

The scene sets up an expectation. It is easy for us to identify with and feel pity for the woman who is afraid of the worst.

19. ER Desk

Billy brings Carol a battered helmet; he could not find anything better. She takes it to Patrick who refuses to wear it. He would rather hurt his head again and come back. Carol asks if Patrick wants to stay with them for a while. This is exactly what Patrick wants.

The scene provides the answer to an earlier question. Patrick seems to be a sympathetic patient with a mental deficiency.

20. Ultrasound Room

Lewis is examining the woman patient who has stomach pain with an ultrasound device. Suddenly she reacts strongly to what she sees on the monitor. The patient is now sure that it is appendicitis or a tumour. No, it is a twelve-week-old foetus. The woman is ecstatic. For years she has tried unsuccessfully to have a baby. She thanks Lewis who requests a picture of the baby.

The suspense is over. The audience can participate in the woman's joy. Such a sudden and dramatic insight constitutes *anagnorisis*. The scene offers relief in the middle of serious drama and the other suspense stories. It reminds us of the doctors' role as fairy godmothers and givers of gifts. In this way it relates to the theme of the episode. It also reminds us of Lewis' warm-heartedness.

21. Examination Room

Doug, Carol and Carter enter a room where a fat boy with his uptight mother are waiting. He has eaten something odd and Doug tells Carter to examine the boy. The mother is hustling. As Carter examines the boy, Doug is seen in the background wishing Carol merry Christmas. Carol advises Carter to wait a while and Doug agrees but Carter does not understand. Suddenly the boy throws up over Carter's tie.

This is a comical scene that reminds us of Carter's position as a beginner and of Doug and Carol's relationship.

22. Hallway – Examination Room

Lewis, glancing at Carter covered with vomit, makes her way to the man with electrical burns. She tells him how to take care of the burns and gives him a bag of electric lights. The man is delighted and asks where she found them.

This is another example of Lewis' kindness and a question is posed but left unanswered.

23. ER Desk

Jerry wonders where the electric lights that were on the desk have gone. He says that first someone ate all the popcorn and now the lights have disappeared. Bob looks at Jerry.

Poor Bob is the target of suspicion. The scene is perceived as comical because the audience know that Lewis is the guilty one.

24. Patient Room

Doug is examining an elderly woman suffering from insomnia and depression. She says that her depression is at its worst at Christmas and sometimes she does not even want to get out of the bed. She admits to having made big mistakes in her life and Christmas reminds her of them.

The audience are naturally curious about the woman's mistakes. Sometimes we all ponder what we could have done differently in our lives and whether we have really made the right choices, so it is easy to identify with the old woman.

25. Patient Room

Benton enters the room of the coma patient with the patient's wife. He tells her that there is no hope; her husband is brain dead. The wife asks why then is he wired to all the machines. Benton replies that they are needed to keep his organs in good condition for donation. The wife notes that the body is still warm and that she has heard of coma patients waking up even though they were said to have no hope. Benton says that in this case there is absolutely no hope of recovery. She says she wants another opinion. Benton explains that it is the machines that make the man look as if he is alive and that his organs are needed. The wife insists on another opinion.

The purpose of this scene is to provide Benton with a serious obstacle. The story's suspense begins.

26. ER Desk

Linda arrives at the desk and asks Greene if he has seen Doug. Linda offers Greene a chance to attend a conference sponsored by the company for which she works. Doug appears laughing and tells Linda that there is no point in making business propositions to assistant doctors. Doug and Linda are flirting. Linda says that she has put a tuxedo in Doug's wardrobe. Doug asks Greene if he were able to find a gift for his wife. Greene says that he has not even been able to leave the hospital. Linda offers to go and buy the present for Greene's wife. It is embarrassing for Greene to admit that the present should not be too expensive.

This scene reinforces our admiration for the protagonists' heroism. Their work is extremely demanding as they try to save people's lives and yet they are underpaid. We admire them and become emotionally involved with them.

27. Hallway

Lewis comes across Carter and tells him that she likes his tie. Carter says he was given it by his 'secret Father Christmas', Haleh, and asks if Lewis has opened her present from her 'secret Father Christmas'. Lewis replies she has not had time and walks away. Mrs Cavanaugh enters singing. Carter asks if he can help. Mrs Cavanaugh thinks she is in a hotel and asks for a suite.

The scene reminds us of the mystery of the secret Father Christmas and introduces the lady whose song will have a special meaning at the end of the episode.

28. Patient Room

Benton and Lydia are standing beside the coma patient's body. Benton says that it is beginning to be difficult to sustain the functioning of the vital organs and there is maybe an hour left. Haleh enters and says that Hicks would like to have a word with Benton. Benton goes to the hallway where Hicks asks what the delay is with the coma patient. Organ transplant teams are on their way. Benton says that the wife is reluctant to sign the donation papers. Hicks becomes furious. Did Benton inform the transplant bank about the availability of organs before receiving consent from relatives? Hicks yells that now there are eight surgeons, two patients and a group of relatives waiting for nothing. What are they going to tell them?

Since we know that Benton's intention was good, we feel such criticism is undeserved even though he did not proceed according to the rule. The situation looks bad for Benton.

29. ER Desk

Doug hands a prescription and the name of a therapist to the depressed lady. She tells Doug the reason for her depression: forty years ago a young man proposed to her but she refused because her parents would not have accepted a Jewish son-in-law. It was the biggest mistake of her life. After the death of her mother she found all the letters that her mother had hidden in which the man asks why she does not reply and whether her love has faded. When she phoned the man, there was a familiar voice at the other end: it was his son. Sammy had died three years earlier.

In this scene we hear a beautiful, touching story that fulfils the expectation established in an earlier scene. Doug obviously realises something important about love. This insight functions as a motive for his actions in later scenes.

30. ER Desk

Benton asks Greene to talk to the coma patient's wife because the organs will soon start to deteriorate. Greene says that it is sometimes difficult to get permission from relatives. Benton admits to having informed the transplant teams. Greene says that that was not wise but he will try talking to the wife.

The clock is ticking. Macho Benton has, after all, to rely on the help of others. Benton's personal flaw is that he is unable to handle the soft side of the job. Now he has to be humble and this makes his character more human and appealing. The suspense is sustained because again there is hope.

31. Hallway – Trauma Room

Carter is pushing the black Father Christmas in a wheelchair. It is an emergency situation. Lewis comes along. Carter says the patient had been there earlier complaining of nausea. Lewis asks Carter why he let him go. They try to resuscitate the patient. There is no pulse.

In this tragic way the Father Christmas introduced in the first scene has returned as the audience probably anticipated. Despite its seriousness, there is something comical in this situation and again we are reminded of Carter's flaw in that as a beginner he is not able to make all the right judgements.

32. Hallway

The wife of the coma patient is sitting on the stairs. Greene approaches her and admits that he has come to talk to her at Benton's request. The wife makes a guess: to persuade her to sign the donation papers. Greene says that she should listen to her own voice and also do what her husband would have wished. She says she does not know, that they have been separated for five months. Yesterday her husband had called and suggested Christmas together. But she had wanted to punish him so she refused. She had wanted him back on his knees. She cries, she would like to hold him and tell him that she still loves him.

A touching story that makes her behaviour, and Benton's conflict, understandable. The consequence of this conversation remains to be seen.

33. Trauma Room

Lewis decides that there is no point in continuing the resuscitation of the Father Christmas. Carter is upset: he feels responsible for the death.

One of our expectations is fulfilled. From Carter's point of view it is a tragedy and for the audience it is a reminder that doctors can make mistakes. This gives the series more credibility and intensifies the feeling of suspense. The fact that patients die has the same effect. We are made aware that no matter how much we love a character, there is always the possibility of a tragic ending.

34. Patient Room

Doug is beside the nearly drowned boy. The results of the neurological tests have not yet arrived. Greene enters. Doug says that he hopes the boy will recover.

In being reminded of this story, expectation in the audience is increased and the suspense intensified when it is learned that the results will soon be known.

35. Hallway – Patient Room

Mrs Cavanaugh sings as she walks along the hallway. She can hear Patrick singing and enters the room. Patrick is singing Christmas carols to a child patient. Mrs Cavanaugh joins in. Carol and Carter stop to listen and talk about these two patients. Patrick's parents had left him in the care of their neighbours for Christmas. Mrs Cavanaugh had been left in the care of her cousin when her Alzheimer's condition had worsened.

The scene is a reminder of the Christmas theme. Answers are given to the questions raised in our minds as to the identities of Patrick and Mrs Cavanaugh and why they are in hospital.

36. ER Desk

Lewis asks Jerry if he has seen Div. A male nurse says that he thinks that Dr Div Cvetic has left. Lewis is surprised, picks up the phone and asks the operator to get her Dr Cvetic. After a while she thanks the operator. Carter asks what is wrong. Lewis says she does not know and asks him for a lift as he is just leaving.

The scene introduces a mystery about the fate of Lewis' lover.

37. Staff Changing Room

Doug is dressing in a tuxedo. Greene enters and asks if Linda is coming to collect him. He replies that he is going first to a cocktail party by himself and then to Linda's parents' Christmas party for two hundred guests. Greene remarks on Doug's lack of enthusiasm. Doug smiles and says that it is better than doing some other things. Carol enters with news of patients and wishes them merry Christmas. After she leaves, Doug admits to thinking of Carol constantly. Greene asks if Doug has told her about his feelings. Doug says it is too late. Greene remarks that Carol is not yet married.

This is a touching moment when we find out for sure that Doug is still in love with Carol. The scene functions as the motivation for the emotional climax of the episode.

38. Patient Room

The coma patient's wife is standing beside her husband's body. Benton asks if she has spoken with Greene. He says that time is running out. She reacts with anger. Benton gives up and starts to leave the room. The wife stops him and asks him for the form to sign.

Every good story needs a moment when all hope seems to be lost followed by a sudden turn for the better. This is what happens here. The audience probably understand the wife's reasons both for refusing and then agreeing. To them, her action is logical, understandable and plausible. Suspense is released. A combination of *anagnorisis* and *peripeteia* takes place. Benton's reaction is not shown which is clever because it allows the audience to experience the emotion for themselves.

39. Staircase of a Block of Flats – Div's Apartment

Lewis and Carter stand in front of a door. Lewis has a present in her hand. They can hear a telephone ringing. Nobody opens the door. Lewis uses her own keys and they enter the empty apartment. Lewis realises that Div has left. Carter picks up the phone and replaces it saying that the line was dead.

Lewis is rejected by her boyfriend. The function of this story is to enhance sympathy for her and to create a mystery about Div's fate.

40. ER Desk

Jerry asks Bob if it was she who took the Christmas lights. Bob denies it and says that if someone says she did, then he is lying. Jerry replies that it was just a question.

A comical scene that refers to the story of Lewis and the man with the Christmas lights.

41. Staircase to Lewis' Apartment

Lewis thanks Carter for the lift. She says he is a real friend. As they stand at the door, Carter admits to being her secret Father Christmas. Lewis thanks him and gives him a kiss on the cheek. Carter asks if he could come in and tries to kiss Lewis. She says that it is not a very good idea. Carter apologises but Lewis says that there is nothing for which to apologise and gives Carter the gift meant for Div. Then she enters her apartment leaving Carter outside. Carter opens the wrapping and finds a dressing gown that he puts on and starts to dance in a funny way. Lewis' neighbours arrive and laugh at Carter who leaves embarrassed.

In the scene the identity of the secret Father Christmas is revealed and we are again reminded of Carter's clumsiness that makes him so likeable. There are comical elements and the scene sets up an expectation concerning the relationship of Carter and Lewis in the future. This will be resolved in later episodes.

42. Taxi – Street

Doug gets out of a taxi in front of a restaurant. He watches the people coming out of the door. Suddenly he turns and starts to run after the taxi but he can't catch it. He mingles with the crowds. Christmas lights are shining.

Doug's behaviour is a mystery. We are being prepared for the emotional climax.

43. Staff Room

Greene is studying x-ray pictures. A nurse brings him a parcel from Linda. Greene opens it and finds a sexy nightgown. Lydia just happens to pass by. She commends Greene's taste. She received a vacuum cleaner from her ex-husband.

At last Greene has a gift for his wife. Because of the omniscient position of the audience, the scene is experienced as comical: Greene has not chosen the gift and we can remember him saying that he gave his wife a dust buster last Christmas.

44. Operating Theatre

Benton, Hicks and nurses are removing the organs from the coma patient. Hicks is advising and Benton performing. After the heart is stopped they have to act fast.

Here is suspense related to action: will the transplantation finally succeed?

45. Lewis' Apartment

Lewis opens the gift given to her by Carter. It's a musical box. Her sister Chloe calls from another room. Lewis goes to her. Chloe asks about Div. Lewis tells her that they found Div's apartment empty. Chloe commiserates: she has been dumped by many men, Lewis will get over it. Chloe puts on a dressing gown. Lewis says that it's her gown. Chloe asks if she can borrow it. Lewis says she can. They laugh and go into the living room. Chloe admires the music from the musical box. It reminds her of a merry-go-round in her childhood. Chloe gives Lewis her present: a Christmas tree decoration with the name Susan. Chloe says that her sister must let the baby also play with it because her name is going to be Susan too. Chloe lets it out: she is pregnant. Lewis is shocked.

Again we are reminded of Lewis' misfortune. Viewers might asks themselves how someone can reject such a beautiful and intelligent woman as Lewis. We also realise that the seedy-looking sister is just exploiting her sister's kindness. This is Lewis' personal flaw that intensifies our compassion for her. It could even be said that the function of Div and Chloe is merely to enhance our sympathy for Lewis. When Chloe announces she is pregnant, we realise that in the future it will be Lewis who will have to take care of the baby since Chloe cannot even take care of herself. How Lewis is going to manage all this remains unclear and this will be explored in later episodes.

46. Street – Restaurant

Doug enters a restaurant. A party is taking place. Through a window we can see that Doug is talking to Carol. Then Carol rushes out followed by Doug. She orders Doug to go home. He says he loves her but she rejects him. Doug says that he will change. Carol says she is not asking him to change. Tag comes out asking what the problem is. Doug asks Carol to admit that she does not love Tag and that when she is with him, she is actually thinking of Doug. Tag punches Doug in the face. Carol rushes between them, looks into Doug's eyes and begs him to get out of her life. Carol and Tag walk inside the restaurant leaving Doug outside.

This is the climax of the episode. The audience know that Doug sincerely loves Carol. They also realise that the story told by the old depressed lady was the catalyst for Doug's action. Doug and Carol's relationship is a story that will continue in later episodes.

47. Operating Theatre

The removal of the organs is almost complete. Hicks praises Benton for good work. Benton wants to close the body himself.

The suspense story involving Dr Benton is resolved with a happy ending. He has received recognition from his superior.

48. Hallway – Patient Room

Mrs Cavanaugh is walking along singing a Christmas carol. Greene passes her on his way into the room of the nearly drowned boy. Father, mother and sister are beside the boy. Greene says that there is no sign of permanent brain damage. The father bends down to his son who opens his eyes. The father hugs him.

The story that hooked the audience emotionally and morally at the beginning is resolved. As with Benton's story, it has a happy ending. It is important to notice that both these happy endings take place after Doug's outburst, the emotional climax of the episode. In this way the episode achieves Aristotle's 'proper pleasure' at the episodic level while leaving many unresolved stories to continue into later episodes.

49. Street

We see a brightly lit building, like a castle in a fairy tale book, and next to it a street. Mrs Cavanaugh's singing continues from the previous scene. Doug is sitting alone on a hydrant while people walk by.

This is a beautiful moment relating to the theme of the episode. Many people spend their Christmas alone, possibly regretting their choices in life. We are reminded of Doug's undeserved suffering. We would like to see the moment when Carol realises that Doug truly loves her.

50. Operating Theatre – Hallway

Benton is standing by the body of the coma patient. Hicks enters and says that the helicopter is about to arrive. Benton grabs the icebox and walks out. In the hallway he comes across Greene and Haleh who hand him a coat. Greene asks if Benton finally succeeded. Benton affirms. Greene and Haleh wish him merry Christmas. Haleh places some Christmas decoration on the

icebox. Benton turns to look at the coma patient once more through the window of the operating theatre.

It is a warm-hearted moment confirming the happy ending and emphasising the theme of the true meaning of Christmas. The patient and Benton are giving two human beings the ultimate gift. The touching mood continues into the last scene.

51. Staircase – Roof

Benton arrives on the hospital roof with the box. A helicopter is just landing. Benton hands the box to the pilot and then watches as the helicopter leaves with the gift. Once more we can hear Mrs Cavanaugh singing a beautiful Christmas carol.

In his book *Screenwriting*, UCLA Professor Richard Walter says that right after the ending of a movie the audience should feel not uplifted, not superior, not virtuous but quite the contrary, humbled.

Each viewer should be reminded of their own humanity. This episode of *ER* ends like a good movie should. The theme of the real Christmas touches our emotions and understanding. The writer's choice of *mimesis* has created sudden insight for the audience about the significance of the earlier events and scenes.

In this analysis I hope to have shown how the various storylines have fulfilled the functions that are necessary in order to provide the audience with the 'proper pleasure'. To summarise:

The nearly-drowned boy and his father. This story hooks the audience morally and emotionally from the beginning. It provides undeserved suffering that is resolved happily at the end of the episode.

Dr Benton: This is the suspense story about organ transplantation that demonstrates how a story proceeds through conflicts. It has the requisite combination of *hamartia*, *peripeteia* and *anagnorisis*. It also provides a powerful symbolic dimension in the theme of the true meaning of Christmas. Benton's personal flaws – being too masculine and unable to deal with sensitive issues both of which cause problems – are exemplified. Before the outcome of this story, the audience have become involved in several other storylines and suspense structures.

Dr Greene: His goal in this episode, to buy a gift, is thwarted by his commitment to his work. The story ends with a comical surprise and we are reminded of his personal flaw, lack of finesse with women.

Dr Doug Ross: Undeserved suffering since Carol rejects his love. The elderly, depressed lady who lost her love brings a symbolic dimension to this story. Doug's personal flaw is demonstrated in his inability to sustain lasting relationships.

Dr Lewis: She is presented as morally good. She gives a gift of Christmas lights to the burns patient and the gift of life to the female patient. She wins our compassion by being rejected by her boyfriend. Her personal flaw is that she is too kind and that is why other people, such as her sister, exploit her.

Dr Carter: He is a slightly comical character. Because he is a newcomer to the hospital world it is easy for us to empathise with him. His personal flaw is that as a beginner, he often makes mistakes and wrong evaluations.

These doctors are sympathetic, self-sacrificing and heroic and at the same time humane, fallible and realistic. We therefore want to spend time with them every week. Suspense and realism, intensified by overlapping the stories, involve the audience completely. At dramatic moments we are transferred to other stories and left in a state of anticipation wanting answers. This maintains interest and suspense. Curiosity and unresolved issues concerning the doctors' personal lives function as the incentive for watching the following episode.

As a whole, the episode brings about the 'proper pleasure' on the episodic level and at the same time leaves us with the promise of fulfilment. In this way *ER* brilliantly combines the ideas and emotional experiences of an episodic series with a continuing serial and intense audience involvement results in huge popularity.

9.2 A Detective Series

I should now like to consider how the ideas of the 'proper pleasure' can be exploited when creating a detective series. There are many familiar detective series such as the British *Hercule Poirot, Sherlock Holmes, Inspector Morse, Miss Marple,* the American *Columbo, Matlock, Perry Mason,* and the German *Derrick* and *Der Alte.*

The formula of the classical detective story was probably first articulated in the 1840s by Edgar Allan Poe. His famous stories *The Murders in the Rue Morgue* and *The Purloined Letter* contained the elements that became the conventions of the classical detective story. This begins with an unsolved crime and proceeds towards the solving of that crime. The story can be 'closed' in which case the mystery is about the identity and motive of the murderer, as in the case of *Rue Morgue* or *Perry Mason*; or the story can be 'open' in which case the audience know the identity and motive of the murderer. In the latter case the story lies in how the detective manages to solve the mystery and catch the criminal. This is the formula of Poe's *The Purloined Letter.* A modern-day example is the television series *Columbo.*

John G. Cawelti has analysed Poe's early detective stories in his book *Adventure, Mystery and Romance*. According to him, Poe's stories have the following elements typical of the formula: (a) introduction of the detective; (b) crime and clues; (c) investigation; (d) announcement of the solution; (e) explanation of the solution; and (f) denouement. What is important to notice is that these phases do not always follow this chronological order, which, as I shall show, is relevant when using the idea of the 'proper pleasure' within the formula.

The standard characters are the detective, the victim, the criminal, and several witnesses and suspects. There can also be potential victims, characters who are threatened by a crime but are unable to solve the identity of the murderer themselves.

Poe's typical pattern was a murder with several tangible clues as to the identity of the murderer but the mystery had to appear as insoluble. In other words, the hero (the detective) faced a seemingly insurmountable task, a situation familiar from mythology, folktales and many movies where there was also usually an element of suspense.

In Poe's stories 'the crime and clues' section was followed by the introduction of several witnesses, suspects and false solutions that constitute the investigation as it is presented to the reader. In folktales and in the hero's journey, these are the obstacles,

helpers and qualifying tests with which the protagonist is confronted and must pass on his journey to achieve the main goal. They were essential for creating the suspense-relief-pattern that is important in creating the 'proper pleasure'.

Poe would appear to have understood the importance of sympathy and the suspense related to it. The investigation would often threaten to expose the identity or the guilt of a character with whom the reader had been encouraged to sympathise or identify, so that the detective's final solution is not only a clarification of the mystery, but a release from suspicion or danger of characters with whom there is empathy.

Finally, the crime's solution occurs suddenly and at a dramatic moment so it functions as the climax of the drama. This revelation is even more pleasurable if the story has been well told and the audience have been involved both emotionally and morally, since this intensifies the need and desire to resolve the conundrum. Such involvement is brought about by using the strategies that create the 'proper pleasure'.

The importance of suspense in mystery stories can be exemplified by the urban legend *The Choking Doberman*. This was used by Ron Tobias in *20 Master Plots* as an example of the perfect basic plot.

A woman returns home after spending the morning in town taking care of her business. She finds her pet Doberman Pinscher choking and unable to breathe. She takes him to the vet for him to have emergency treatment and returns home.

Arriving home, the phone is ringing. It is the vet. 'Get out of your house now!' he shouts.

'What's the matter?' she asks.

'Just do it! Run to your neighbour's'

Frightened by the tone of his voice, the woman does as she is told.

A few minutes later, three police cars arrive at high speed and stop in front of her house. The police rush in with their guns drawn. The terrified woman rushes outside to see what is happening.

The vet arrives and explains that when he looked inside the dog's throat, he found a human finger and thought the dog had surprised a burglar.

At that moment the police escort a man with a bloody hand out of the house. He had been hiding in a cupboard.

This story has evolved with constant retelling until it can evolve no further, just like the telling of *Cinderella*. It is a mystery that provides basic intellectual pleasure and contains the essential functions for bringing about emotional pleasure as well.

The story begins with the mystery of why a woman, returning home, finds her Doberman choking. What did he eat? The suspense lies in whether the vet can rescue the animal.

The *peripeteia* occurs when the woman receives the telephone call telling her to leave the house immediately. Naturally the audience realise that there is impending danger but the nature of it remains a mystery. The clue is in it being connected to the mystery of the choking Doberman. The suspense is intensified as the woman continues to listen to the vet's tone of voice. Finally the woman rushes out of the house to safety.

The manner in which the police arrive reinforces the implication of real danger. The recognition, *anagnorisis*, occurs when the vet reveals what he has found in the dog's throat. His theory is confirmed by the police escorting a burglar with a bleeding hand.

This elementary story demonstrates the importance of suspense in mystery stories. A more sophisticated version of this combination of mystery and suspense is Sophocles' tragedy *Oedipus Rex*, analysed in an earlier chapter. But this tragedy differs from the classical detective story in one striking way: the detective himself turns out to be the guilty person. However, in classical detective stories the detective's function is exactly the opposite: to prove someone else guilty, since if he himself is proven to be the culprit, it would destroy the possibility of a series.

The formula of the detective story will bring about pleasure and, as with folktales, it has evolved to provide ever greater pleasure. The mystery itself naturally brings about intellectual pleasure. It is important that the mystery is neither too difficult nor too easy but an appropriate challenge for the audience who are given the relevant clues. If the challenge is too difficult, the audience will be disappointed when they realise that their intellectual involvement has been a waste of time and energy. The pleasure occurs when the viewer can say 'Oh yes, of course, I should have realised!' – the solution being surprising, but inevitable. One method of achieving this is to give the audience the relevant clues in the first act, and provide an ending that relies only on facts or clues already revealed.

When creating a successful detective series, it must be understood that mystery relates to suspense in the sense that the audience should be in suspense about the outcome. They should be eagerly and impatiently awaiting an acceptable, plausible explanation for what initially appeared to be an insoluble puzzle. Just as Edgar Alan Poe did, the writer of a television detective series can create suspense by having the investigation point to the guilt of sympathetic characters with whom the audience has come to identify and like. The audience can then be released from this anxiety when the detective proves that someone else is the criminal. The detective, by averting the impending, undeserved misfortune, becomes the intellectual hero.

Good drama frequently has a structure in which there are constant changes from suspense to relief throughout. A detective story that has its audience guessing at the guilt of several suspects, can also use the viewers' fluctuating, subjective, possible solutions to cause even more bewilderment. For example, the detective finds evidence that points to the guilt of a loveable character but later new evidence appears that points suspicion at another character. Further fluctuations of suspicion can enhance the pleasure of the climax when the loveable character is finally exonerated.

The detective is the intellectual hero, able to solve mysteries and restore moral order and thereby win the admiration of the viewer. Sometimes the affection felt for the hero can be enhanced by making them rather eccentric and humorous like Hercule Poirot or Miss Marple. With features that make them very human and amusing, they nevertheless remain intellectually superior with their flaws merely making them vulnerable and sympathetic.

An efficient way to increase sympathy for the hero is to make him a real underdog, despised by the arrogant criminal. Columbo is a good example of this. Week after week viewers have pleasure in seeing this lame, badly dressed detective cleverly beating the antagonist. It is quite possible that people want to be intellectually involved in trying

to solve the puzzle, but their greatest pleasure lies in seeing the amiable detective winning and bringing about moral justice at the last moment.

As mentioned earlier, it is of the utmost importance that an episode of a television series engages the audience as early as possible. This can be done by showing a case of intense, morally undeserved suffering such as the murder of a likeable or empathetic character, or by letting the audience know of a threat to them. For example, a husband is leaving on a business trip, he kisses his beautiful, loving wife and asks her to keep the doors and windows locked at night. When he returns two days later, he finds her badly beaten and tied to the bed. She appears to be dying. He finds the telephone is not working and rushes to the neighbour to call for help. When he returns, his wife has disappeared. Now it is time for the detective hero to make his appearance. He needs to solve the riddle (what happened, who did it and why?) and rescue the woman in time. What we have here is a combination of mystery, undeserved suffering and suspense.

In this example, the kidnapping of the woman functions as a suspense factor. The detective not only has to resolve the mystery itself, but also has to do it in time to rescue the woman before she dies. Hitchcock's clock is ticking. But there is another intriguing possibility. What if the whole scene was a set up? What if the woman just pretended to be badly hurt? Such a possibility would bewilder audience expectations in the same way as happened in the movie *The Fugitive*, where it was a possibility that Dr Kimble was, after all, guilty of the murder of his wife. This would make the story more intriguing – something that sophisticated audiences appreciate.

Such a story will involve the audience emotionally, morally, intellectually and symbolically. The writer's next task is to intensify that involvement by tightening the suspense until the climax when the woman who is about to be lost forever, is rescued at the last possible moment. A more familiar example of such a situation appears in the courtroom series when a sympathetic character is about to be convicted and the crucial witness enters the court. (Here one needs to be careful of *deus ex machina*, that is, no completely new, last minute information should be disclosed at this point or the audience will feel cheated.)

In order to increase the intensity of involvement in the episode, the detective needs to meet increasingly complex difficulties; clues prove to be false; a crucial witness is found but then disappears or is murdered; the murder leads to a series of unsolved murders; the guilt seems to fall on a close family friend or even the husband himself; or could this be a plan by the couple to mislead the detective from investigating crimes committed by them, and so on.

If the hero is a police detective, he might, as we often see, have a superior who thinks the detective's theory is ridiculous and the clues mis-read, and who therefore threatens to remove the detective from the case. The function of this familiar, bad-tempered boss is to increase audience sympathy for the detective hero and create further complications. As in the case of the mythical hero, the detective has to pass these qualifying tests on his journey that becomes a suspense-relief-suspense experience for the audience as they sympathise with the hero, the victim of the crime and empathetic suspects. The audience anticipate that the detective's theory is correct and wants him to listen to the inner voice and stick with his theory. Because of his

morally undeserved suffering, they emotionally support the detective's decision and are able to experience the conflicts as suspense.

The writer can allow the audience to know more than the detective, such as the existence of a new impending danger that is unknown to the detective and to the other characters. If this information is followed by a scene showing the detective's boss setting up obstacles for the investigation, this will add even more to the suspense.

Dramatic intensity can be increased by applying the idea of *hamartia*, that is, by allowing the detective to make a crucial mistake that aggravates the victim's state or by allowing the audience to anticipate a grave mistake on the part of the detective.

In the middle of the episode something should occur that makes it look as if matters have been resolved. For instance, it could be that the whereabouts of the criminal and the victim are revealed. But when the police arrive at the location, the place is empty. This makes it even more urgent to rescue the woman.

Quite obviously, we are supposed to admire the intellectual capability of the detective but he should have a flaw in order to make him more empathetic. Like the doctors in *ER*, the detective can have problems in his personal life (for example, a spouse who does not understand the pressures at work), or he can be burdened by some heavy guilt from the past (feeling responsible for the death of partner or spouse). These flaws make the audience's emotional support even stronger when the detective succeeds in resolving the mystery. They are also important in providing symbolic pleasure as the audience relate to their own journeys in overcoming a personal crisis.

At the end of the episode, when time is running out and things look really bad, the detective suddenly realises something that so far has gone unnoticed (*anagnorisis*), and the consequence is that the victim is rescued at the very last moment (*peripeteia*). The detective receives recognition and his boss has to admit being wrong. In a folktale this is when, in the final glorifying test, the hero solves the crucial riddle. In a courtroom series, it is the moment when the sympathetic accused is about to be given the death penalty but the lawyer's *anagnorisis* enables him to reveal the real criminal sitting in the courtroom, so allowing the innocent character to be acquitted.

It is crucial that the riddle be resolved at the very last moment but the nature of the riddle can change. For example, the identity of the murderer can be revealed before the end because the crucial question then becomes whether the next victim can be rescued in time. The emphasis should move from mystery to suspense in order to involve the audience to the maximum extent.

In this way a detective series with the 'proper pleasure' not only appeals to the viewers' intelligence but also to their emotions and sense of morality. The intellectual involvement that opens the gates for emotional involvement should be correctly exploited by the writer. If the identity of the criminal has to be revealed at the beginning, the villain should be seen as a fascinating, three-dimensional character whom we love to hate.

Intense undeserved suffering and the urgent need to solve the mystery will bring about strong involvement. But it must be remembered that these strategies need to be kept under control. The series should look realistic and characters credible. If the crimes are too cruel, there will be rejection by the audience.

Symbolic pleasure can be brought about, for instance, by a subplot relating to the detective's search for balance in his personal life or his commitment to his conscience when placed in a dilemma. Another way of achieving this pleasure can be by showing how the guest characters involved in the catastrophe find psychological ways of overcoming the crisis. For instance, at the grave of his wife the husband finally realises his important role as a father to their daughter. The promise of the possibility of the detective solving his own personal crisis can be continued into the next episode.

The same concepts can be applied to television movies. For example, the protagonist of a thriller could be the victim, a woman haunted by a rapist. The movie starts with the anticipation of something bad being imminent as young women are seen through the eyes of a stranger. Then the protagonist, the woman is introduced. She lives in a pleasant house in a comfortable suburban area with beautiful children and a successful husband. Everything seems happy but there is a sense of something dysfunctional in this family.

The woman is raped. Deep despair and constant anxiety take over her life, damaging the lives of everyone in the house. She decides to take action to prevent the rapist from striking again and although the audience anticipate that she is right to do so, the other characters do not share her belief.

Suspense is intensified when the rapist strikes again in the neighbourhood, this time killing the victim. There is further intensification when the villain sends threatening messages to the woman. The protagonist is supported by a family friend and a lawyer, but the police, her boss and her husband all think she is paranoid and imagining the threats.

There is sudden release from the tension when the police announce that they have caught the man. But he turns out to be the wrong person. The woman then realises something (a clue that has been misinterpreted so far) that results in a new plan. It leads to a moment of the greatest despair (something goes awfully wrong and the woman faces the villain alone in the middle of the night). This is the moment of the ultimate ordeal for the protagonist. In the climax she is able to find a way to defeat the villain who is then caught and she receives recognition from those who thought she was crazy. The sense of family unity is restored and the woman's integrity is re-established. Such a scenario provides the 'proper pleasure' in its basic form.

Storytellers are particularly aware that certain kinds of dramatic structures have appeal to audiences. The conventions and genres of storytelling have been born not only from writers' inventions but also from the sometimes unconscious demands of audiences. Many elements of the 'proper pleasure' are familiar in the detective story formula, which no doubt explains the popularity of the genre. However, the same principles of the 'proper pleasure' can be applied to create new and perhaps even more appealing series.

9.3 The Sitcom

Sitcoms also need the correct dramatic structure essential for the 'proper pleasure'. There are usually three dramatic acts in sitcoms. But as Jürgen Wolff explains in *Successful Sitcom Writing*, the format requirements of commercial American television

need a commercial break in the middle of a 24-minute sitcom, so there are only two acts. It is therefore important to create a strong cliffhanger in the middle in order that the audience returns after the commercial.

The correct dramatic structure in a sitcom requires a character (or characters) who has a goal or need of which the audience must be aware very soon after the beginning of the episode. When this has been established, obstacles are required in order to create conflict and thereby suspense. Every scene has to relate to the need of the character to achieve the original goal. Scenes may present funny misunderstandings between characters (anti-climaxes), but they must relate to the goal, for instance by making it even more complicated to achieve.

The middle of the story (the second act) should consist of complications and obstacles that become ever greater, causing the audience to become increasingly involved and interested in seeing the resolution. As in The Hero's Journey and in Propp's pattern of folktales, the midpoint of the story presents a moment of truth. Although the problem seems to be resolved, the resolution itself results in further complications (in folktales it is often the chase by the witch). The character in a sitcom finds himself with an even greater problem. This is the technical end of act one and the commercial break. By now the audience should have been surprised and involved emotionally and intellectually so that they will return after the break.

At the same point in a Russian folktale, the hero who has rescued the maid from the witch, returns home only to be betrayed by his brothers who throw him into a dungeon. The same thing happens to the hero of the sitcom after the break in that obstacles and complications occur which create even more intense suspense. This growing intensity is important for the sitcom if it is to provide a satisfying experience for the audience.

The end of the sitcom brings about the resolution of the character's problem. Even if the goal is not achieved in every respect, the character realises that they have derived something from the experience. This represents the symbolic dimension of the 'proper pleasure' model. For instance, in an episode of *Home Improvement*, the main character has to sack his partner (because the owner of the company insisted on it), but in the end there is recognition of the importance of friendship. The hero returns with an elixir from the journey.

It could be said that the only real difference between comedy and drama in television lies in the point of view, but they use the same principles to provide enjoyment for the audience: in comedy things are seen as funny; in drama, as serious.

One of the most popular American sitcoms in 1999 was *Frasier*. The series is about Dr Frasier Crane, an intellectual, eccentric psychiatrist who has started a new career as a radio psychiatrist in Seattle. He has begun to re-acquaint himself with his father Martin and his brother Niles and he struggles with being a long-distance father to his son Frederick. His fame has brought with it the development of his ego and like many others, he is looking for the right woman to complement his personality.

His father, Martin, is a former policeman with two upper-crust psychiatrist sons. He is gruff but basically loveable. Constantly mocking the idiosyncrasies of his aberrant boys, he often wonders why they are so different from him.

Niles is an uptight Yale graduate who is even more neurotic and eccentric than Frasier. His wife, who is never seen, is cold and distant but he loves her. Nevertheless, he is much attracted to Daphne, a semi-psychic home-care worker from Manchester, England.

One of the episodes (entitled *Pick a Con, any Con*) starts with Frasier claiming that he can recognise any con. His father suggests inviting three characters to their home for a game of poker and he bets that Frasier cannot work out which of them is a former criminal. Frasier, who naturally thinks of himself as being an excellent judge of character, accepts the bet. The episode begins by hooking the audience with a situation provoking anticipation, conflict and curiosity.

The three guests arrive and Daphne serves food and coffee. The dialogue and Frasier's comments are all related to the theme of the episode. He comes to several quasi-intellectual conclusions about the guests and his comments make us laugh. The jokes are all related to the situations and are funny in their own right. There is a constant action-reaction link between the events which gives the story coherence.

Finally Frasier fails to recognise the criminal and loses the bet. He and his father agree that Jimmy, the former criminal, is a very pleasant person. The reversal occurs when Daphne, who had been making coffee in the kitchen with Jimmy, says that he has asked her out and that she has accepted. Martin now becomes concerned and does not want her to accept the invitation and argues with Frasier who says he believes in second chances. Daphne becomes angry and claims that, as a grown-up woman, she can take care of herself. The situation becomes more complicated and the suspense that has been created holds the audience over the commercial break.

Act two begins with Frasier and Niles meeting in a restaurant where Frasier relates the story of the bet. At first Niles is open-minded about former criminals and condemns society's prejudice that precludes them from having a second chance. Then Frasier mentions that Daphne intends to go out with Jimmy. Niles (whom we know is in love with Daphne) reacts immediately by saying that Jimmy should be put away forever. He blames Frasier for putting Daphne in danger with a sociopath: 'They are all animals.' The brothers decide to rescue her from the Topaz Bar (a new intention and goal), where she has gone on her date.

When they arrive at the Bar, where all the clients look like criminals, Daphne has already won a game of billiards and has had Jimmy thrown out. Frasier and Niles realise Daphne has everything under control and they try to leave without her noticing. On their way out they accidentally knock a menacing looking customer, who reacts by punching them. As in any good suspense structure, Frasier and Niles have complicated things further. Daphne appears on the scene and paradoxically she, 'the victim', has to rescue 'the rescuers'. In a suspense-laden game of billiards against the menacing customer (the crucial test), she loses but they manage to make a successful escape.

Characters in sitcoms need to be loveable (in their own way) or eccentric so that week after week we want to revisit them. But story also matters and the narrative of the episode should follow the story schema: one major conflict with goal-oriented, rising action involving increasingly intense complications until the climax. Frasier

believes himself to be an excellent judge of human character, but during the episode learns that he is not (this, typically of sitcom characters, is a lesson forgotten by the next episode). Both Frasier and Niles think of themselves as being open-minded but they are revealed to be as narrow-minded as everyone else. In fact, even though they have degrees from Harvard and Yale, the bartender is a better judge of character than these two psychiatrists.

Modern audiences demand ever more complexity from television series which then have to create the 'proper pleasure' in increasingly more skilful ways. For instance, characters need to have more dimensions in order to appear as realistic and enable identification. Such a person is the heroine of the hit drama series *Ally McBeal*, with her complex insecurities, quirky but realistic thoughts, her intelligence and misfortunes in love. She is able to represent many very 'human' qualities and it is therefore easy to identify with her.

Then there is Sydney Hansen, the protagonist of the hit-series *Providence*. She is a beautiful plastic surgeon who is betrayed by her boyfriend and loses her mother in the first episode. She has humour and self-irony and although at times she is strong-willed and determined, at other times she herself needs all the mothering her dad, sister and her dead mother (whom she often meets in her dreams) can give her.

The sophistication of the hit series *Law & Order* lies in its concentration on complex law cases drawn from recent headlines in the United States. Another strategy is to use real-life characters, as in the British series *Airport*, where we follow the actual people who deal with highly identifiable conflicts at Heathrow airport.

Even though the characters and stories appear very realistic and complex, basically these series are using the same elements and creating the same experiences as much older stories. They bring about empathy, sympathy and suspense; they provide surprises and intellectual pleasure and involve us in sophisticated moral dilemmas. They feel realistic and serve as metaphors for modern urban life and, at their best, both the characters and the stories help us deal with the problems that we face in our own everyday lives.

10 The 'Proper Pleasure' in Cyberspace

In 1993 a video game called *Doom* was launched which became an instant bestseller and a cult phenomenon. It was a new and absorbing experience for the players who, like readers of a page-turning novel, were glued to their seats late into the night.

The premise of this game is that you are a bored marine stationed on a lonely moon base near Mars. Suddenly there is an urgent distress message from a horrified group of scientists who have been researching inter-dimensional transport on a nearby moon. Their experiment has gone horribly wrong and something unspeakably evil has been created. Your mission is now to save the world from the demons from hell.

There was one thing that set this game apart from other shooting games and the crucial element was not greater graphics. An estimated ten million users were fascinated by the intense fear this game was capable of creating as they entered the dark, narrow corridors where medieval demons were lurking. Unlike other games in which you merely eliminated enemies and scored points, *Doom* offered a captivating emotional experience in which the player himself was the lonely underdog hero on a hellish journey. People became addicted to the game for days and weeks as they tried to fight their way, level by level, back to humanity. In the cinema you can watch your hero in *Terminator*, *Rambo* or *Predator*, but in front of a computer screen you can have the same emotional experience with an added new dimension: now you can be Rambo.

In this digital world you are first introduced to your role and premise. You become that character and the direct object of impending danger. Saving the damsel in distress or entire humanity from evil becomes your mission and success depends on your wit, courage, and ability to learn new skills and resolve problems under pressure. It is you who have to go into the corridors to discover the horrors. Days and weeks can be spent in this world trying to solve puzzles and overcome challenges because you want your experience completed. And if you pass the increasingly difficult tests, it is you in the climax who faces the final ordeal and returns with relief and *catharsis*. You have created the story and acted it. It is your Hero's Journey.

Having entered the digital era, multimedia experiences are becoming a powerful new medium of entertainment. In 1998 the video game industry made $6.3 billion, just slightly less than the $6.9 billion that the major Hollywood studios took at the box office. The first three *Tomb Raider* adventure games have generated over $400 million in revenue, and another adventure title *Final Fantasy* generated $151 million in Japan in a single day (*Variety*, August 9–15, 1999).

Today's interactive multimedia can be compared to the early days of film and television. At the beginning of the twentieth century, people were paying to see films even though there were no stories or characters in the sense that we know them today. It was definitely far from being an art form. But within a couple of decades, talented people such as D. W. Griffith were able to turn the new technology into a medium of emotionally powerful, sophisticated and dramatic storytelling.

There is a potentially huge market for interactive titles but this market will only exist if the audience can be entertained in compelling ways. Even though thousands of titles are produced every year, as with movies, only a few become successful. The crucial element is the fascination and intensity of the experience.

What is the role of the 'proper pleasure' in cyberspace? So far we have been dealing with linear narratives without the possibility of 'real' participation in the story. The audience's exclusion from affecting the story's events is part of the traditional story experience. For example, we can enjoy anticipation and dramatic irony when we know that the character, through his own choice, is putting himself in danger. This pleasure would not appear to be possible if we were the protagonist in the story.

Although game designers can skilfully create an illusion of the player's freedom to create their own story, many of the popular games actually have a linear story structure; as the obstacles in the way of achieving the requisite desire become ever greater, so does the enjoyment in overcoming them. Interactive texts give the user a freedom in the environment in that there is choice as to which monsters to destroy first or how to destroy them, but destroyed they must be in order for the player to move on to the next phase of the predetermined plot.

Interaction, by opening up a new dimension to the story experience, still retains similarities to the pleasure derived from earlier forms. Fear, in its broad sense, is an essential part of any story experience whether it is a novel, film or an interactive game. But there are different methods of creating fear. For example, by allowing better access to a character's mind, a novel is often able to create more sophisticated inner conflict than a film. Computer games may not yet be sophisticated enough to produce suspense through a character's inner conflict, but there is certainly suspense in knowing that monsters are somewhere just waiting for you. As with other media, we can enjoy fear in games because we are not really in the cave with the demons. As with watching a high adrenaline action movie or a horror movie such as *The Blair Witch Project* or riding a roller coaster in a theme park, we know that we are basically safe. Our enjoyment is the high intensity of controlled fear. That is the entertainment. Compared to novels and films, the suspense experience of a game can potentially be even more intense.

In this digital era when we can be heroes by becoming the protagonists of the story, we might think that the importance of pity and the moral dimension diminishes because the audience's emotional link with the fictional character does not need to be established. This is certainly true if we are talking about simulation games that allow the user to drive a racing car or fly a plane. The same can be said about strategy games that are basically electronic board games.

However, in shooting games there needs to be a premise by which you know that the character you are playing is morally good with a morally valid mission. In other words you cannot shoot good guys in the fictional world (although there are games that offer sadistic pleasures). So at the beginning of the game a premise is created so that the character's undeserved suffering produces a stronger story experience. The pleasure derived from a shooting game that takes place in virtual reality can be intense but rather one-dimensional.

The 'Proper Pleasure' in Cyberspace

Arcade games in which two characters are fighting and flying is a martial arts experience comparable to kung fu movies from Hong Kong. It is certainly true that the popularity of beat-them-up and shoot-them-up games, such as *Duke Nukem* and *Quake*, relies more on the visceral excitement of the game play rather than any real story experience. With the advancement of 3D technology, the market for these violent experiences could also be huge in the future but, as interactive entertainment consultant Robert Gelman in *Interactivity* says, this entertainment basically just offers exercises to enhance the motor reflexes of pre-adolescent males.

We are now at an early stage in the evolution of interactive games and part of their success is due to novelty value. As the virtual reality technology advances, the story world will become more real and immersion more effective, bringing our endocrine responses to new levels. There will certainly be more realistic rally car driving and shooting experiences. These pleasures explain the popularity of video games today and for some time to come but eventually users may start to desire more meaningful experiences. Furthermore, the ability to create new kinds of experiences opens up the possibility of reaching new audiences such as girls and older people.

Helsingin Sanomat, the largest newspaper in the Nordic countries, published a series of reviews of computer game classics. Game critic Leena Sharma wrote about *System Shock* with enthusiasm:

> If I were allowed to take a computer and one game to a remote island, that game would be System Shock. At its best the game is like watching a perfect action movie or reading a suspense-filled detective novel. It takes you into a world that is total nonsense. But when the plot runs smoothly, there is enough action and the mood is dense so you forget the reality. In this game designed by American Looking Glass Technologies all the pieces are in their right place. There is a megalomaniac artificial intelligence out of control with a plan to conquer the world. There is a spaceship with sudden death by mutants and robots lurking behind every corner. There is a lonely computer nerd – the player – who is fighting against the superior enemy. The player's weaponry is just his shrewdness and a device picked up in the corridors. It is almost impossible to explain to someone not familiar with computer games how you can be totally immersed in them. In the 3D environment of System Shock the player walks, runs, crawls, jumps and even flies. He peers at the enemy from around corners, ambushes them with mines or bravely attacks outnumbering forces of robots.
>
> Spaceship Citadel is a vast multi-layer complex where lifts break down, rooms darken suddenly and stuck doors open only to reveal radioactive zones. When the player enters a new level he opens the door with his heart pounding because artificial intelligence Shodan has set traps everywhere. The crazy Shodan accompanied by robots and mutants has caused total destruction in the spaceship. Occasionally there are e-mail messages from desperate people fighting their last battle. When the player rushes to help them he runs into a pile of dead bodies and Shodan's derisive messages that would make any player angrily curse the evil murderer. Every time the player defeats the obstacles invented by the artificial intelligence or eliminates its helpers, there is the genuine joy of succeeding. And finally, having defeated Shodan – in the worlds of computer games anyone can do it

by adjusting the level of difficulty – you feel for a moment as if you were
Schwarzenegger.

This description of a game experience is reminiscent of the traditional story experience
at its best with suspense, mystery, undeserved suffering and intellectual challenges. It
has the 'proper pleasure' with two added dimensions: participation and intensification.

Game designers currently have problems creating deeper and richer experiences,
partly because the technical challenges are so great. So they are concentrating on
genres such as action, horror and simulation, those very subjects that appeal to young
males who go to the cinema to see *Speed* or *Con Air*. But some games are taking steps
towards creating more complex interactive stories with the potential of an increasingly
satisfying experience.

Some of today's best-selling interactive titles are role-playing games of action,
adventure and mystery. On the *Review Planet* one enthusiastic player of the highly
successful *Wing Commander IV* said: 'The game play is fast and furious and the movies
in between missions advance the plot and story which are solid and deep. In other
words, when you fight you know you are fighting for a reason, you feel that there are
real people at stake and the game play matters to you because the story is so good.'
Another user's comment reads: 'Well thought out story and action. This really is the
true definition of an interactive movie. As the game unfolds you are like the starring
character in a movie.'

In the framework of a game's story, a straightforward flight simulation is capable of
creating an immense amount of suspense.

The earlier version, *Wing Commander III* opens with a scene filmed in the evil
Kilrathi imperial throne room. The emperor and prince Thrakhath order the execution
of captured confederation pilots; only one of them is 'worthy of being treated as a
warrior'. Then a beautiful brave female officer, Angel, is brought in. The crowd want
her to be executed as well and she bravely asks for her disintegration, but with an evil
grin prince Thrakhath announces that there is another form of execution that awaits
her. As the bloodthirsty cries get louder we pass to another scene in which Colonel
Blair (Mark Hamill) and General Taggart view the wreckage of her spaceship.

There is now anticipation and curiosity as to the fate of Angel. The conflict and
main characters are established and we know the objective of the heroic mission.
Angel's fate is in doubt for the protagonist (Blair), but because of our superior position
we know that she is about to face a horrible death. The stakes are high for Blair: he
must resolve the mystery because of his romantic feelings for Angel. We want to help
him and it is dependent upon our skills, wit and heroism whether our alter ego –
Colonel Blair – will succeed. When we watch a Hitchcock film we want to shout
warnings to a potential victim of a murderer; now we can actually help her.

As the news of the numbers of men killed in battle and the imminent execution of
Angel reaches Blair, he is driven to drink. In this scene there are two interactive choices
regarding the course of a dialogue between Blair and his female subordinate Flint. As
Jon Samsel and Darryl Wimberley demonstrate in *Writing for Interactive Media*, the
dialogue's path depends on Flint's moral stand. In the highly moral version, Flint

sublimates her feelings for Blair and directs the discussion to the loss of the other woman. She consoles her commander and enables him to fly effectively again. This is an example of more sophisticated character development, still lacking in most multimedia texts, which makes the story experience deeper and richer for the user. In the less moral version, the dialogue ends in Blair's icy rejection of Flint's 'lecturing'.[1] As so often in movies, we sense that they belong together and by our interaction we must help them overcome obstacles that arise from misunderstandings.

The writers of *Wing Commander III*, Terry Borst and Frank De Palma, won the 1996 Academy of Interactive Arts & Sciences 'Cybie' for the Best Writing. In *The Multimedia Scriptwriting Workshop* Douglas J. Varchol interviews these writers about creating the sequel, *Wing Commander IV – The Price of Freedom*. The writers explain that their aim was to devise a good story.[2]

At the beginning of the game our hero Blair is working on a modest farm. The evil Kilrathi empire has been destroyed in the previous game and the galaxy is at peace. The former hero is now a frustrated farmer but fortunately he receives the call to adventure. The Border Worlds seem to be waging a guerrilla war against the Confederation. He meets up again with his good friend Major 'Maniac' Marshall. But on flight missions Blair senses that something is wrong. He becomes suspicious and confused. Then, much to his surprise, he is informed that his trustworthy friend Maniac has stolen a shuttle and is defecting to the enemy with important intelligence material. Blair is sent after the defector's shuttle and coming into firing range, he must decide whether to fire on or go with his friend. Now the dramatic choice becomes the user's responsibility.

If the user chooses that Blair joins his friend and enters the Border Worlds, he finds that someone powerful within the Confederation administration is trying to set up Border Worlds as an instigator of war. Blair's task now is to return to Earth to prove Border Worlds' innocence. There is a further moral dilemma to be faced when a choice has to be made between helping some people from being killed or fetching weapons needed to return to Earth. The climax of the game takes place in a courtroom when Blair has to prove that there is a traitor within the Confederation or face execution himself. The stakes are intensified for you because Blair's performance depends on you. In the end, the Assembly votes on whether or not to declare war. It is your fast thinking and good choices at dramatic moments that shape your story experience: there is either a happy ending after the climax in the courtroom or, with the knowledge of an impending dark era for the entire human race, you die.

Usually the enemies in games are distant monsters but in *Wing Commander IV* the enemy is discovered on your own side. Blair's *anagnorisis* is the realisation that he might have been fighting for the monster. It is a case of self-discovery for the character.

Wing Commander IV has elements of the Proppian story pattern with a psychological dimension to the Hero's Journey and moral dilemmas that together create a more complex drama. Compared to the dramatic experience of a compelling film, it might be regarded as clumsy but at least it is more than just shooting and scoring points.

It is easy to agree with Ty Burr who in a review of *Psychic Detective* – an interactive movie about a man who can enter other characters' minds to see and hear the action

through their eyes – says: 'For interactive movies to reach a mass audience, they'll need to get beyond stale genre fixations and address genuine dramatic concerns. *Psychic Detective* proves that the potential is there. All that's missing is a story worth interacting with.' (*Time*, 29 April 1996)

The best story experiences can be said to be deep and narrowly shaped by the predefined plot. Interactive stories, on the other hand, are often broad and shallow. Hollywood has come up against this difference when studios have tried to turn successful video games into feature films, box office figures having been modest for attempts such *as Wing Commander, Super Mario Bros, Street Fighter* and *Double Dragon*. The only success so far has been *Mortal Combat* with US box office figures of $70 million. These disappointments have resulted in film projects based on the highly successful games *Duke Nukem, Quake* and *Doom* being abandoned. Studios have realised that popular games do not necessarily have interesting characters and good plots. But by bringing in better writers and directors a couple of studios are trying to break the series of failures. Paramount developed *Tomb Raider* into a film and Columbia Tristar released the film *Final Fantasy* in 2001. *Final Fantasy* should have a good chance of succeeding as the game from which it derives falls into the category of adventure and role-playing in which a good story and plot is especially important.

Final Fantasy VIII was released in 1999 and in Japan it sold three million copies in four days. Perhaps the previous game had produced an appealing experience that players wanted to repeat or, more likely, they expected an even better version of the experience.

Plot is at the heart of every game in this immensely successful role-playing series. The protagonist of *Final Fantasy VIII* is Squall Leonhart, a young man attending a top private military training academy known as The Garden. As the game opens, he is trying to pass an exam that will enable him to join an elite soldier unit known as SeeD. Only the best students are selected, those who fail are expelled. After Squall has past the first test, things start to become complicated. Squall's nation is under threat from the neighbouring country of Garibaldia that is run by a corrupt government. SeeD is in fact an organisation that helps the rebel force of Garibaldia. Squall makes it into SeeD and meets the beautiful Rinoa who, he later discovers, is actually the leader of the rebel force.

Squall, Rinoa and a few elite soldiers are sent on a secret mission to Garibaldia whose president has as an ally the beautiful but evil witch Edea. Eventually she kills the president and plans to conquer the whole world. Squall's goal is to overcome the powerful Edea before it is too late. On his journey Squall struggles to survive and distinguish friend from foe; he has to face intrigue, betrayal, and the death of beloved characters. He has to discover why he keeps dreaming about a man called Laguna Loire and how these dreams are related to the sorceress' war plans. He also has to deal with Rinoa who would appear to be romantically interested in him.

The plot has many elements of the Proppian folktale pattern and designers have improved the characters from the previous game: they are consistent and are rendered more realistically. Since they look more like real human beings and less like animated

characters, the game induces players to care more for them and the illusion of reality is intensified. As in several other role-playing games, the characters are able to develop by courageously facing monsters and enemies on their journey. With different spells, the soldiers are able to survive ever more demanding ordeals. The game is also visually impressive with good action animation, seamless slips into CGI-rendered sequences, and altogether more than sixty minutes of high-quality cinematic scenes.

However, in some reviews the game has been criticised for not having enough suspense at times, the lack of a proper arch of drama, and creating too little identification with the characters, all of which reduce the appeal of the game. What these critics are in fact talking about is the lack of the 'proper pleasure'.

The creators of the film version of *Final Fantasy* tried to combine the photo-realistic CG-animated characters and visuals with a compelling story. If they had succeeded, they might have had in their hands one of the blockbusters of 2001.

Another adventure game that has a great story and plot is *Grim Fandango* produced by Lucas Arts. The player's role is that of the Grim Reaper, Manuel 'Manny' Calavera in the Land of the Dead. His mission is to bring mortal souls, or clients, to the department of death to see if they qualify for the trip to the land of Eternal Rest. The Land of the Dead is a fearful place and if you have not been a good human being during your life, the final trip can be a terrible experience. The more good souls Manny is able to deliver, the sooner his own debt will be paid.

The pace of the narrative is regulated by the insights of the player. The predetermined plot is invisible and advances only when a puzzle is solved. The story is so appealing that the player wants to overcome every obstacle as soon as possible in order to see what happens next. This delay is felt as intense suspense. If the story of a game is indifferent to the player, so are the puzzles. If the puzzles are too difficult, the action stops for too long; if they are too easy, the reward, a new sequence of the story, will lose its appeal. In *Grim Fandango* the riddles are suitably difficult to please the player's self-esteem and provide a really entertaining experience.

Hollywood has also tried to turn successful feature films and television series into CD-ROMs but often they have been failures. It is not enough just to show clips from a film and then only provide the player with the action of a simple beat-them-up game. Even a more sophisticated game can fail to meet the expectations set by the film. An example of this is the adventure game *Indiana Jones and the Infernal Machine*. It was criticised for being simply boring: there was not enough suspense and no story arch of rising action, just an endlessly repeating series of pushing boxes, jumping and pulling levers. The interactive Indiana Jones lacked all the charm and wit he had in films. And the bad guys did not create any real suspense as they were far too stupid to pose any threat for Indy who thus just became a poorer version of his female counterpart Lara Croft of the *Tomb Raider* series.

What audiences expect is the appeal they experienced from the film now that it is turned into an interactive form. A movie such as *The Blair Witch Project* would, for example, make a great game. The atmosphere of the internet web site already creates a mood of pity and fear. The surprise hit movie has left people guessing about the witch who was never seen on the big screen. Was there a witch at all? What really happened

to the three young film-makers? There is an excellent premise for a scary modern Hansel and Gretel type of game about a journey through dark woods. After finding the map, solving the puzzles, interpreting all the clues and being able to escape at dangerous moments, you finally discover what really happened. Furthermore, the internet is an excellent means for advertising such games and movies by giving potential buyers part of the emotional experience of pity, fear and *catharsis*.

One of the problems facing interactive narratives is the pace. Part of the appeal of dramatic stories in films is the fast momentum. But in interactive titles, it is the player who creates the pace by, for instance, exploring a mysterious room for clues. The story stops at the moment the user has to click on his choice, which kills the illusion of a dramatic story. One way of overcoming this is to keep the music and the sound-effects at a fast pace. In some interactive narratives this problem is overcome in part by allowing the player only a limited time to make choices in the final scene. Or they can make the story play several scenes simultaneously in real time. If the player spends too much time in one scene, he might miss relevant clues provided in the other scenes.

Another major problem is that the majority of games are far away from any character development, which is an essential part of a genuine story experience. When the player is faced with a challenge such as a puzzle or fighting a monster, the resolution can take hours and completing the entire narrative can take days or even weeks. The experience therefore comes closer to that of a television serial where the episodes break at suspenseful moments rather than a movie that is completed in just two hours.

One of the most successful applications of story-driven interactivity is the game based on the popular *X-Files* television series. In *Writing for Interactive Media* the game's designer Greg Roach explains that they wanted to 'create a sense of acceleration, accomplishment, and release that is critical to a classic three-act structure, as opposed to meandering toward the end of the game.' In the game you play the protagonist, a junior field agent with the Seattle bureau of the FBI, a reluctant hero. He pursues a quest while investigating the disappearance of Mulder and Scully. Finally he has to make a meaningful sacrifice. The quest ends with the agent (you) solving the case and redeeming his integrity.

Roach says that in *The X-Files* they applied a combination of cinematic storytelling with the interactivity of games allowing the user to be an active participant in the drama, solving problems as an FBI agent. Roach continues: 'Our goal with *The X-Files* was to create something that has the same degree of suspense that you might find in a traditional film – only more so because the experience is wrapped around you. Many games have puzzles that are just sort of tacked or stuck into the middle of the story. Very often the user wonders, what does this puzzle have to do with anything? I feel very strongly that all the obstacles to your progress, all of the problems that you are presented with to solve, need to arise organically out of character and situation. In *The X-Files*, all of the natural impediments to your forward progress are as organic to the story as we could possibly make them. *The X-Files* is a single story that allows for a high degree of player freedom or nonlinearity within the structure of the narrative.

Part of what we always search for in a design is balance and good variety of activities – from character interaction to the intellectual challenge of trying to solve a crime.'

A good story in cyberspace also follows the traditional story schema and needs the basic elements: an efficient trigger, a three-act structure with major reversals and recognition scenes, a climax and a *catharsis*. But the cyber-story provides the possibility of enriching the story experience through the user's participation. People do not want puzzles that are meaningless and do not organically belong to the story. If a user faces hieroglyphic messages on the gate of Mayan temple as in the 3D adventure game *The Journey Man Project 2 – Buried in Time*, in order to provide intellectual pleasure, the game designer must make sure that the clues are relevant to the plot. When facing a puzzle at an exciting moment, the player may push a help button to make the task easier but if the puzzle is resolved without any help, the satisfaction is much greater.

There should be surprises for the player: just when he thinks that he is safe in a room, he suddenly discovers a monster in there too. And the moral dimension of the 'proper pleasure' can be involved, for example, in an interactive movie when you have to prevent a mysterious murderer from killing sympathetic characters, or a character with whom you have fallen in love.

A state of undeserved suffering can be created in the more traditional way as in the best-selling psychological horror story game *The 11th Hour* in which the protagonist, Carl, finds a package on his doorstep. When he opens it he finds a small computer. He switches it on and there appear images of mayhem and monsters followed by an image of his lover, Robin Morales, who mysteriously disappeared some time ago. She asks Carl to help her, she says she cannot get out and then the image fades away. It is Carl's (the player's) task to find out what happened to Robin. In order to do so he must enter a haunted mansion. The game becomes a combination of mystery and suspense as the protagonist (player) needs to solve puzzles set by the evil master of the mansion. When a puzzle is successfully solved, the player is allowed to see a new clip of the video that reveals more clues as to Robin's fate. Finally the protagonist is able to discover what happened to his lover and, just as in the classical story, there is the final climax, a battle between the protagonist and antagonist. If the protagonist has successfully pieced together and understood Robin's story, he has a better chance of winning in this scene. The protagonist has to make the right choice in order to achieve a satisfying story experience. The wrong choices lead to rather chilling story endings.

As Timothy Garrand states in *Writing for Multimedia*, the writer's challenge in multimedia is to find a balance: to give the player some control over the narrative, while allowing the writer himself to perform the necessary functions of the classical storyteller. If the user can simply choose whatever happens in a story, he is not likely to feel immersed in the experience that follows. Where is the pleasure in a story where simply by clicking you can choose whether you want a good or bad ending? The story might play to an bad ending if you do not intervene but if you interact with events and characters, you might create the happy ending. The satisfaction comes from overcoming challenges that ultimately provide the traditional story pleasure. Remember Michael Hauge's definition of the dramatic structure of any successful film: 'Enable a sympathetic character to overcome a series of increasingly difficult,

seemingly insurmountable obstacles and achieve a compelling desire.' Some of the most successful interactive titles in the future will be those that master the combination of classical narrative structure and responsiveness while creating a seamless experience of a high degree of immersion. The result is a vivid illusion and maximised pleasure for the user in becoming the true hero of the story.

Naturally new technology enables us to enjoy a variety of pleasures including the escape from reality. *Myst*, the hugely successful interactive role-playing saga (*Myst* and its sequel *Riven* have sold more than seven million copies), appeals to both men and women of nearly all ages and offers a journey to a beautiful, seemingly peaceful world. For many people one of the pleasures of this game is the atmosphere of a virtual trip. But there is also a classical story buried in the mysterious island. This game is about exploring the landscape, interpreting clues and discovering the story about what members of a family did to each other in the past. The journals of an invisible mentor, Altrus, provide story information on the player's mythical quest.

In a 1999 interview Rand Miller, the creator of *Myst* and *Riven* (with his brother Robyn), was asked what effect he is after in his future games. He answered: 'I want to change people in a positive way. I would like them to come away thinking a little bit about why they're here. I don't want to be preachy and force what I believe down anybody's throat. But I want them to at least ask what it is they stand for, why they do the things they do. Asking those questions is the start of a valuable personal journey.'

The British game-designing guru Peter Molyneux emphasises the emotional aspect of games. So far, games have advanced in the areas of special effects and cosmetics. But this is not enough to make the game industry reach mass markets. He says that the players need to be able to care for the characters in the games, to feel for them and cry with them. To do this, game designers need to realise how to create a language for computer games that enables emotionally powerful storytelling.

Molyneux describes his new game, *Black and White*, as a huge personality test for the player. The player enters happy worlds of Greek, Japanese, Red Indian and many other tribes and destroys the harmony. The player can create a new harmony or make the worlds dark and evil places. The game analyses the way it is being played and will reflect it. For instance, huge creatures will destroy poor villages unless the player interferes and teaches the creatures some moral values. In this way, the world that is created reveals much about the player. Molyneux hopes that this game with ethical aspects will subconsciously model the player's personality. Immersion in this game is intensified by eliminating all the icons from the screen and simply with your mouse you can throw an object or cast a spell and control speed and direction. The Lionhead company calls its new technology 'Gesture Recognition'.

Researcher Brenda Laurel's vision of a complete combination of interactivity and storytelling is the 'Artificial Playwright' concept. It is a system that would encode the dramatic principles of suspense, relief and climax into a set rule. As the player moves through the digital world, story situations would be generated and developed by the system.

Although the technological challenges are huge, there might in future be new kinds of role games that allow you to become someone else. You will be able to experience

through someone else's identity. Alternatively, some interactive stories might evolve into fascinating journeys of character revelations. In our real lives we all wear social masks but through interaction with characters in story worlds we might find clues to our identities. And if we do not like what we discover about ourselves, we might want to learn how to find paths that could take us on the journey of a hero, which is essentially a quest for completeness of the self. The power of computer games is that we can learn from them. In interactive worlds we can meet mentors who would prepare us for making choices at critical moments. We might bring to our story character our own real dominant characteristics that we feel inhibit us from achieving our personal goals in life. We can meet characters who would tell us the truth about ourselves. These other characters look and feel very real and we can fall in love with them or hate them. And at some point we would need to face our own deepest fears. In the virtual reality world we might discover ways for a meaningful life.

Nobody really knows the direction interactive multimedia will take in the future. Even the leading experts seem quite contradictory. However, as the technology improves it will enable more fluid dramatic story experiences. Ultimately we might have a far greater illusion of reality than films are able to create. Will this evolution and audience feedback gradually reveal the nature of the 'proper pleasure' of interactive entertainment? It remains to be seen.

Today, young males form the overwhelming majority of consumers and therefore certain genres, such as shooting and arcade games, action adventures and simulations, sell well. But if the industry can create romances, comedies and psychologically more meaningful experiences, it may reach new audiences. A successful interactive writer needs to master linear scriptwriting skills combined with an understanding of the potential of interactivity. The telling of stories for the multimedia is a demanding challenge with complex problems and fascinating opportunities.

The advancement of technology will not create a totally new narrative; instead it will create new ways to enjoy the narrative. As did filmmakers a few decades ago, game designers will need to discover how to apply the ancient 'proper pleasure' inherent in storytelling to the new media. Interactive multimedia will not replace the older media. The majority of people probably will not want to be active agents in a demanding game trying for weeks to solve puzzles and at the same time being chased by virtual reality, gothic demons from hell. Instead they will want to enjoy their stories in a more traditional form having their favourite detective solve the mysteries for them in an hour. Along with books, movies, television, theme parks and music concerts, multimedia will add just one more choice in a selection of entertainment experiences for pleasure-seeking audiences.

References

1 Jon Samsel & Darryl Wimberley: *Writing for Interactive Media*. Allworth Press, New York (1998).
2 Douglas J. Varchol: *The Multimedia Scriptwriting Workshop*. Sybex, Alameda, California (1998).

11 The Anatomy of the 'Proper Pleasure'

There are millions of stories in the world. Even in primitive societies stories had many different functions including education and the passing on of values and wisdom to the next generation. There are scholars of narrative who say that cultural differences have to be taken into account in order to understand the meanings of stories. And there are those who say that claims for the universal popularity of American TV-melodrama as an indicator of a universal, archetypal form of experience are no more than just a highlighting of Western culture. Cultural differences undoubtedly play an important role in several ways. For instance, a scene in a story can be interpreted as a threat of social embarrassment for a likeable character, whereas another audience from a different culture may not interpret the scene in the same way and consequently are not able to experience the intended suspense.

Although the contents and functions of stories vary according to culture and time, there seems to be one theme and form of narrative that is universally more popular than any other. Joseph Campbell discovered the dominance of the Hero's Journey myth both in Western and Eastern cultures. The origin of the Cinderella tale in ancient China points to the cross-cultural popularity of this story. Because the tradition of folktales and myths contains age-old themes and patterns that are met all over the world, psychoanalytic thinkers such as Sigmund Freud, C G Jung and Bruno Bettelheim have considered them to reflect the common, unconscious territory of the human mind. John G Cawelti believes that the discovery of universal story types probably reflects basic psychological interests and needs and thus gives us insight into the working of the psyche. According to Wallace Martin, the existence of patterns of universal narratives does not only tell us about literature but also about the universal characteristics of the human mind and culture.

Robert Scholes and Robert Kellogg give plot an important role in the history of storytelling, and in their book *Nature of Narrative,* imply the existence of a narrative schema:

> On the whole, however, of all aspects of narrative, plot seems to be not only the most essential but also the least variable, insofar as its general outlines are concerned. We demand variety of incident more than we demand variety of plot in our fiction. When we pick up a modern picturesque tale, whether it is narrated by Felix Krull or Augie March, we know in a general way what to expect. We know our destination though we do not know specifically what scenes we shall pass by on the way. The specifics of incident admit as much variation as the specifics of characterisation, and it is in this area that we expect an author to exercise his originality in plotting. Plot, in the large sense, will always be mythical and always be traditional. For an author like Jane Austen one plot, in this large sense, can suffice for all her novels.[1]

The prevalent idea of a universal, canonical narrative schema is, to a large extent, based on a theory of A J Greimas. He based his theory on Propp's discoveries and used the word 'actants' to describe the roles assumed by the characters in a narrative. Several actants can be represented by one and the same actor. Thus in an adventure story, the Subject (Propp's hero) may have several enemies, all of whom function as Opponent (villain); and in a love story, the boy may function as both Subject and Receiver while the girl functions as both Object (princess) and Sender (dispatcher).

According to Greimas, a canonical narrative is the presentation of a series of events oriented in terms of a goal. Specifically, after a contract (to bring back the princess) between Sender (father of the princess) and Subject (hero) whereby the latter acquires competence and undertakes to attain an Object (princess) for the benefit of a Receiver (family, community and so on), the Subject goes on his quest and as a result of a series of tests, fulfills or fails to fulfill the contract and is (justly) rewarded or (unjustly) punished.

Competence is the qualification of the Subject along the axis of desire (wanting to do) and/or obligation (having to do) and the axis of knowledge (knowing how to do) and/or ability (being able to do). There are three tests that the Subject must pass: the qualifying, decisive and glorifying tests. The glorifying test results in the recognition of the Subject's (hero's) accomplishment and takes place when the decisive test has occurred in secret.[2]

Nearly all researchers agree that a narrative schema has the following format:

1. Introduction of setting and characters
2. Explanation of a state of affairs
3. Initiating event
4. Emotional response or statement of a goal by the protagonist
5. Complicating actions
6. Outcome
7. Reactions to the outcome[3]

In other words, the universally popular narrative is a goal-oriented structure in which a protagonist wants something. This desire is based on some disturbance of the equilibrium. There are, however, difficulties in achieving the object which results in conflict. Eventually the outcome is achieved and equilibrium restored.

According to cognitive psychology, narrative comprehension is guided by the goal of creating a meaningful story out of the material presented. But according to Aristotle's principles, it might be said that comprehension is also guided by the goal of creating an appealing experience.

We can use diagrams to help us discover the pleasure embedded in the universal narrative schema. If narrative is a goal-oriented structure, there also has to exist an intention that desires the attainment of the goal. An intention comes into existence when a character is motivated. An intention that is not opposed must necessarily reach the goal which it sets out to attain.

Diagram 2a

If the path of the intention is obstructed with difficulties, a conflict arises. As a result the attainment of the goal will be delayed.

Diagram 2b

If the audience strongly hope that the goal will be reached, this delay will be experienced as suspense.

Intention and obstruction collide and produce conflict. This is an important consequence of the intention. People can maintain different positions but conflict can only arise as a result of their different intentions. Not only are intention and goal-oriented action extremely important as a means of creating conflict, they are also a very important element in the perceivers' anticipation of future events.

When nearly all researchers of narrative agree that there is a goal and complicating actions in a traditional narrative, they are implying that there is an intention, obstacles that tend to frustrate it and as a result, conflict which is necessary to create the dramatic impact and 'proper pleasure'.

The canonical narrative schema can be represented in a diagram that resembles that of the delayed goal-attainment. The diagram is similar to Gustav Freytag's pyramid that he created in *Die Technik des Dramas* of 1876 to depict the normal plot in literature:

$$A \diagup B \diagup C \diagdown D$$

Diagram 3

In this diagram AB represents the exposition, B the introduction of the conflict, BC the 'rising action', complication, or development of the conflict, C the climax or turn of the action, and CD the denouement or resolution of the conflict. As Martin states[4], this pattern became conventional because many people over many years learned by trial and error that it was effective. And, we might add, this pattern brings about pleasure.

Freytag's diagram is identical to the paradigm that depicts the arc of classic drama. There is the beginning, middle and end. The story at the beginning is the start of the rising action. The protagonist is faced with one conflict after another until the major conflict which is the climax. This is the major event the protagonist must experience in order to achieve his goal. The denouement, or falling action, marks the final stage of the story when the protagonist demonstrates that he has grown as a result of his experiences.

Bryant and Zillmann's pattern of sudden release from great distress resulting in great enjoyment also produces this kind of diagram.

A more detailed diagram of the behaviour of intention in a story is constructed by the British literary scholar Harold Weston. In *Form in Literature* (1934) he states that in a plot the main character's intention is the driving force. Every point of the action has some relation to the execution of the intention, constantly hovering between possible success and failure. He describes the course of the intention in *Hamlet* in the following diagram:

Diagram 4

in which AB is the line of intention (Hamlet intends to avenge his father's death); AC is the obstacle to the intention (Hamlet's vacillations); CD is the secondary incident (the King commands the courtiers to spy on Hamlet); DE is the reversal of the obstacle (Hamlet tricks the King into betraying his guilt); EF is the crisis (Hamlet discovers the King kneeling at prayer); FG is the reversal of the crisis (vacillation atrophies Hamlet's will); GH is the catastrophe (Hamlet sails for England); HI is the reversal of the catastrophe (Hamlet boards the pirate ship); IB is the denouement (Hamlet slays the King and achieves his intention).

The paradigm of the folktale discovered by Vladimir Propp closely resembles this diagram of intention. There are several obstacles in the first part of a folktale such as the challenge by the donor. These result in a crisis such as meeting the evil magician. Victory and the rescue of the princess imply the near achievement of the intention that is represented by F in Weston's diagram. However, the magician is not completely defeated and he begins a chase that creates suspense, represented by distance from the line of intention. Betrayal at home is represented by H. At the end, the unrecognised hero solves the riddle in the court, is recognised and wins the princess for his wife. The intention is fulfilled, the goal achieved.

It is interesting to compare the previous patterns to Syd Field's diagram of the ideal structure of a Hollywood film. In his book *Screenplay: The Foundations of Screenwriting* he says that the structure of a Hollywood movie can be divided into three acts. In the first act (pages 1–30) the ingredients are introduced and the story is set up. The first plot point takes place around pages 25–27 of a screenplay. The second act, from page 30 to page 90, is about confrontations and the second plot point occurs around pages 85–90. The third act is about the resolution. Later Field discovered that in the middle of the movie (around page 60) there is also a plot point where something dramatic happens. He calls it the midpoint.

As Vogler describes in his book, the Hero's Journey model also takes place in three acts and has many similar elements to Propp's folktale pattern (see appendix) thus creating the same kind of story experience in many ways.

The Anatomy of the 'Proper Pleasure'

The first act begins with the story stages of the Ordinary World (Propp's Initial Situation). It is followed by the Call to Adventure (Mediation), Refusal of the Call, Mentor and at First Threshold (Counteraction, Departure), shifts into the second act where there is the Test, Allies, Enemies (Donor, Receipt of Agent), Approach to the Inmost Cave (Spatial Change), Ordeal (which marks Field's midpoint and Propp's Struggle) and Reward (Victory, Liquidation). In the third act there is The Road Back (Pursuit, Chase), Resurrection (Difficult Task, Solution, Recognition) and Return with the Elixir (Wedding). The protagonist is permanently altered by this suspense-laden series of conflict and action sequences.

The Hero's Journey is a powerful metaphor for audiences that conforms with Field's, Weston's and Propp's patterns. If depicted as a diagram it would also resemble the arches of classical drama and Freytag's plot.

If we combine all the previous diagrams of narrative structure, the result is a diagram of the emotional structure of the desired experience – the 'proper pleasure'.

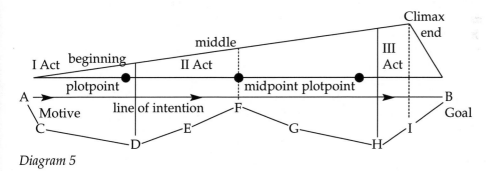

Diagram 5

In this book I have attempted to trace the essence of popular narrative. By using the same approach as Aristotle did 2300 years ago, I have shown the form and design of pleasure that is particular to storytelling. These principles have their origins in myths, folktales and ancient Greek drama. After thousands of years we still want the same pleasure from stories. The digital era will not change this.

The evolution of storytelling can be considered through four dimensions: emotional, moral, intellectual and symbolic. Although all these levels of pleasure have been in narratives from the dawn of storytelling, their inner centres of gravity have changed. In the early heroic stories the listeners might have been fascinated by the emotions brought about by the tales. Later in folktales the experience could have been intensified through a clearer moral structure. These levels are still emphasised in stories for children. As culture and civilisation progressed, adult audiences became more demanding with regard to the intellectual aspect of stories. The audiences of Shakespeare's *Romeo and Juliet* in the seventeenth century found it believable that a medicine could put people into a death-like sleep. Nineteenth century melodrama concentrated on suspense and identification, but characters remained stereotypical. Modern audiences no longer accept plot developments or character portraits of a simplistic nature.

Modern audiences also demand more realism from the symbolic dimension of stories. Narratives need to provide psychological insights and positive models for frustrated individuals searching for meaning and values for their lives in today's complex societies.

As audiences have become more sophisticated, storytellers have been able to use narrative with more flexibility. Stories no longer need to be told in a strict chronological order. For instance, in some TV-movies we are first shown a dramatic scene from the latter part of the story after which we are turned back 'three months earlier'. This is a method of emotionally hooking the audience through anticipation and it is especially used in television where the competition for viewers' quick attention is fierce.

Albert Zuckerman demonstrates how Mario Puzo in *The Godfather* created suspense for his scenes by beginning with a sudden shock. Out of the blue something happens that changes the course of the story. Then Puzo backtracks in time to a scene, the outcome of which we know but 'which we nonetheless read toward with excitement and dread much as we become drawn into the mounting horror in a foreordained Greek tragedy'. For instance, there is a scene in which Tom Hagen is working quietly in his office when he picks up the phone. It's Jack Woltz screaming and cursing. Then Puzo backtracks, has Woltz wake up in his bed, lift his sheets and see the head of his prize horse at his feet.[5] *The Fugitive* has several flashbacks. There is one scene in which Dr Kimble, when cold and lying in bushes by the river, dreams about the tender moments in the past with his wife.

Although these methods change the chronological order, they are used for one purpose: to create a dramatic impact. The principles of the 'proper pleasure' do not change but the evolution of narrative and the sophistication of audiences allow new ways of providing it.

The creation of successful storytelling is a process in which feedback from the audience plays an important role. Stories become polished according to the desires of audiences. For folktales this process could have taken generations but in Hollywood this polishing may take only a few years or months as screenplays are passionately rewritten over and over again. Such was the case of the screenplay for *The Fugitive* that was rewritten 25 times over a period of five years.[6]

Insight into the 'proper pleasure' can be used in to create stories in many ways. First of all, it helps us understand what kind of elements well-told stories need and what kind of ideas are worth further development. Understanding of the 'proper pleasure' can be used to arrange the elements of the idea into a dramatically powerful plot. When there is a well-dramatised story, the principles of the 'proper pleasure' can be used to maximise the enjoyment. For example, by making the hero more sympathetic, the effect of undeserved suffering and suspense can be intensified and ultimately the climax can be made more compelling.

However, this is not to say there is a formula for creating the perfect story. Talent, luck, timing and clever marketing will always play important roles in producing successful stories. But there are principles and lessons from the past that can be used in creating new stories with the potential for success. The most successful stories are often those that rely heavily on ancient principles but also deviate from the conventions in

fascinating ways. A story becomes unique when it combines the pleasure inherent in the classical structure with a new element from the personal vision of the creator, which opens the gates for the 'proper pleasure' experience for the modern, demanding audience.

Cultural differences also matter. In fact, the 'proper pleasure' experience can be further enhanced by taking into account those factors that are meaningful in any given culture. Combinations of the universally popular archetypal narrative with culture-specific material can create successful stories in their own cultures. A historical Finnish TV-series with a good dramatic structure can be very successful in its own country without ever succeeding in other parts of the world.

When applying the insight of the 'proper pleasure', the special nature of each individual story must be taken into account. The 'proper pleasure' is not a formula. For instance, the fascinating experience of insight created by the writer's use of *mimesis* is hard to reach through any formula. Formulas are something that lead to the death of creativity and clumsy results as can be seen in Europe where Hollywood movies have been imitated without an understanding of the nature of storytelling. Storytellers must first acquire an understanding of the 'proper pleasure' which they can then apply appropriately.

Since current analysis and research into the enjoyment of storytelling and brain physiology support Aristotle's theories of 2300 years ago, the value of the *Poetics* could be even more significant than previously thought. Although some significant factors in popular storytelling, such as the villain's or the hero's journey, were not specifically mentioned by Aristotle, many key aspects of the enjoyment still sought by the modern world were identified by him. It could be that the use of the villain's or the hero's journey offer easier ways for screenwriters to create story enjoyment than Aristotle's suggestions such as *hamartia* and *mimesis*.

Aristotle's instructions for writers can be used as strategies to intensify the enjoyment created in the standard Hollywood story. *Hamartia* is used to intensify undeserved suffering and consequently our empathy for the protagonist whose credibility is enhanced by our identification with them. *Anagnorisis* is used to intensify the effect of the sudden release from empathetic distress and to increase the intellectual satisfaction from the drama. *Peripeteia* intensifies the surprise effect of changes in fortune when things have apparently been proceeding for the better; a surprising and sudden reversal intensifies empathetic distress though causality and probability (needed in order to make the story coherent and intellectually acceptable) are also prerequisites for the audience to experience empathetic distress.

I have tried to combine Aristotle's analysis of drama with cognitive-empirical research into the enjoyment of stories, analyses of typical stories, popular story patterns in folktales and myths, as well as with Hollywood narrative in an attempt to formulate a theory about the nature of enjoyment afforded by such stories. This theory consists of four inter-related dimensions: affective (empathetic distress), moral (undeserved suffering), intellectual (mystery, realistic surprise, credibility, logic), and symbolic (*mimesis*, the psychological value of the hero's journey, solving of life problems), with all these dimensions having an effect on each other. For instance, the

presentation of undeserved suffering, realistic surprise, credible characters, and recognition of one's own life problems all contribute to and intensify empathetic distress. A satisfying resolution of this intense empathetic distress can bring about a great deal of relief and enjoyment.

The global success of Hollywood might be even more patterned on Aristotle's principles than has previously been understood. I hope I have shown that the insights in the *Poetics* can be used to engage both our analytic abilities through mystery and our emotions through suspense in the creation of captivating and thrilling entertainment.

Diagram 6

When we realise that this diagram in fact depicts pleasure, we will also realise how to maximise it. This is the secret of success in the entertainment industry.

References

1 Robert Scholes and Robert Kellogg: *Nature of Narrative*. Oxford University Press, London, Oxford and New York (1979).

2 Gerald Prince: *A Dictionary of Narratology*. University of Nebraska Press (1987).

3 Edward Branigan: *Narrative Comprehension and Film*. Routledge, London and New York (1992).

4 Wallace Martin: *Recent Theories of Narrative*. Cornell University Press, Ithaca and London (1986).

5 Albert Zuckerman: *Writing the Blockbuster Novel*. Writer's Digest Books, Cincinnati, Ohio (1994).

6 *The Hollywood Reporter*, 2 September 1997.

12 Storytelling in the New Millennium

One chilly morning Dr Rolf Jensen, the director of The Copenhagen Institute for Future Studies, held a meeting with a major telecommunications firm and a leading bank. After the presentation one client asked: 'What comes after the Information Society?'

The director of one of the world's leading future-oriented think tanks was confused and uncertain and promised to call if he came up with an answer. Eventually he and his colleagues did come up with an answer and they expounded on it in a fascinating book titled *The Dream Society – How the Coming Shift from Information to Imagination Will Transform Your Business* (McGraw-Hill, New York 1999).

According to Jensen, what comes next is what he calls the Dream Society: 'It's a new society in which businesses, communities and people as individuals will thrive on the basis of their stories, not just on data and information.' This will be the successor to our Information Society.

Human communities first evolved when hunter-gatherers formed an agricultural society. This was followed by the industrial society that has recently been transformed into the information society. But now a hundred thousand years of history in which people concentrated on the acquisition of the material aspects of life is drawing to an end. People will cease to define themselves so much through material products as they become more interested in the feelings that can be elicited by stories. In this new society, myths, rituals and stories in all forms will become more sought after. According to Jensen, the consumer of the new millennium will buy experiences and feelings, perhaps many of them interactive. The post-materialistic consumer will soon want a story to go with the product.

He tells a story about ice cubes as an example of new possibilities: 'In 1996, Copenhagen Airport imported pieces of the Greenland ice cap. The ice cube was transformed into a story about millennia and millennia of ageing. The bubbles in the ice cubes contain air from the time before the Pyramids were built. Pure air in new drinks. The realm of possibilities for a trivial product, the ice cube, has been expanded. You order an ice age ice cube and it even comes with a drink included! The story was the product.'

Dr Jensen has created handy categories for the stories. *Formula One Car Racing Story, Extra Large*, means actually taking part in the event. Experiencing it *Small* size means watching it on TV. The story also comes in *Medium* size when you purchase a PC-based racing simulator and 'you feel as if you are colliding head on with reality'. The *Nature Story* in *Extra Large* is a safari through the African savannah. The *Medium* size is a visit to the zoo and the *Small* size is reading about it or buying a nature film.

In mountaineering the biggest adventure story is climbing Mount Everest. This is the story in *Extra Large*. Submitting oneself to pain, cold and mortal danger is irrational but the mountaineers' answer is The Challenge. They want to tell themselves and others a heroic adventure story. Companies will adopt the same ideas. For example,

what is NASA's real product? Is it exploration of space in the name of science? No. It's adventure.

The future global market will be emotionally driven. People will continue to seek the emotional fulfilment that they have always sought from stories. What is new is that our natural craving for stories will move on from the realm of books, movies and entertainment towards actual consumer retail products. The market place will be dominated by the consumers' freedom to choose products depending on their emotional appeal. Therefore the story of a product must be told effectively if consumers are to buy it. Storytelling is becoming an important part of business strategy. Whoever tells the best story, and whoever tells it the best, will win.

The market for stories in the twenty-first century will be vast and many companies will grow and become global by entering this market – just as Microsoft grew in the short time that the Information Society prevailed. The obvious icon for today's Information Society is Bill Gates. The closest that we now have to a Dream Society icon is Steven Spielberg. Common to the icons of the future society is the talent for telling stories that appeal to our emotions. 'This is where we find the vast, yet-to-be-satisfied demand of the future.'

Dr Jensen goes as far as to claim that in the future practically all companies will be selling emotions. Research at The Copenhagen Institute for Future Studies shows that the major growth in consumption in the future will be of a nonmaterial nature, making it crucial that 'every company gear itself to corralling the growth of the emotional markets right now'.

From this analysis by one of the world's leading futurists and the strategic advisor to over 100 leading international companies and government agencies, we can conclude that the understanding of how stories evoke emotions and pleasure will become of even greater importance not only for writers, producers and entertainment companies but also for companies in other fields of business which want to succeed in the global market.

According to Rolf Jensen, some of the best 'new storytellers' come from the world of sport and they are already now becoming the top wage earners. The story of the athlete's heroic success, of the will to achieve results regardless of the cost, is the kind of story we need in our everyday lives and we are willing to pay for it. The Olympic drama in Atlanta in 1996 was watched by 3.5 billion people. Companies pay these athletes high prices to have their stories attached to their products. Formula One racing stars, the Finnish Mika Häkkinen and the German Michael Schumacher, earn tens of millions of dollars because their story – the technology, the excitement, the risks, the speed – has global appeal. And the future is looking good: we will demand an increasing number of stories, particularly those with high intensity and which unfold instantaneously as we watch. Those who create and arrange sports events will benefit from a proper understanding of the nature of drama and its ability to bring about pleasure.

Another area of application is theme parks. There will be a huge market for theme parks, such as Jurassic Park. As Jensen says, an entire universe is created and narrated through a film and a theme park. Disney theme parks immerse guests in rides that not

only entertain, but involve them in an unfolding story which can provide an exciting story experience for the entire family. Designers of these theme parks need to know how to arrange and create the elements that produce the most compelling and satisfying pleasure. And the best rides will be those that need the guests to complete the stories and allow entire families to play the part of heroic groups.

Advances in virtual reality allow the immersion in these journeys to become very intense. Combining new technology with a pleasure-providing story structure will help in designing fantastic roller coaster rides through the Milky Way or in the Wonderland of Alice. Designers will know how to arrange the elements of fear and relief, how to create a sense of the Hero's Journey and spiritually exciting experiences that will bring a rewarding sense of unity for families.

Dr Jensen is not the only analyst predicting a new transformation. Michael J Wolf, a leading industry strategist, says that entertainment (movies, television, popular music, spectator sports, theme parks, magazines, casinos, books, toys, and so on) is in many parts of the world the fastest-growing sector of the economy. Wolf says: 'But of even wider impact is the way the entertainment content has become a key differentiator in virtually every aspect of the broader consumer economy. From travel to supermarket shopping, from commercial banking to financial news, from fast foods to new autos, how we relate to political candidates, what airline we want to fly, what pyjamas we choose for our kids, and which mall we want to buy them in, entertainment is increasingly influencing every one of those choices that each of us makes every day. Multiply that by the billions of choices that, collectively, all of us make each day and you have a portrait of a society in which entertainment is one of its leading institutions. Without the entertainment content, few consumer products stand a chance in tomorrow's marketplace.'[1]

Business analysts B Joseph Pine II and James H Gilmore predict *experiences* are the foundation for future economic growth. Companies need to know how to script and stage compelling experiences. Buying a train or a flight ticket will not only be about paying for getting from A to B. Going to a restaurant will not only be about eating. It will be about entering a new world or era, such as Medieval Times or Rainforest Café. Stores will become theme parks such as Recreational Equipment, Inc. in Seattle, with waterfalls and bike test-riding areas and a climbing spire. According to Pine and Gilmore, customers need to be engaged on an emotional, physical, intellectual, and even spiritual level. Just as in the theatre, business companies will need producers, directors, dramatists and scriptwriters who know how to create the drama and the performances.[2]

Rolf Jensen says that among the highest ranks in corporate management in the future will be, for example, the chief adventure officer, responsible for the stories marketed by the organisation. He believes that in the near future this kind of storytelling will be taught at Harvard Business School and that earnings of future storytellers will be huge.

At the dawn of the new millennium, we are entering a new world of stories and, paradoxically, advanced technology is making this transformation from the Information Society even faster. The rulers of this new world will be those who know how to tell great stories.

References

1 Michael J. Wolf: *The Entertainment Economy*. Times Books (1999)

2 B. Joseph Pine II & James H. Gilmore: *The Experience Economy*. Harvard Business School Press (1999)

Appendix

The Emotional Pattern of the Folktale and *Kidnapping in Los Angeles*

In the following analysis, Vladimir Propp's pattern of story functions will be considered as an emotional pattern. I shall try to demonstrate how closely the conventions of a typical Hollywood thriller reflect the emotional pattern of the folktale.

Propp discovered 31 functions which do not necessarily occur in every tale but their order is always the same. These are the functions Propp introduced in his book Morphology of the Folktale (1928):

1. Initial Situation:
Members of a family are introduced and so is the hero.

A loving family of father, mother and five year-old daughter living in a beautiful area of Los Angles is introduced.

2. Absentation:
One of the members of the family leaves the home. The parents leave for work in the forest. 'The prince had to go on a distant journey, leaving his wife to the care of strangers.' In extremis, the parents die.

The father of the LA family is about to leave on a business trip.

3. Interdiction:
The interdiction is given to the hero. 'You must not look in this closet.' 'Often did the prince try to persuade her and command her not to leave the lofty tower.'

There is news about a serial killer who is on the loose in the city. The husband tells his wife to keep all the doors and windows shut.

As Propp realised, this comfortable state of affairs serves as a contrasting background to the misfortunes that follow. 'The spectre of this misfortune already hovers invisibly above the happy family.' So we have the elements of suspense and anticipation: the superior position of the audience, innocent victims, violation of the interdiction which will result a catastrophe, and a villain who represents impending danger.

4. Violation:
The interdiction is violated and the villain enters the tale.

'His role is to disturb the peace of the happy family, to cause misfortune. The villain may be a dragon, a devil, bandits, a witch, or a stepmother … He comes on foot, sneaks up or flies down … and begins to act.'

As the father says goodbye to his family we see the killer sitting in a car across the street watching them.

5. Reconnaissance:

The villain attempts to get information. He tries to discover the location of children or precious objects. A bear says: ' Who will tell me what has become of the tsar's children? Where did they disappear to?' In an inverted form the intended victim questions the villain.

The killer, posing as a parent of a dead child, makes friends with the mother and daughter in a nearby children's park.

6. Delivery:

The villain acquires information about his victim. 'A mother calls her son home in a loud voice and thereby betrays his presence to a witch.'

The killer discovers that the girl is very attached to her teddy-bear.

7. Trickery:

The villain tries to deceive his victim. He assumes a disguise. He seeks alms as a beggar or he rearranges wood shavings that are to show a young girl the way to her brothers.

The killer hides the girl's favourite teddy-bear so that nobody can find it.

8. Complicity:

The victim succumbs to the deception and thereby unwittingly helps the enemy. As Propp mentions, interdictions are always broken and deceitful proposals are always accepted in folktales, perhaps because of the dramatic appeal of hamartia.

The next day the killer knocks on the door: he has found the teddy-bear. The girl is happy and the grateful mother invites him in for a cup of coffee.

9. Villainy:

The villain causes harm to a member of the family (or lack: member of family lacks something; desires something).

The killer rapes and murders the woman and kidnaps the girl.

This is actually where the story begins with the occurrence of an undeserved misfortune. According to Propp this function is of the utmost importance because it gives the story its movement and direction. All the previous functions have actually worked in preparation for making this function's impact as dramatic and powerful as possible.

10. Mediation:

The misfortune is revealed; the hero is approached with a request or command; he is allowed to go or is sent away.

The father returns home to find his wife murdered and his daughter kidnapped.

This function brings the hero into the tale. According to Propp, there are two kinds of hero. If a girl is kidnapped and a man goes to search for her, he is a seeker hero. If a girl is kidnapped and the story focuses on her attempt to save herself, the story has a victimised hero. Undeserved suffering is the emotional state that needs to be created

here. It forms the motive for the hero's goal-oriented action. The suspense felt by the audience now shifts to this intention.

The police investigate the murder scene and start to search for the girl. The father, frustrated with police inefficiency, considers searching himself. Alternatively, an efficient detective is introduced who becomes the hero.

11. Counteraction:

The hero (seeker) decides on or agrees to counteraction. Because there is an element of hope, despair in the audience becomes suspense. But the hero has the odds stacked against him: how can he succeed in that of which the entire LAPD is incapable? In the first part of the story, suspense was related to the anticipation of the villain's actions (fear), now it is related to the hero's actions (hope).

12. Departure:

The hero leaves home and meets a donor from whom he receives some (magical) agent that eventually permits the misfortune to be rectified.

The first function of the donor: the hero is tested, interrogated or attacked which results in him receiving a magical agent or helper. 'Forest knights propose that the hero serve them for three years … The hero must listen to the playing of the gusla without falling asleep.' The hero is asked for mercy, a prisoner asks for his freedom, or a dying character asks for a favour. This is a test of the hero's character, integrity and the extent of his sacrifice; it convinces the audience of the hero's true love for the princess.

The father begins his own quest. The clues discovered by the father are not taken seriously by the police so he has to rely upon himself. He finds a man who possibly knows the whereabouts of the killer. The man escapes on to the roof and the father risks his own life in the chase as he makes a dangerous jump across to the roof of another building.

Passing this test, in addition to creating suspense, makes the final victory over the villain justifiable.

13. Hero's reaction:

The hero reacts to an object or the actions of the donor. He pays his respects to a dead person, frees a captive or shows mercy. He demonstrates his intelligence as he saves himself by using his enemy's tactics.

The father catches the man. They struggle. The man hits the father and escapes. But he drops something on the ground. It's a secret map.

14. Receipt of Agent:

The hero acquires a magical agent. The audience experience relief as they are shown that morally good action is rewarded.

The father realises that the map reveals information about the whereabouts of his daughter.

15. Spatial transference:

The hero is transferred, delivered, or led to where the object of his search is located. 'Generally the object of the search is located in a different realm.' The hero flies to this

other world on a bird or a carpet or is led there by a fox or finds a secret stairway. The audience are afraid as the hero approaches the witch's castle.

At dusk the father arrives at a suspicious-looking farm.

16. Struggle:

The hero and the villain are joined in combat. The may fight on an open field, engage in a competition or play cards.

The father surprises the killer and they fight.

17. Branding:

The hero is branded. He receives a ring or a wound during the skirmish, or the princess marks him with a kiss on the forehead. This creates a great recognition scene at the end of the story.

18. Victory:

The villain is defeated.

During the fight the father reaches for a log and knocks the villain unconscious.

19. Liquidation:

The misfortune or lack is 'liquidated'. 'The object of the search is seized by the use of force or cunning.'

The father finds his frightened daughter in the dark basement.

The action changes direction as this reversal occurs. There is relief as the goal seems to have been achieved. This is the midpoint.

20. Return:

The hero returns.

The journey home begins as the father runs into the woods carrying his daughter.

21. Pursuit, chase:

The hero is chased. The villain has not been defeated altogether. 'A witch flies after a boy', 'A she-dragon turns into a maiden and tries to seduce the hero'. The suspense increases again.

The killer recovers consciousness, grabs a gun and begins to chase the hero through the woods.

22. Rescue:

The hero evades his pursuer.

The father reaches a major road and at the last moment is rescued by a passing car. Many tales end at this function. 'But often the tale has another misfortune in store for the hero: a villain may appear once again, may seize whatever Ivan has seized, may kill Ivan, etc.'

A further undeserved misfortune occurs at the police station when the girl disappears again.

After the relief, the effect of the new fear is increased as the search starts again.

23. Unrecognised arrival:
The hero, unrecognised, arrives home or elsewhere. He is serving as an apprentice to a goldsmith or shoemaker or he arrives at the king's court as a cook or groom. This is a form of injustice: the hero deserves recognition and to marry the princess.

The detectives arrive, the father explains he had the daughter with him just a minute before but they do not believe him and think he is hallucinating.

24. Unfounded claims:
A false hero makes unfounded claims. A soldier at the court poses as the conqueror of the dragon. In reality he is the man who, at a crucial moment, left the hero to face the dragon alone. Now he claims to have the right to marry the princess and there is a new threat to justice.

25. Difficult task:
A difficult task is proposed for the hero. According to Propp, this is one of the tale's favourite elements and represents the climax. The hero has to endure the crucial ordeal. For instance, he has to choose the right girl from among twelve identical girls; he has to build a palace in one night; or he has to solve a difficult riddle. The stakes are high.

The murderer telephones the police station threatening to blow it up with the girl within a few minutes. The killer says something that gives the father an idea as to the whereabouts of the girl.

26. Solution:
The problem is resolved.

At the last moment the father runs to the basement and saves the girl and the staff.
There is relief and joy for the audience.

27. Recognition:
The hero is recognised. This is by a mark or a brand (a wound, a kiss on the forehead that had left a mark that the princess recognises). Recognition takes place after the solution of the difficult task, thus ensuring the greatest emotional impact.

The detectives realise that the father was right and he is a real hero for having saved them all.

28. Exposure:
The false hero or villain is exposed. He is not able to complete the task while the true hero succeeds.

It turns out that the killer is the detective who was in charge of the investigation.
A great *anagnorisis* occurs.

29. Transfiguration:
The hero is given a new appearance. He becomes handsome, builds a beautiful palace or acquires new clothes.

30. Punishment:

The villain is punished.

The villainous detective tries to escape but falls through a window to his death.

31. Wedding:

The hero marries and ascends the throne. Justice is finally served.

The denouement also speaks to us at the symbolic level: if you are true to your heart, you will eventually achieve harmony in life. The *Kidnapping in Los Angeles* story does not end in a wedding but in a funeral.

The husband is ready to say goodbye to his wife. He realises that life must go on and he has an important role as a father.

Both the folktale and the conventional Hollywood thriller have been able to create the same kind of pleasurable experience for the audience by using the same functions.

Bibliography

Aristotle, *Rhetorica*. Translated by W. R. Roberts. *The Works of Aristotle Vol. XI*. Clarendon Press, Oxford (1924).

Aristotle's Poetics. Translated by S. H. Butcher. Introduction by Francis Ferguson. Hill and Wang, New York (1961).

Poetics with the Tractatus Coislianus. A Hypothetical Reconstruction of the Poetics II, the Fragments of the On Poets. Translated with notes by Richard Janko. Hackett Publishing Company, Indianapolis, Cambridge (1987).

The Art of Rhetoric. Translated with an introduction and notes by H. C. Lawson-Tancred. Penguin Books, London (1991)

Barnet, Sylvan & Berman, Morton & Burto, William, *A Dictionary of Literary Terms*. Constable, London (1964).

Beckson, Karl & Ganz Arthur, *Literary Terms: A Dictionary*. André Deutsch, London (1990).

Belfiore, Elizabeth, Tragic Pleasures. *Aristotle on Plot and Emotion*. Princeton University Press, Princeton, New Jersey (1992).

Bettelheim, Bruno, *The Uses of Enchantment: The Meaning and Importance of Fairy Tales*. Vintage Books (1989).

Blacker, Irwin R, *The Elements of Screenwriting: A Guide for Film and Television Writers*. Collier Books, New York (1986).

Blake, Carole, *From Pitch to Publication: Everything You Need to Know to Get Your Novel Published*. Macmillan, London (1999).

Bordwell, David, *Narration in the Fiction Film*. Methuen & Co, London (1985).

Branigan, Edward, *Narrative Comprehension and Film*. Routledge, London and New York (1992).

Brayfield, Celia, *Bestseller: Secrets of Successful Writing*. Fourth Estate, London (1996).

Brennan, Anthony, *Shakespeare's Dramatic Structures*. Routledge, London and New York (1986).

Brewer, William F & Lichtenstein, Edward H, *Stories are to entertain – A structural-affect theory of stories. Journal of Pragmatics*, 6, 473–86 (1982).

Bronowski, J, *The Ascent of Man*. British Broadcasting Corporation, London (1973).

Bryant, Jennings & Zillmann, Dolf (ed.), *Media Effects: Advances in Theory and Research*. Lawrence Erlbaum, Hillsdale, New Jersey (1994).

Campbell, Joseph, *The Hero with a Thousand Faces*, Princeton University Press (1973).

Cawelti, John G, *Adventure, Mystery, and Romance: Formula Stories as Art and Popular Culture*. The University of Chicago Press (1976).

Cole, Joanna, *Best-Loved Folktales of the World*. Doubleday, New York (1983).

DiMaggio, Madeline, *How to Write for Television*. Simon & Schuster, New York (1993).

Field, Syd, *Screenplay: The Foundations of Screenwriting*. Dell, New York (1984). The Screenwriters's workbook. Dell, New York (1984).

Fisher, Walter R, *Human Communication as Narration: Toward a Philosophy of Reason, Value, and Action*. University of South Carolina Press (1987).

Fortenbaugh, W. W., *Aristotle on Emotion. A Contribution to Philosophical Psychology, Rhetoric, Poetics, Politics, and Ethics*. Duckworth, London.

Friedmann, Julian, *How to Make Money Scriptwriting* (second edition). Intellect Books, Bristol (2000).

Garrand, Timothy, *Writing for Multimedia*, Focal Press (1997).

Gray, John, *Men are from Mars, Women are from Venus*. Thorsons, London (1993).

Grisham, John, *The Firm*. Arrow Books, London (1993).

Hatlen, Theodore W., *Orientation to the Theater*. Prentice-Hall, New Jersey (1987).

Hauge, Michael, *Writing Screenplays That Sell*. HarperPerennial, New York (1991).

Jensen Rolf, *The Dream Society: How the Coming Shift from Information to Imagination Will Transform Your Business*. McGraw-Hill, New York (1999).

Karetnikova, Inga, *How Scripts are Made*. Southern Illinois University Press (1990).

Malinowski, Bronislaw, *Magic, Science, and Religion, and Other Essays*. Waveland Press (1992).

Mandler, Jean Matter, *Stories, Scripts and Scenes: Aspects of Schema Theory*. Lawrence Erlbaum, Hillsdale, New Jersey, London (1984).

Martin, Wallace, *Recent Theories of Narrative*. Cornell University Press, Ithaca and London (1986).

Oppenheimer, Stephen, *Eden in the East: The Drowned Continent of Southeast Asia*. Weidenfeld & Nicolson, London (1998).

Orton, Peter, *Effects of Perceived Choice and Narrative Elements on Interest in and Liking of Story*. Doctoral dissertation, Stanford University, Department of Communication (1995).

Pearson, Carol S, *Awakening the Heroes Within: Twelve Archetypes to Help Us Find Ourselves and Transform Our World*. HarperCollins, New York (1991)

Pine, Joseph B, II, & Gilmore, James H, *The Experience Economy*. Harvard Business School Press (1999).

Prince, Gerard, *A Dictionary of Narratology*. University of Nebraska Press (1987).

Propp, Vladimir, *Morphology of the Folktale*. University of Texas Press, Austin, Texas (1979)

Radway, Janice A, *Reading the Romance*. Women, Patriarchy and Popular Literature. The University of North Carolina Press, Chapel Hill and London (1984).

Root, Wells, *Writing the Script*. Holt, Rinehart and Winston, New York (1979).

Samsel, Jon & Wimberley, Darryl, *Writing for Interactive Media*. Allworth Press, New York (1998).

Scholes, Robert & Kellogg, Robert, *Nature of Narrative*. Oxford University Press, London, Oxford and New York (1979).

Seger, Linda, *Making a Good Script Great*. Samuel French, Hollywood (1987). The Art of Adaptation: Turning Fact and Fiction into Film. Henry Holt and Company, New York (1992).

Stephen, Martin & Franks, *Philip: Studying Shakespeare*. Longman York Press (1984).

Bibliography

Straczynski, Michael, *The Complete Book of Scriptwriting*. Writer's Digest Books, Cincinnati, Ohio (1982).

Styan, J. L., *The Dramatic Experience*. Cambridge University Press, London (1965).

Tobias, Ronald B, *20 Master Plots (And How to Build Them)*. Writer's Digest Books. Cincinnati, Ohio (1993).

Varchol, Douglas J., *The Multimedia Scriptwriting Workshop*. Sybex, Alameda, California (1998).

Vogler, Christopher, *The Writer's Journey: Mythic Structure for Writers* (second edition). Michael Wiese Productions, Studio City, California (1998).

Walter, Richard, *Screenwriting: The Art, Craft, and Business of Film and Television Writing*. Plume, New York (1988).

Weston, Harold, *Form in Literature: A Theory of Technique and Construction*. Rich & Cowan, London (1934).

Wolf, Michael J., *The Entertainment Economy*. Times Books, New York (1999).

Wolff, Jürgen, *Successful Sitcom Writing*. St. Martin's Press, New York (1996).

Wolff, Jürgen & Cox, *Kerry, Successful Scriptwriting*. Writer's Digest Books, Cincinnati, Ohio (1991).

Zillmann, Dolf, *Anatomy of Suspense*. In Tannenbaum, Percy H. (ed.), The Entertainment Functions of Television. Lawrence Erlbaum, Hillsdale, New Jersey (1980).

Zillmann, Dolf, *Empathy*. In Bryant, Jennings & Zillmann, Dolf (ed.), Responding to the Screen: Reception and Reaction Processes. Lawrence Erlbaum, Hillsdale, New Jersey (1991).

Zillmann, Dolf, *The Logic of Suspense and Mystery*. In Bryant, Jennings & Zillmann, Dolf (ed.), Responding to the Screen: Reception and Reaction Processes. Lawrence Erlbaum, Hillsdale, New Jersey (1991).

Zillmann, Dolf & Bryant, Jennings & Sapolsky, Barry S, *The Enjoyment of Watching Sports Contents*. In Jeffrey H Goldstein (ed.), Sports, Games, And Play: Social and Psychological Viewpoints. Lawrence Erlbaum, Hillsdale, New Jersey (1979).

Zuckerman, Albert, *Writing the Blockbuster Novel*. Writer's Digest Books, Cincinnati, Ohio (1994).